HABITUALLY CHIC

Creativity at Work

Sarah—

Hope you are Inspired!

XOXO
HC

HEATHER CLAWSON

powerHouse Books
Brooklyn, NY

To my parents who instilled in me the belief that I could do anything I set my mind to, and also my blog readers for their continued support and encouragement.

This book would not have been possible without either.

"The creative life is the best life of all."

Chuck Close

Introduction

I have always said there are two kinds of creative people. Those who know what they want to do from a very young age and those who get a little sidetracked along the way. I am of the latter variety.

I was very artistic growing up, and even won a few art contests, but didn't keep up with it. I studied art history in college but had no idea what I wanted to do after graduating. I fell into retail management and later went to work at a commercial real estate company. While there, I eventually started to work in marketing and business development, which was slightly creative. After moving to New York in 2001, part of my job dealt with branding collateral materials and updating an online newsletter, skills that would come in handy down the road.

In 2005, I decided to make a change and took a pay cut to work for an interior designer who also owned a gallery. It was there that I started reading shelter magazines and design blogs. When two bloggers in Atlanta wrote about the store that interior designer Charlotte Moss was opening exactly one block behind my office, a light bulb went off in my head. I should write a blog. At that time, not many people writing blogs were actually working in design. They just had a passion for it. I thought I could write about design from an insider's perspective, as well as art, photography, fashion, travel, and other major happenings in New York. From my marketing and branding experience I knew I should name it something that was unique and would come up in a Google search. Since I wasn't sure if my boss would look upon my endeavor fondly, I wanted to remain anonymous. I played around with words in the French and English dictionaries that matched my initials HC until Habitually Chic was born in July 2007.

From the beginning, my blog has always been dedicated to inspiring images, but it has also been just as much about inspiring stories. I'm very lucky that so many people in design, fashion, and art read my blog daily, but when I write my posts I often think about that person who is miserable at work, sitting in a cubicle reading blogs as an escape. I like to remind them, and all my readers, that it is never too late to make a change or take that first step toward achieving their dreams. Martha Stewart was a stockbroker before becoming a caterer and eventually a lifestyle expert, media mogul, and brand. Julia Child didn't start cooking until she was 36 and didn't publish her first book until she was 49.

While many people in this book did know from childhood exactly what they wanted to be like Chris Benz, Jenni Kayne, and Thelma Golden, there are a few who worked at various jobs before striking out on their own like Michael Bastian, Jonathan Adler, and Albertus Swanepoel. Regardless of when everyone figured out what they wanted to do with their life, they all now have their dream job. It is exactly the reason I wanted to profile them for this book.

Something that came to me later in life, and because of my blog, is photography. A blogger these days need to be a writer, editor, and photographer in order to stand apart. I am very grateful that my publisher had enough faith in me to allow me to photograph these subjects in their offices, workspaces, and studios. They spend so much time at work. Their spaces are very personal and full of mood boards and artwork so it's like looking directly into their head.

Creative careers aren't always the ones that bring fame and fortune. Not every day is sunshine and roses. The creative people profiled have all followed their bliss and love going to work. For each of them, the good far outweighs the bad. They will tell you about how they got their start and what keeps them going. Where they go to get away from it all, the best advice they ever received, and more. You'll learn that not only are they all creative, but also curious, courageous, and kind.

I hope they all inspire you as much as they inspired me.

Heather Clawson

Contents

"Things won
are done;
joy's soul lies
in the doing."

William Shakespeare

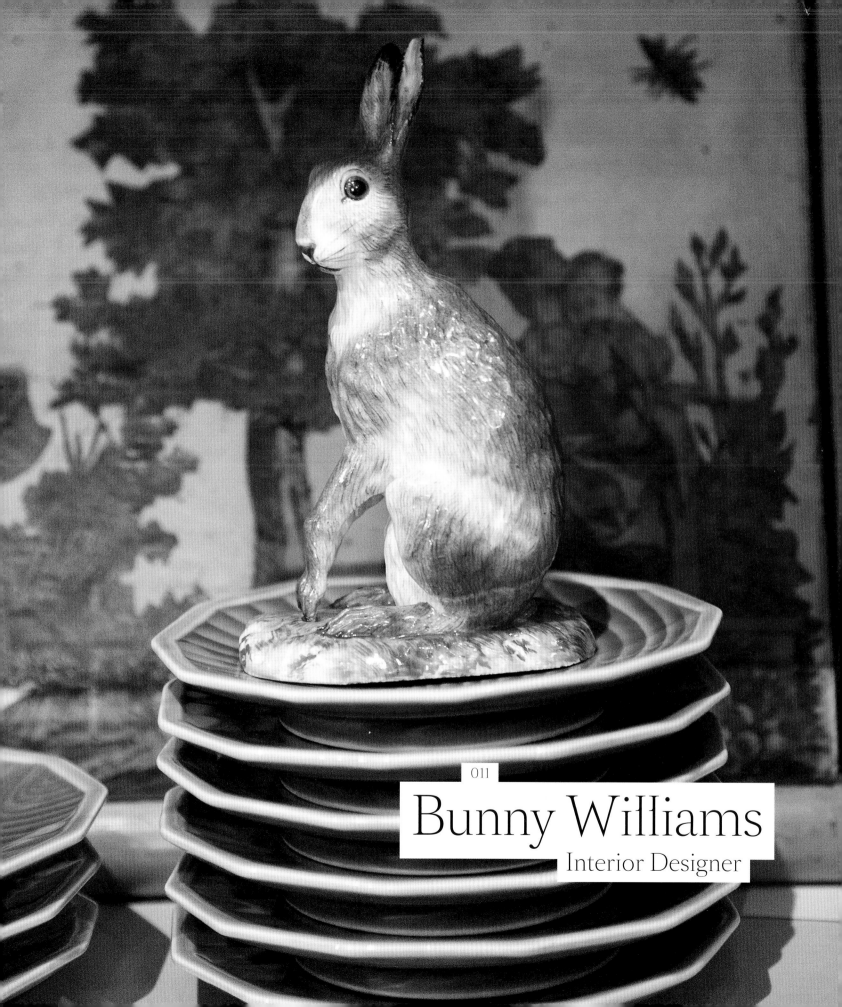

011

Bunny Williams
Interior Designer

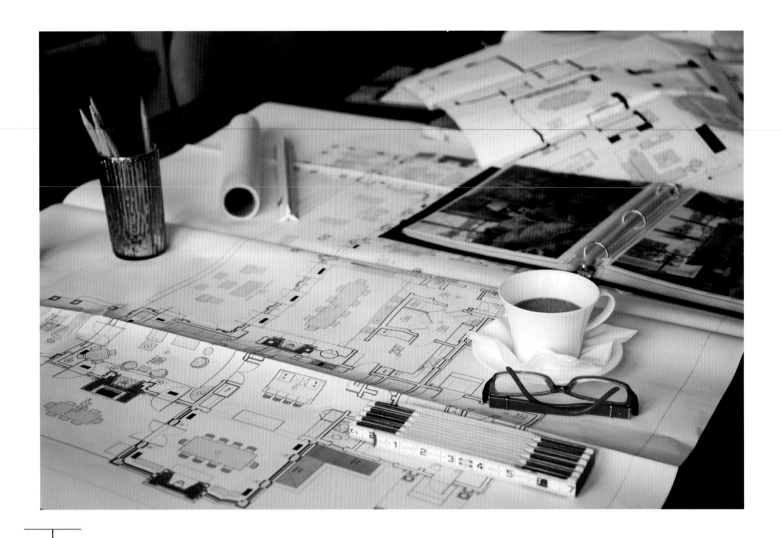

There is an old adage that nice guys finish last, but interior designer Bunny Williams is so nice that I think it's definitely one of the secrets to her success. She is also incredibly talented at creating inviting rooms that make you want to sit and stay awhile. She will have thought of everything and there will always be a place for you to set your drink. But then again, she learned from the best. She worked for 22 years at the venerable interior design firm Parish-Hadley whose door she knocked on one day looking for a job. Even though I've never worked for her, I find myself learning from her example as a designer and a businesswoman. But most importantly, I will always remember to be nice.

"To be creative and never turn your back on new ideas and new possibilities."

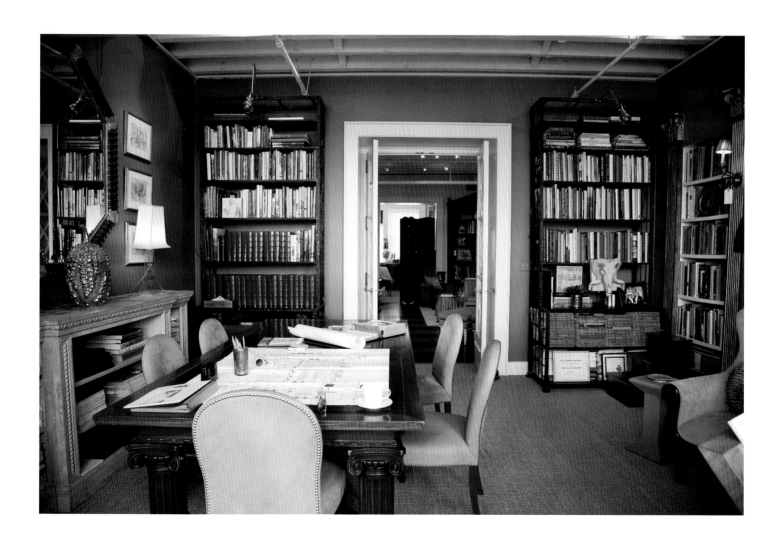

The idea to become an interior designer probably started subconsciously when I spent hours and hours decorating my dollhouse.

When I was 14 I visited the Greenbrier resort in West Virginia. Dorothy Draper had just decorated it and I went with my parents to the opening. I couldn't believe what I was seeing. I came from a staid Virginia house with all this English furniture and here was all this color and pattern in room after room. I thought to myself, wouldn't this be fun. A couple of years later when it was time to go to college, I decided I wanted to study interior design.

I moved to New York in 1965. I loved Virginia but there was an allure to New York. Once you have the dream and it's in your genes, they can't keep you back on the farm.

My first job was in an English antique shop called Stair & Company. It was an incredible experience. I spent two years cataloging shipments, looking at furniture, learning about decorative arts. I learned what a Hepplewhite chair was and about Worcester porcelain. I had to really look because I had to write the descriptions.

I knew I wanted to work for a decorator so I walked up to Parish-Hadley one day and asked if there was an opening. Mr. Hadley needed a secretary so I was hired and that was the beginning.

I worked for Parish-Hadley for 22 years and I could have gone out on my own earlier, but I waited until I was ready to take on the responsibility. When you work for a firm like that you realize the magnitude of all the things that go into it and I knew a lot that made me cautious about starting my own business. When I could set up an office and have an accounting department, I was ready to go out on my own.

I learned from Albert Hadley about design, scale, and proportion. I also learned to think outside the box; to always look at something new; to be creative and never turn your back on new ideas and new possibilities.

From Mrs. Parish, I learned that it is a home. What we are creating for people are places to live. There was nobody who could make a house more inviting or more comfortable than Mrs. Parish. It's a combination of great design and scale, but then making the spaces human.

Young people need to learn that you might have style and you may know a lot of things but it's the experience of understanding how projects are put together, all the details, all the things that can go wrong, all the things you have to think about that you only get from working with somebody who works at a very high level.

One of the most important things you have in interior design is your personality and your ability to engage your clients in a very personal way. If you don't have that personality, you'll always have a hard time with clients.

014

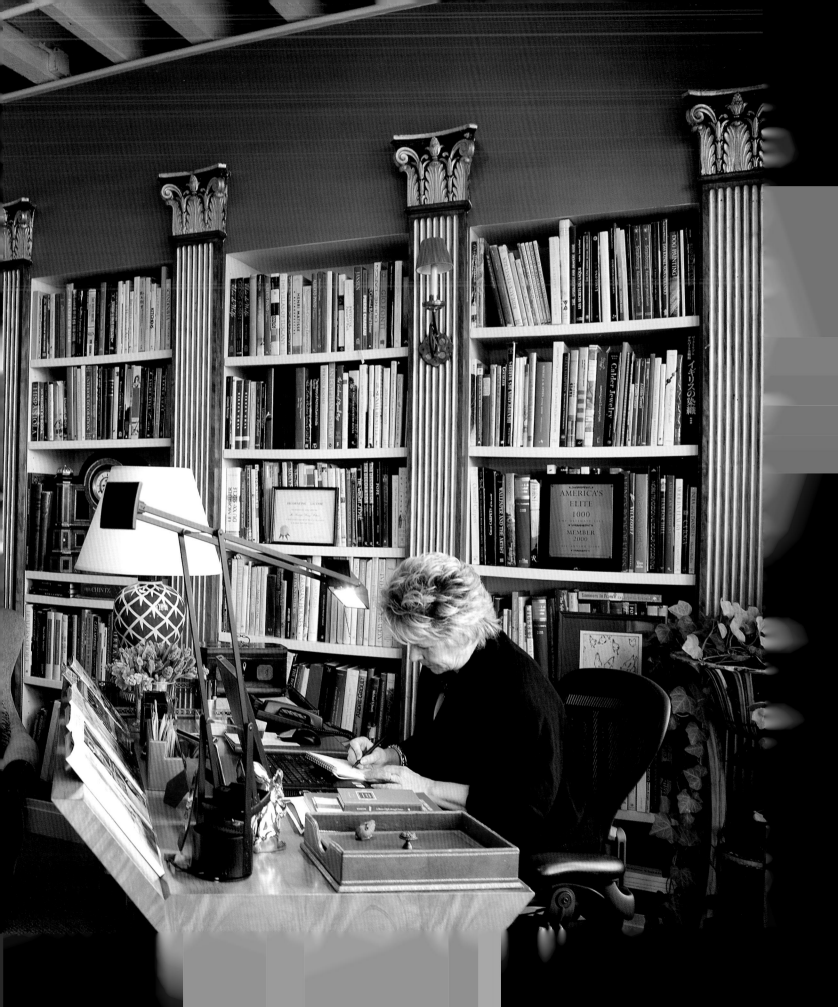

LICENSED
COLLECTION
for MIRROR IMAGE

I love being creative. Every project is a puzzle. Nothing excites me more than trying to figure out a problem space and how to rearrange it and make it better. Sometimes an ugly house is more fun to work on because you've got a bigger challenge.

I wanted to make my own thing so I created BeeLine Home. I go to China to look at it and make sure it's exactly what I want. I control the decisions that are made about the furniture, not some big company. It's exciting. I don't produce anything with my name on it that I wouldn't have in my own house.

I love to travel. I look at books every night. I get every magazine including the European editions. I think if they can, one should travel. As good as books and magazines are, it's nothing like being in a space. That's where you really learn about proportion and scale and excitement. You can't get that from a picture from a book. You can get a little detail or idea but you're never going to be a great designer until you go into spaces and analyze and feel them.

I have a great young group that works with me. They've exposed me to blogs and I spend time every day looking at them. The gift of it is that more people have access to more really good references. It allows more people to hear about your products as opposed to the days when magazines were published once a month. You also get immediate feedback. The hardest part is finding the time to read it all and knowing when to turn your computer off and go out and see things.

Some of my friends aren't interested in decorating, which is nice. You need to get outside of what you do and have people around you who don't just want to talk about decorating or style. Sometimes you need to turn it off...but not always 100%.

I think that we all have to be who we are. I was brought up to be nice and I never want to hurt anybody. I have been in situations where people have been generous to me and helped me along and I want to be able to do that for other people. If you are nice, it allows people to open up to you. My client should never be intimidated by me. They should always feel comfortable with me, and only then can I really help them. It's my style of doing things. The more successful I become, I feel like I have a bigger obligation to be nice.

"Omnia Causa Fiunt."

Anonymous

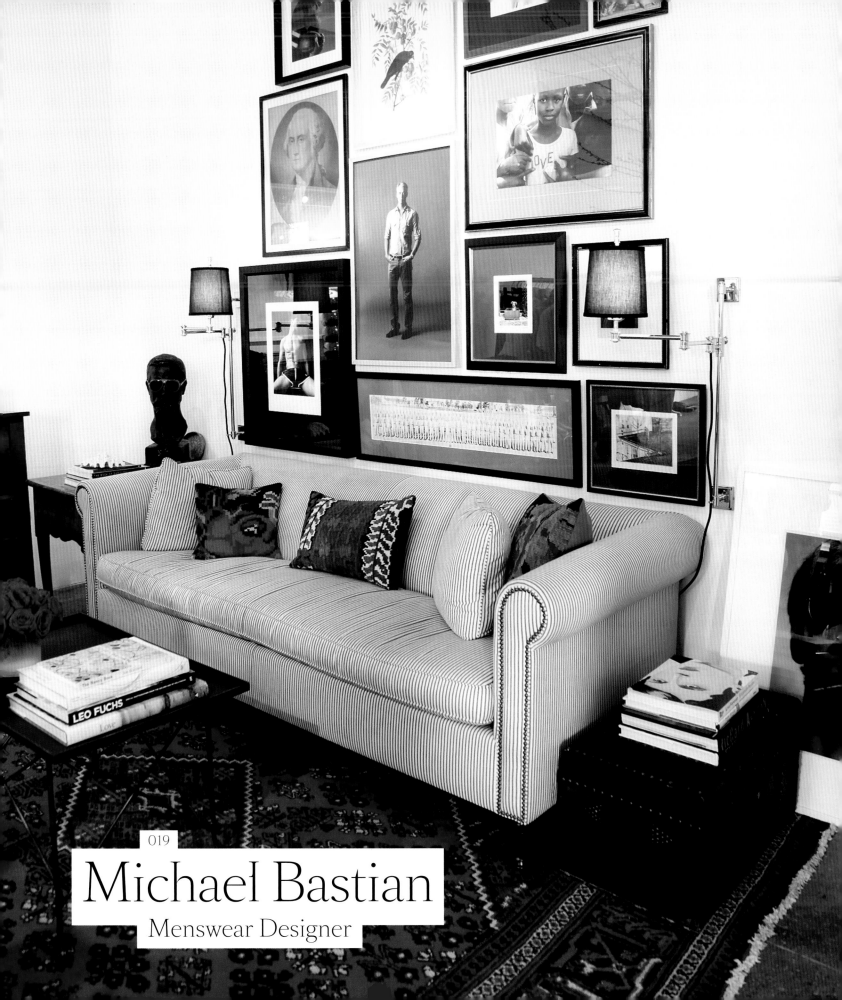

Michael Bastian
Menswear Designer

I can't remember when I first saw Michael Bastian's menswear. I think the reason is probably because his classic-with-a-twist take on American sportswear makes you just assume it's been around forever. It's even more remarkable because Michael didn't go to design school. He'll tell you himself that his "random string of jobs" at Sotheby's, Tiffany & Co., Polo Ralph Lauren, and as the men's fashion director at Bergdorf Goodman prepared him as a designer better than any school. Sometimes people end up taking the scenic route instead of the super highway in life, but they still end up getting to where they were supposed to go. He doesn't design for women under his own name yet so in the meantime, I'm going to take his advice and buy myself a pink shirt.

"Everyone looks better and more alive in a pink shirt."

CREATIVITY AT WORK – MICHAEL BASTIAN

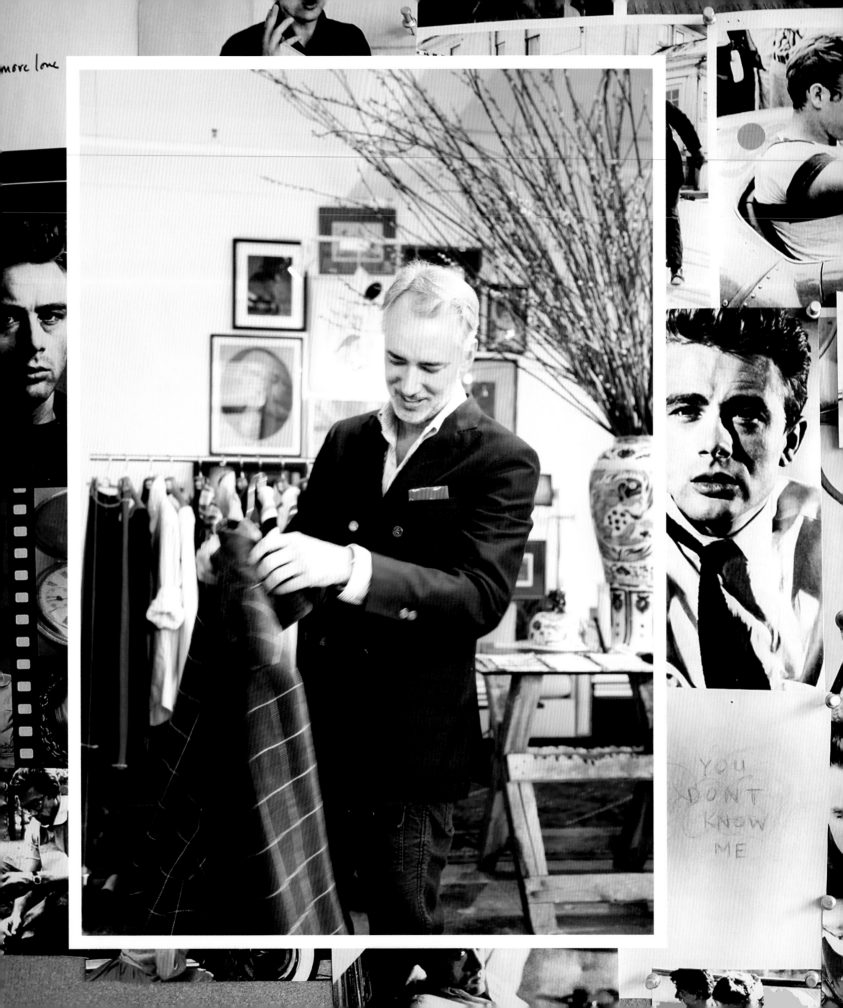

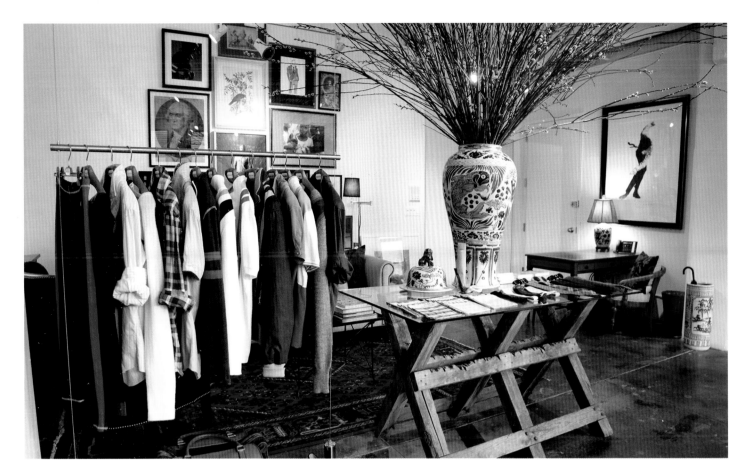

I think my random string of jobs prepared me better than any formal fashion education could. Those were all great learning opportunities for how the luxury customer truly shops what they're looking for, how they like to be treated, what kind of experience they expect.

When I worked for Ralph Lauren I really learned how to conceive of a brand holistically, meaning it all needs to send the same unified message, from the merchandise, the visual components, the advertising, the stores, everything. It's really an invaluable experience being in that environment and seeing how it's done right.

When you're a menswear designer you're working with a more limited toolbox than women's designers, but there are still endless ways to make things men wear everyday look fresh again. You can play with color, proportion, texture, styling—there are lots of tricks.

I'm always excited by the constant renewal that needs to take place. This is an unforgiving industry, and as soon as you show one collection, you need to forget all about it, remove it from your mind, and start on the next one.

The only thing that cures the postpartum depression the days and weeks after a show is to go back to work and open your notebook to a clean white page and start all over again.

Inspiration can come from anywhere: a book, a movie, a place, or person—anything really. I think the job of a designer is just to be open to it all, absorb it, and reinterpret it in your own way. I really look up to Jim Moore at American GQ for this. He's one of the few men I know whose perspective and eye are always evolving.

The best way for me to find balance is to get out of the city and go back home to visit my family in upstate New York. It really reboots my brain and body somehow.

Everyone looks better and more alive in a pink shirt.

I'm in no rush to design a Michael Bastian women's line. I feel there are so few designers solely focused on menswear at the moment and I like being able to give it my full attention. Maybe in the future though...

I think I could do a really good job dressing President Obama.

"In beauty may I walk.

All day long may I walk.

Through the returning seasons may I walk.

On the trail marked with pollen may I walk.

With grasshoppers about my feet may I walk.

With dew about my feet may I walk.

With beauty may I walk.

With beauty before me may I walk.

With beauty behind me may I walk.

With beauty above me may I walk.

With beauty below me may I walk.

With beauty all around me may I walk.

In old age, wandering on a trail of beauty,
lively may I walk.

In old age, wandering on a trail of beauty
living again may I walk.

It is finished in beauty.

It is finished in beauty."

Navajo Prayer

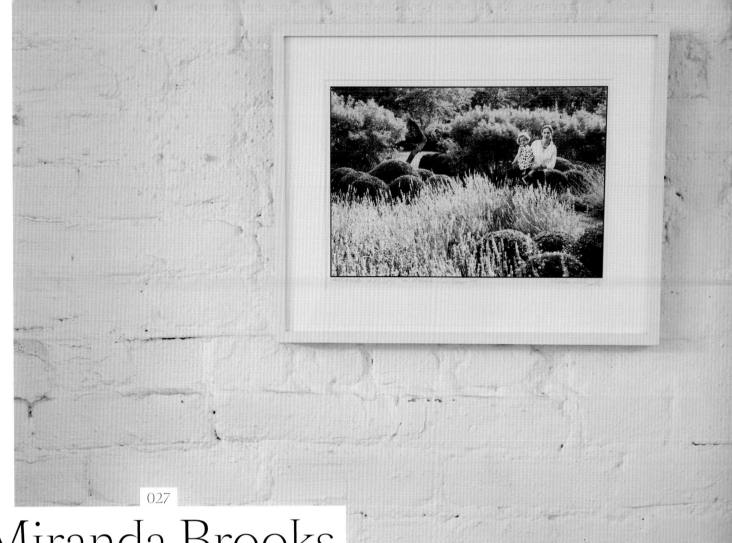

027

Miranda Brooks
Landscape Designer

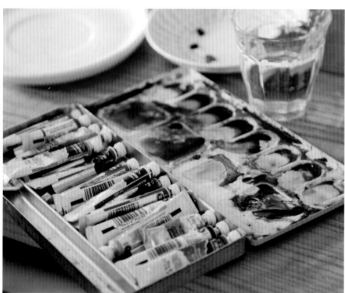

There is something about city living that makes one long for nature. While I love visiting Central Park, I dream of owning a house with a garden. One I don't have to share with millions of other people. When that day comes, I will definitely be picking up the phone to call landscape designer Miranda Brooks to design it. Her work, which has appeared many times in *Vogue*, seems less about perfectly manicured lawns and more about "helping the landscape reveal its full potential while creating a balance between house and garden." Until I have my own house and garden, I will continue to look at photos of her work and dream.

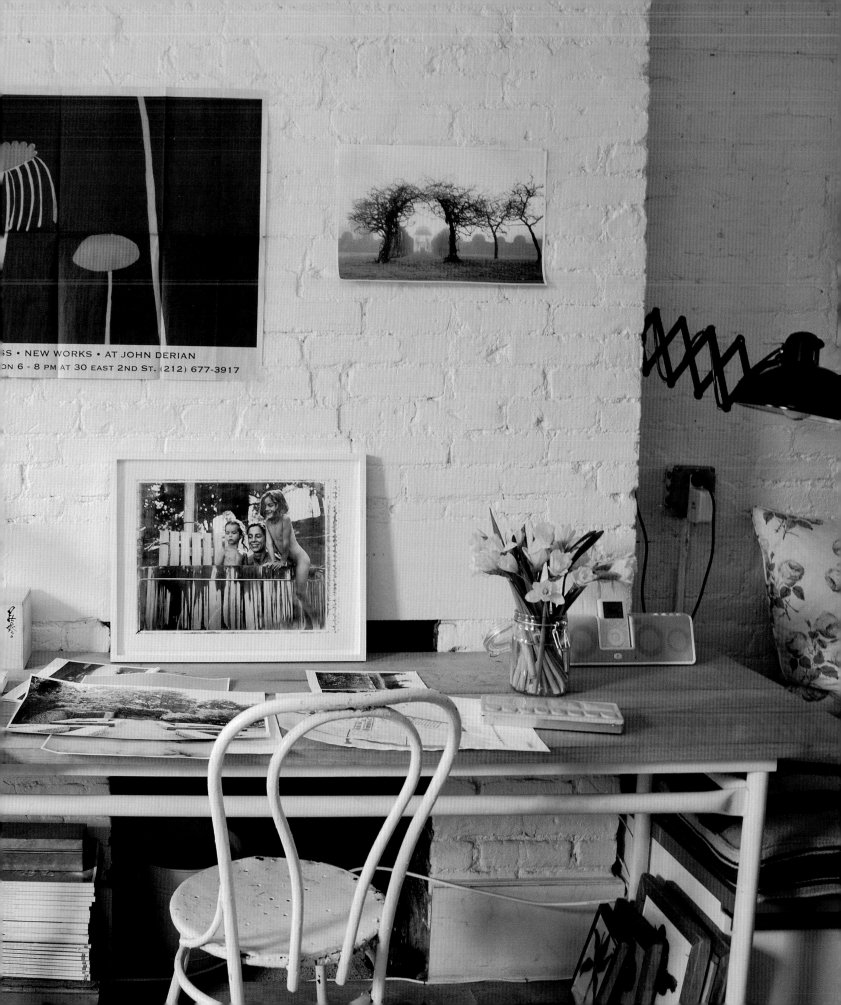

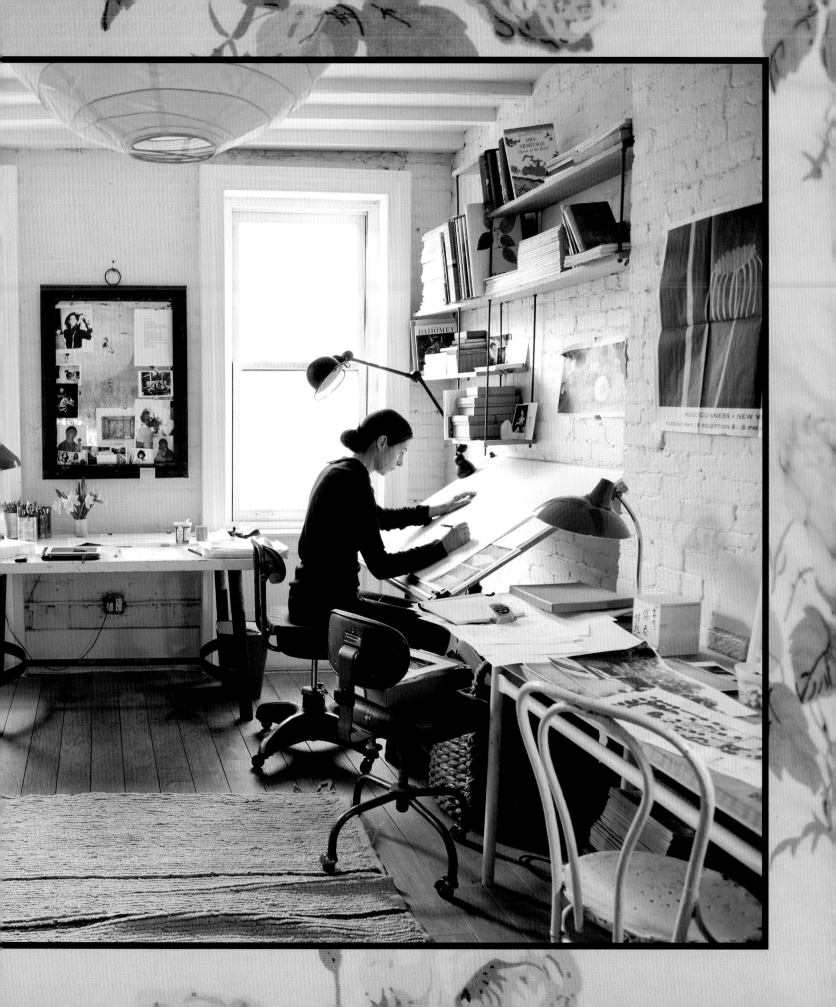

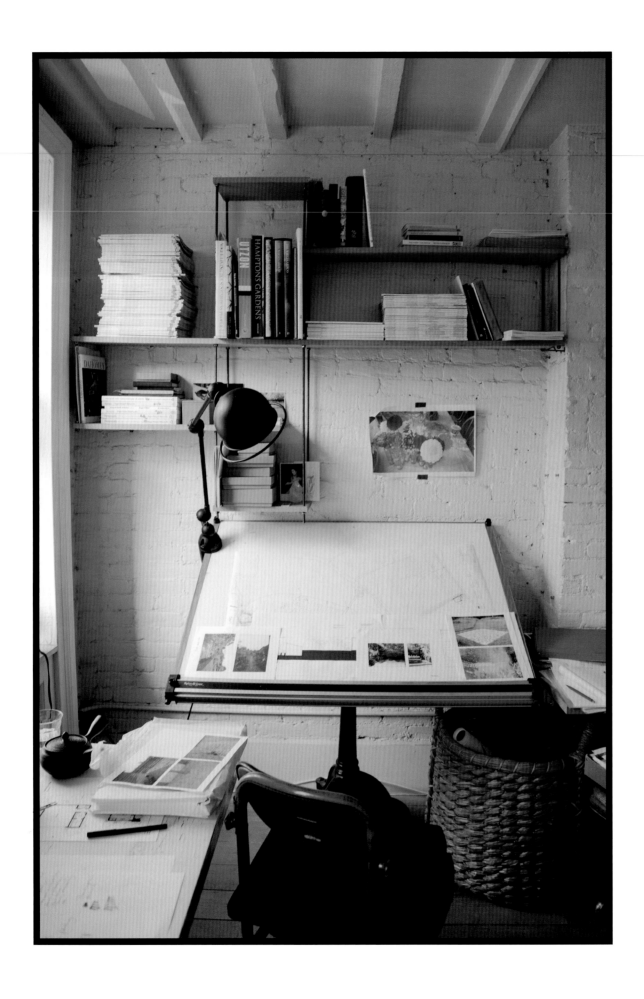

When I was studying art history at the Courtauld Institute of Art and spending every weekend planting trees I knew I wanted to do this.

I think the only lecture spent educating someone before beginning a project is that you cannot call a garden a yard. If you do, this might be too big a leap.

Box and auriculas are my favorites, but because I work in so many different climates, every year seems to bring new loves. At this moment it is Corylopsis pauciflora (Buttercup Winterhazel).

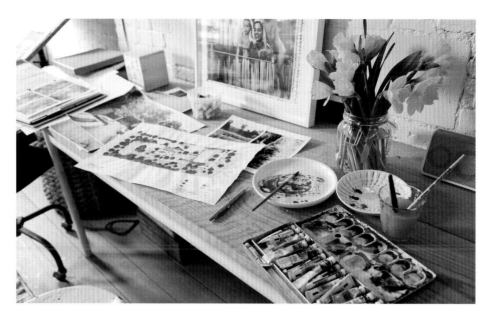

Apart from the pervasive hum of air-conditioning, it's not hard to design a relaxing garden in New York.

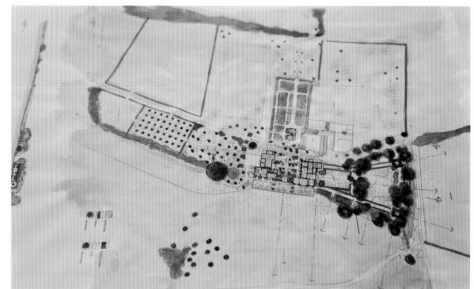

I think ideas come from a combination of the land itself and great gardens I know. Images from books are generally most useful for details.

I most admire Capability Brown. It is basically the same profession as it was in the 18th century, and we work in the same way, but he had no cameras and rode to all his jobs, which I would love!

Don't do anything someone else could do better.

I think it's always rather more about beautiful land than a dream client.

Each new season, each new landscape always excites me.

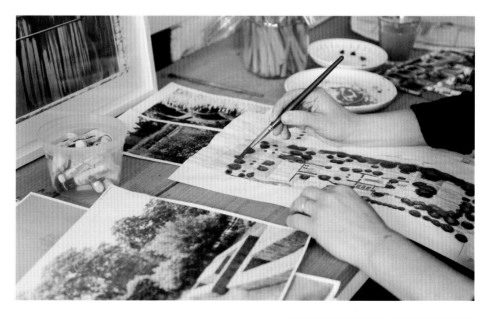

"Quality is remembered long after the price is forgotten."

Aldo Gucci

035

John Truex & Richard Lambertson
Design Directors, Tiffany & Co.

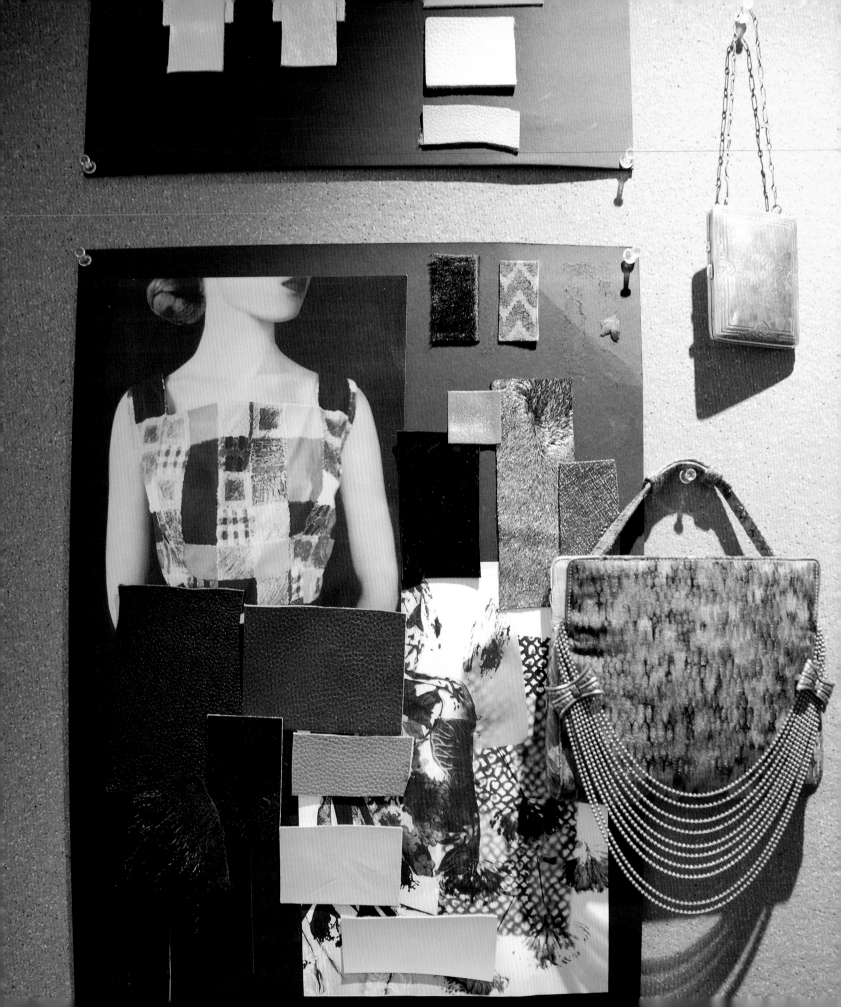

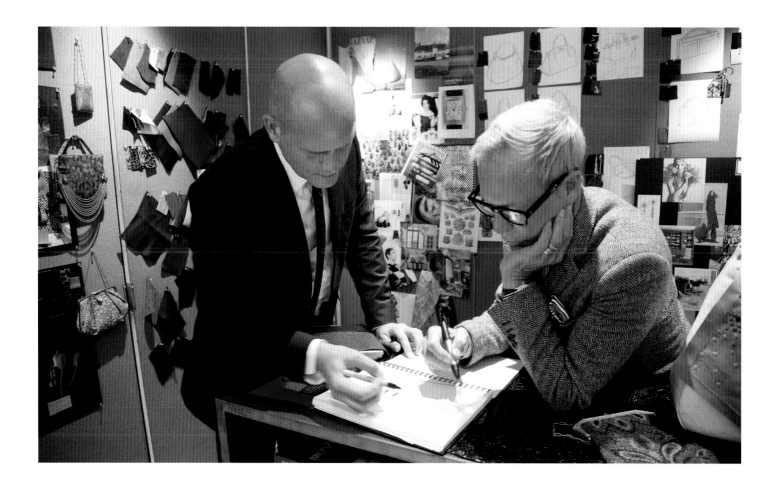

M any people dream of working for themselves but rarely does anyone like to admit how hard it can be. John Truex and Richard Lambertson realized their dream when they created their company Lambertson Truex in 1997. Their handbags were very popular and I still own a large canvas and gold beach bag they designed. But the tough economic times of 2008 took their toll and they were forced to declare bankruptcy. Tiffany & Co. bought them out in 2009 and decided to create their own line of luxury bags with the design duo at the helm of the Tiffany Leather Collection.

It was at a literal breakfast at Tiffany's, where I was seated next to John Truex, that he admitted how hard it was working for themselves. He remembered trying to do payroll on a train in Italy while on a sourcing trip. He said that working with Tiffany & Co. now gives them the freedom to focus entirely on being creative. Judging by the gorgeous bags and leather goods on display in their workspace, I'd say working for Tiffany & Co. definitely agrees with them.

In 1987 I was working at Carlos Falchi and Richard was with Geoffrey Beene. Carlos was designing accessories for Mr. Beene's fashion show—this is how we met. We decided to work together in 1997. We were both ready to do something on our own, so we decided to join together and start Lambertson Truex.

I was walking up Madison Avenue one day and noticed this very chic woman...when I looked down, she was carrying an LT bag. It was my first "sighting," which was very cool.

We share the creative process together. I will start a series of bags, and Richard will finish. We both have extensive business experience as well, so we share that process, too. Honestly, we do go back and forth over each other's designs. I would not say we get "mad" at each other, but we sort of fuss over certain design details. That always makes a great design even greater.

We do so much more than just design. We promote the collection as well, so we interact with the customers. We really enjoy working with such an amazing group of individuals at Tiffany & Co.— it is very inspirational.

Never take your work home with you. It is hard and sometimes doesn't happen, but we try.

We love vintage magazines. Vogue magazines from the 50s, 60s and 70s—fabulous! We travel all the time so you can find us in foreign vintage shops throughout Europe.

Dawn Mello once said, "Stay pure and true to your designs and you will always succeed." She is correct....never get off the path you started on. Your customers will always be there for you.

We are who we are and divas we are not. That just seems so exhausting. What has helped us in our careers is our passion for accessories. We both love what we do.

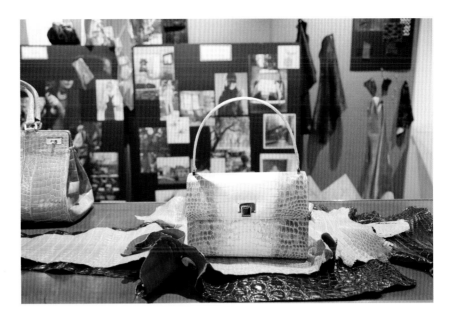

041

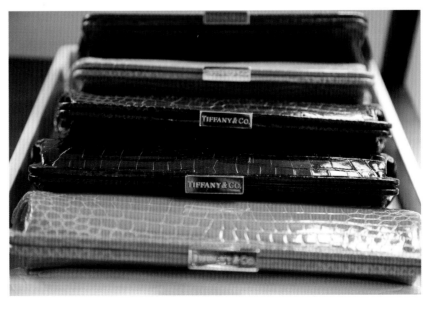

"Do your work,
and I shall
know you."

Ralph Waldo Emerson —

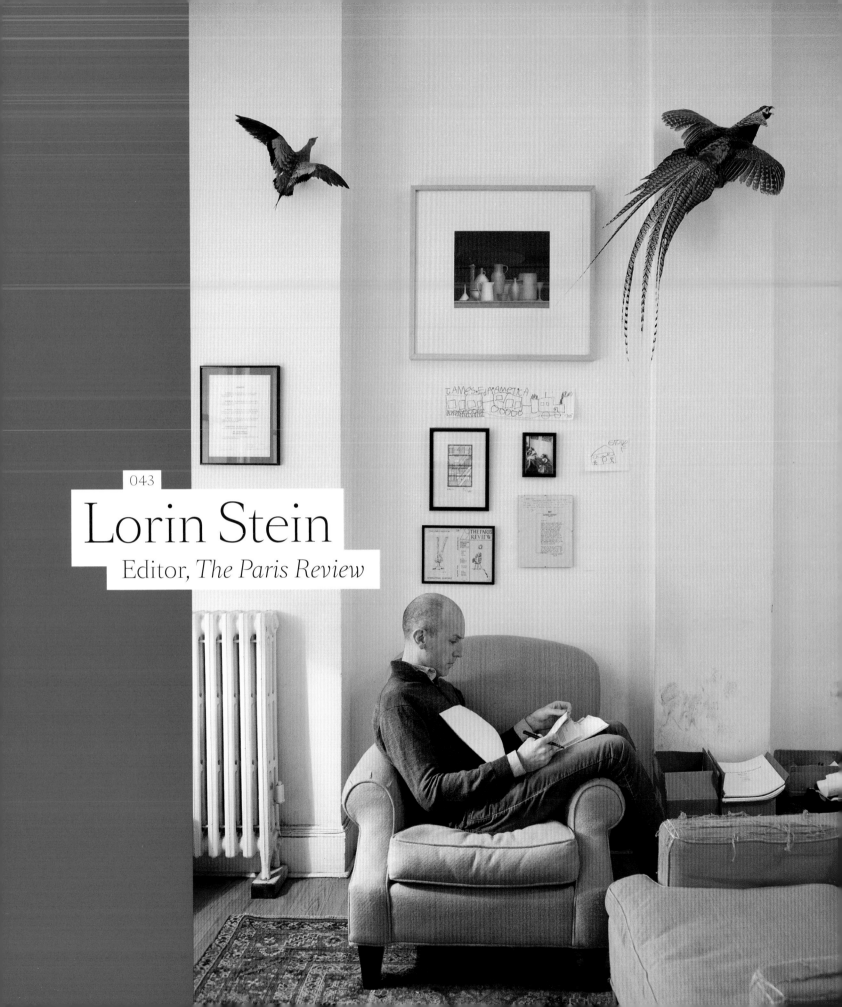

043

Lorin Stein

Editor, *The Paris Review*

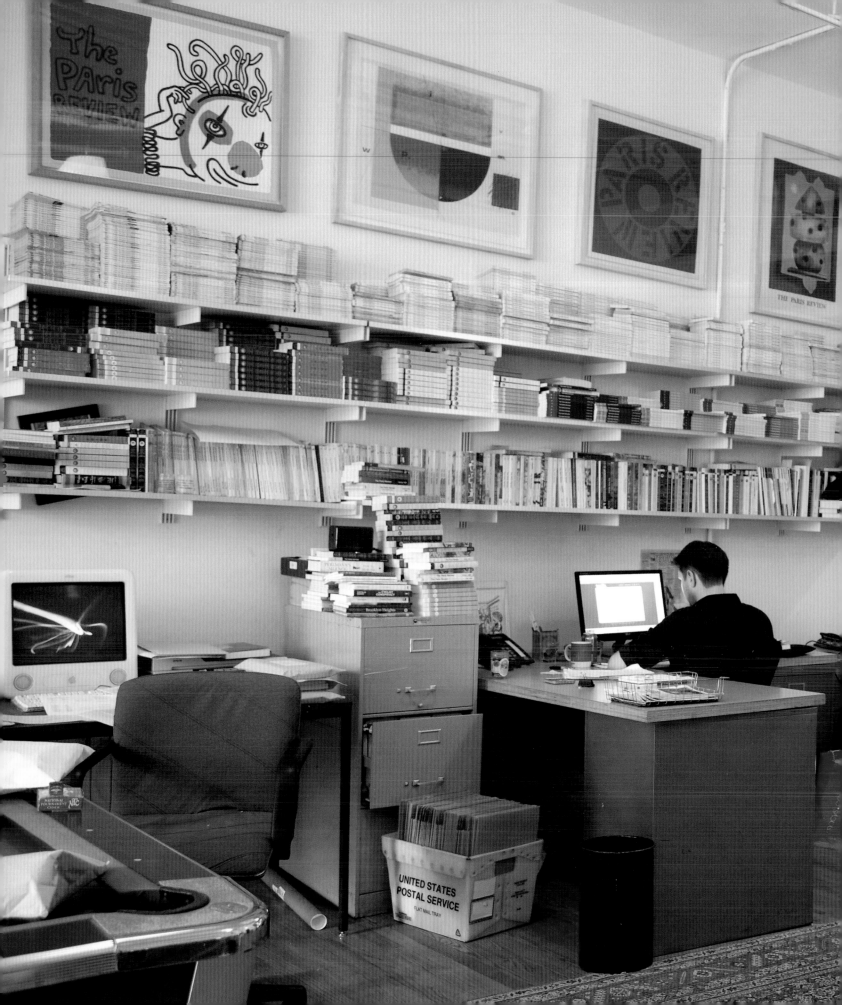

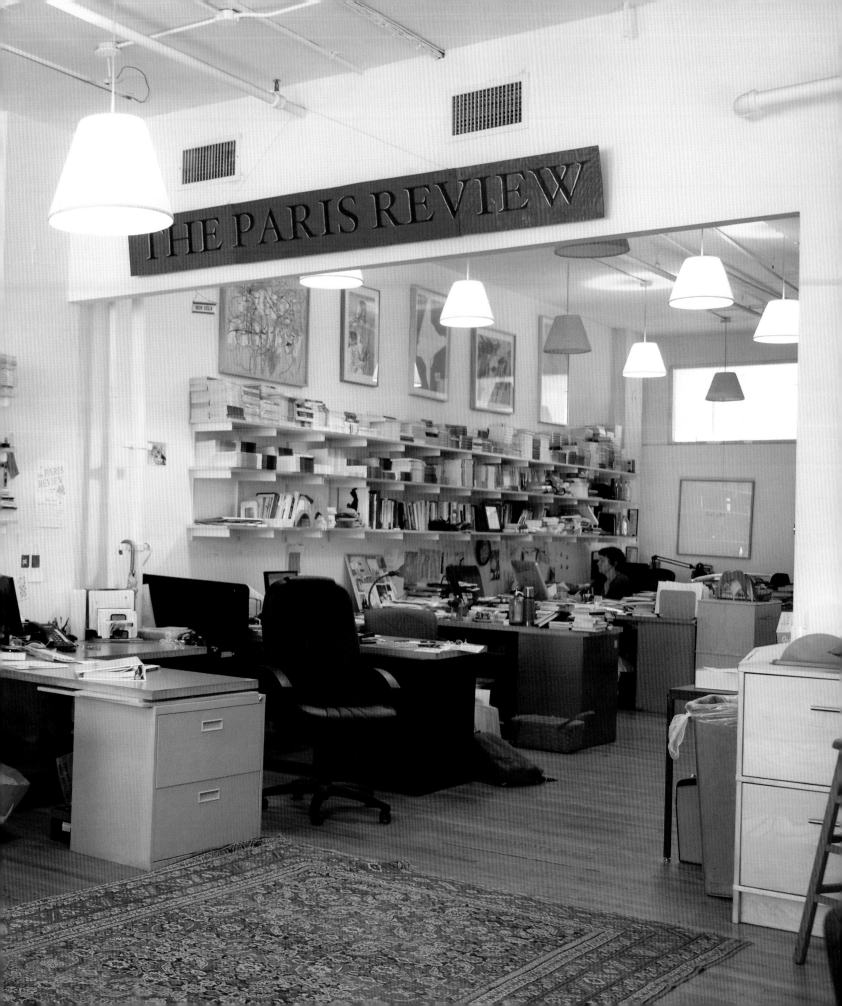

loggers don't usually get a lot of respect from the literary world, so I will admit that I was more than a little intimidated to meet Lorin Stein. If he was intimidated by his appointment as only the fourth editor of *The Paris Review* in the history of the magazine, he certainly hasn't let on. *The Paris Review* was founded in Paris in 1953 with a mission to publish "creative work" of fiction and poetry. Since then, it has published the work of authors such as Jack Kerouac, Philip Roth, Jeffrey Eugenides, and Jonathan Franzen, to name just a few. Unlike its founders, Harold L. Humes, Peter Matthiessen, and George Plimpton, Mr. Stein is now faced with the task of keeping *The Paris Review* relevant and read in a world that has become all about the internet. If anyone can do it though, it's Lorin Stein, who knew at a young age that he wanted a life in books.

Starting in second grade, I knew I wanted to make books. For a long time I thought this meant I had to become a writer— but editing is what came naturally.

The main job of an editor is to choose good writing and publish it with a bang. Sometimes you also give advice or correct people's punctuation, but mainly you are a cheerleader.

George Plimpton founded the magazine and edited it for fifty years, until the day he died. It will always be his baby. That said, times have changed, and writing has changed, in ways that he couldn't have foreseen, so we latecomers have plenty to do.

I get uneasy if I don't read for pleasure. Most nights I read a magazine over dinner and a book in bed.

I walk down the street to the Strand bookstore and go into a fugue state. Eventually I buy two books, one to read and one because I'm always afraid I've chosen wrong.

I admire Robert Silvers. Since 1963, Bob has edited The New York Review of Books, a magazine so smart, so true to itself, and so unlike anything else, that future generations will have trouble believing it existed.

The web is a tool of salesmanship. Of course we want everything we publish online to be interesting, and beautiful when possible, but in the end our web site exists to promote The Paris Review. Our short stories, poems, and interviews have nothing to promote. They exist to be read.

Nowadays most writers, including the great ones, publish at least some of their work online. The problem with online writing isn't the writing. It's the distractions, the feeling of being betwixt and between. You are always halfway onto the next thing.

I would love to publish interviews with J.K. Rowling, Cormack McCarthy, John Berger, Elmore Leonard, and Ira Glass. For now they've all said no—but I live in hope.

048

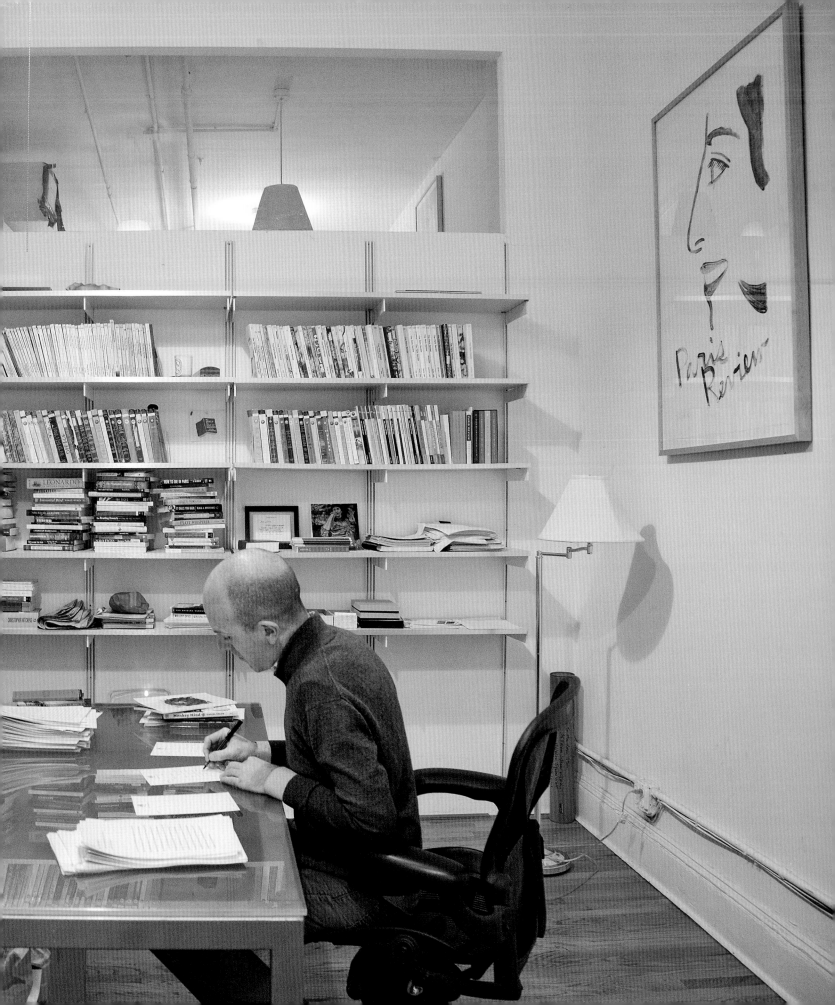

"The past memories, present experiences, and future dreams of each person are inextricably linked to the objects that comprise his or her environment."

The Meaning of Things,
Csikszentmihalyi & Rochberg-Halton

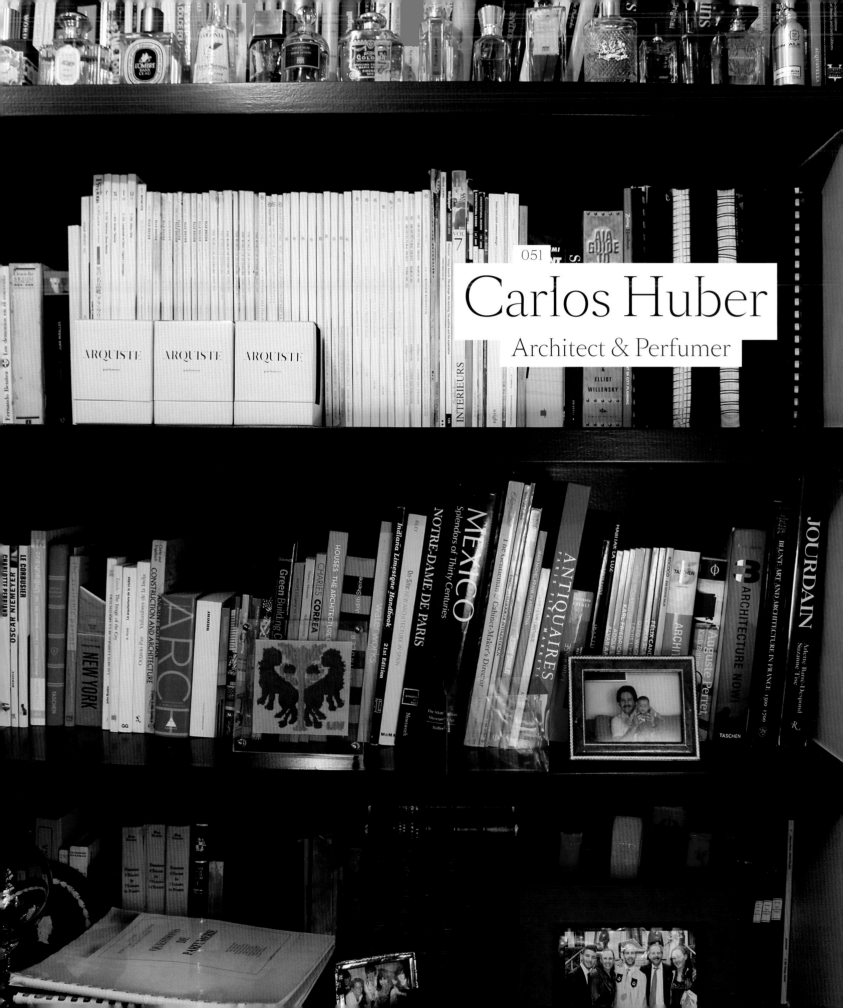

Carlos Huber

Architect & Perfumer

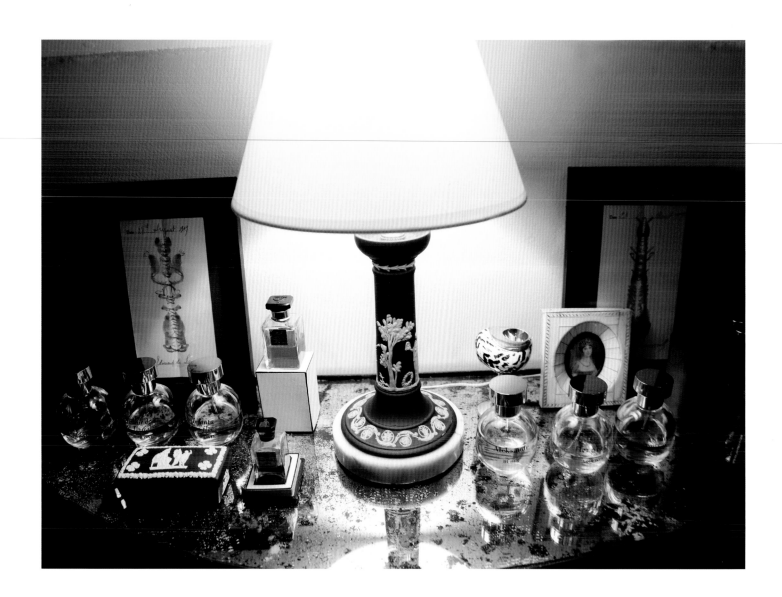

When I learned that Carlos Huber was an architect who also made perfume, I knew I had to meet him. I am always inspired by those individuals whose creativity cannot be confined to just one medium. His intelligent and extremely thoughtful approach to creating perfume is utterly fascinating. Each scent is based on a place and time in history that he thoroughly researches through travel, architectural treatises, and many old books—some in his native Spanish and French. He delves into what residents of certain cities would have eaten, the plants native to that region, and the scents they might have worn at that time. You don't meet many modern Renaissance men, but I can truly say that Carlos Huber is one who will be inspiring us for years to come.

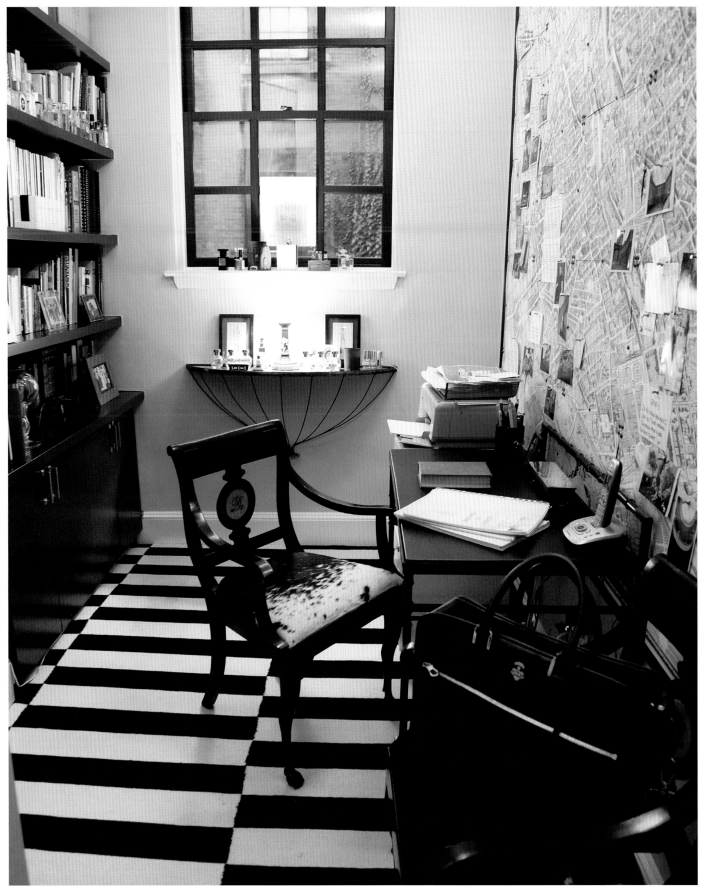

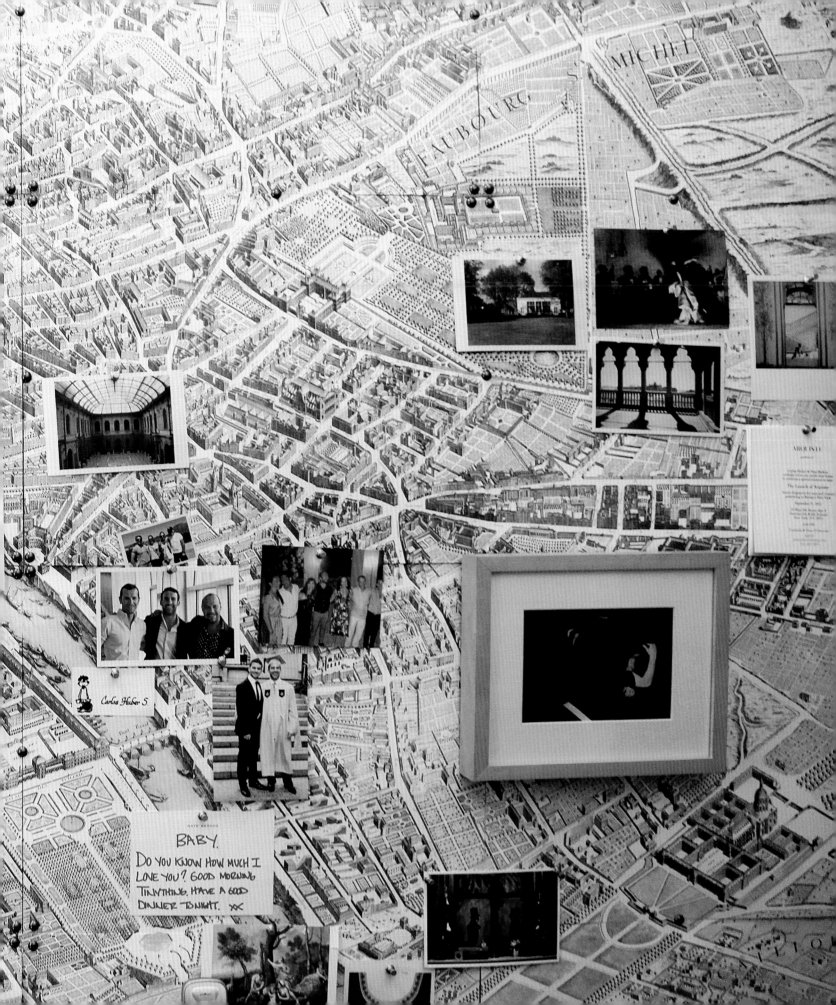

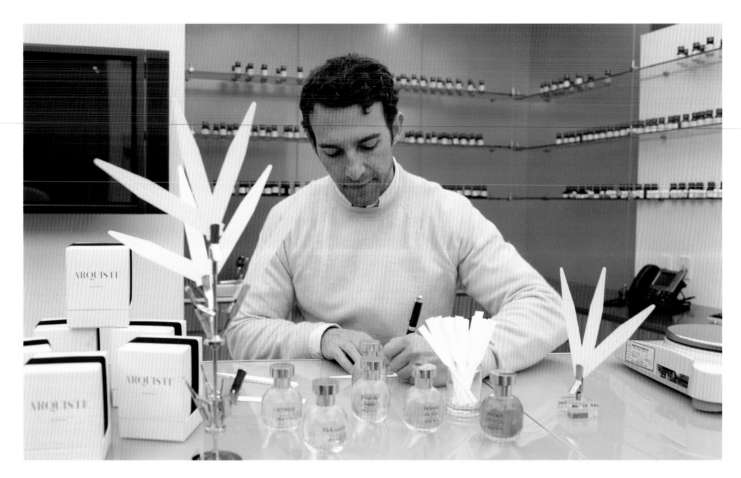

My fascination with historic architecture has always been connected to its experience. And if you are sensitive to scent, then what you smell and feel is just as important as what you see.

I hope to continue to delve into both architecture and perfume. Having the two parts fulfills me. And yes, to me they are very much intertwined! Just like any work of restoration, you start by looking at the structure, the ornament, and the characters that are involved. You choose a direction and put your 21st-century hands on it, change and alter its course to be able to preserve it. I believe that I can do the same with perfume.

Architecture and perfumery are both fields that involve long and complex processes. The research to create a perfume and actually base it on a real story is as thorough as the research behind the restoration of an old building. In both,

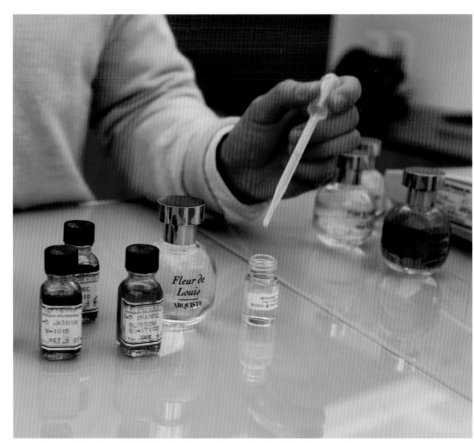

you need to find clues that give reason and justification to the structure that you are building.

Arquiste was born out of the idea to create scents based on serious research; real works of art that would allow us to see the value of a "disconnected" past with our present.

I spent a year of research on each of the stories behind the six perfumes in the debut collection. I visited the sites, studied the architecture, spent many days in libraries and archives; asked botanists, historians, and chefs for clues into what the scents would involve. Every time I would do research on a building or city I would come across an anecdote, a part of the story, where I would think, "What did it feel like? What did it smell like?" That's when I thought, "Could we actually "restore" that olfactive experience?" That was my goal with Arquiste.

The first time I smell a composition it uncovers the emotional connection to the story, and sometimes it's a true revelation. Then, when it's in the final stages, I love seeing how people react to each scent and if they connect to it!

I admire many different perfumers and creators, from Rodrigo and Yann to entrepreneurs like Frédéric Malle, Andy Tauer, and critics like Octavian Coifan, who writes about art, perfumery, and architecture like nobody else.

Rodrigo Flores-Roux is my fragrance AND art history mentor. For a year and a half I took classes with him. We would talk about ingredients, formulas, go into the lab, do smelling sessions, and of course, talk about the cultural significance of specific scents and how they were related to their time. He is like a living cultural encyclopedia, and I don't know anyone who pours as much joy and life into what he does.

When visiting the Historic Center of Mexico City and on my first trip to Europe, I realized what I liked the most was seeing and taking pictures of buildings. My first interest was in old buildings, and so I decided to focus and expand my career based on that first love.

In New York, architect Jorge Otero-Pailos has inspired me to look at historic preservation as a very avant-garde specialty. He has taught me that "freezing" a building's deterioration and interpreting its history is more modern and radical than we think.

My favorite architects and thinkers are Sir John Soane and Carlo Scarpa. Both were so playful and creative. They dissected the past and had a real love for it. At the same time they dealt with incredibly modern and technical details that really show how meticulous they were.

I love books and magazines on design and architecture, but especially the ones that go beyond "trend" and try to translate the "experience" behind the art of design.

Interior designer Nate Berkus has taught me a lot about style and design, but also about how to pursue a life that inspires you. To combine not only styles and design references, but the things that fascinate me and challenge me in order to shape a professional life that is above all, a pleasure.

My favorite refuge in New York is the Metropolitan Museum of Art. I can be there for an hour walking around a new room, or paying a visit to my favorite works of art and I feel restored.

Do what you are passionate about and make yourself happy; this will make those around you happy as well.

"If it's not edible,
it's not food.
If it's not wearable,
it's not fashion."

Alber Elbaz

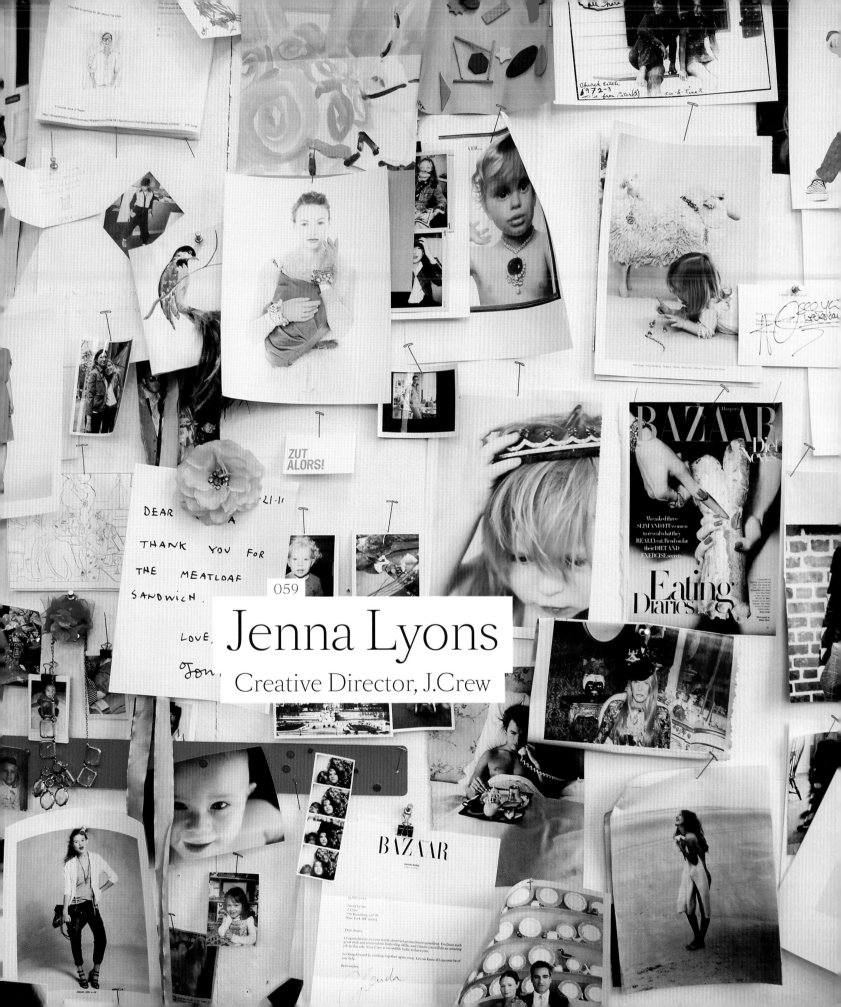

Jenna Lyons
Creative Director, J.Crew

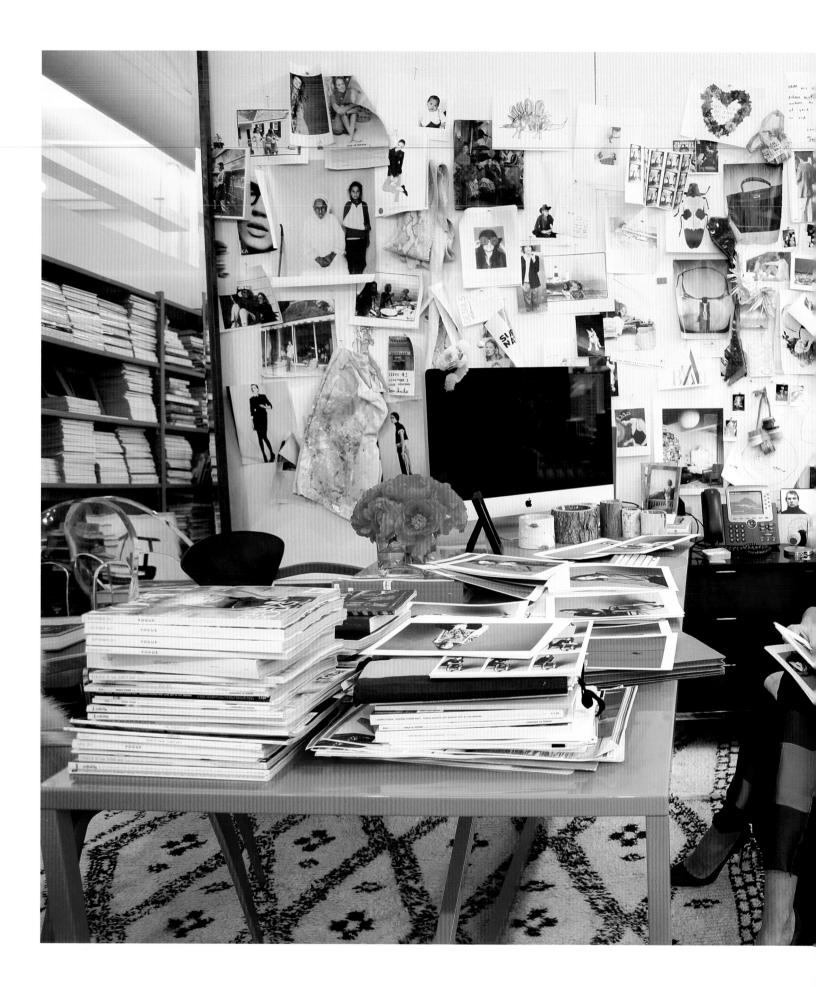

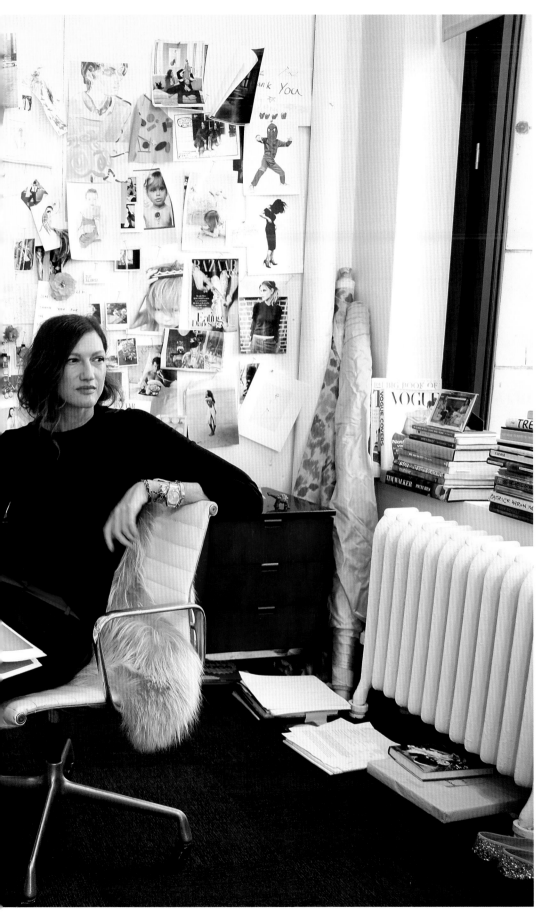

I don't know if it says more about J.Crew or Jenna Lyons that she has been with the company for more than 20 years. It's clearly been a match made in heaven. Now, as she takes on the roles of president and creative director, the catalog company originally known for preppy basics continues to not only grow, but also to impress the fashion critics. Jenna Lyons is also impressing the street style photographers who love to catch her during fashion week. In all the conversations I've had about this new style icon, I've never once heard anyone say a bad word about her. I think that's more impressive than anything she has ever designed or worn.

My earliest memories include raiding my mother's closet and playing dress up. Things solidified in the seventh grade when I took a home economics class. Being six feet tall and incredibly gawky and not cute certainly didn't get me any attention from the cool girls in my class, or the boys. When I made my first long, watermelon-print skirt in home economics the world changed. Yes, a watermelon print changed my life. For the first time, I got compliments on what I was wearing. I still love watermelon prints.

I got an internship at Donna Karan—this was the height of the 1990s. She was everything. I will never forget watching her drape six-ply cashmere on her body in the collection studio. [She was] surrounded by the most beautiful fabrics and beaded pieces. It was a dream come true.

Mickey Drexler has taught me the most in my career. There is no one like him.

J.Crew feels like my home. I'm sure I have spent more time here than my home!

I go everywhere for inspiration: museums, books, movies, people-watching, fabrics, travel, architecture.

I most admire two people. Creatively, Alber Elbaz. He is the most charming, intelligent, talented, and witty man. His sense of humor and intelligence are actually present in the clothes, the packaging, the stores—everything he does! From a business standpoint, Mickey. He is the most energetic, passionate, involved, inspiring, funny, warm, intuitive, relentless person I have ever met. And every day I learn from him.

Amazingly, it's an incredible honor to be recognized for my personal style. I keep thinking I will be found out. Someone will realize that I wore watermelons.

Don't stray— stick to your gut.

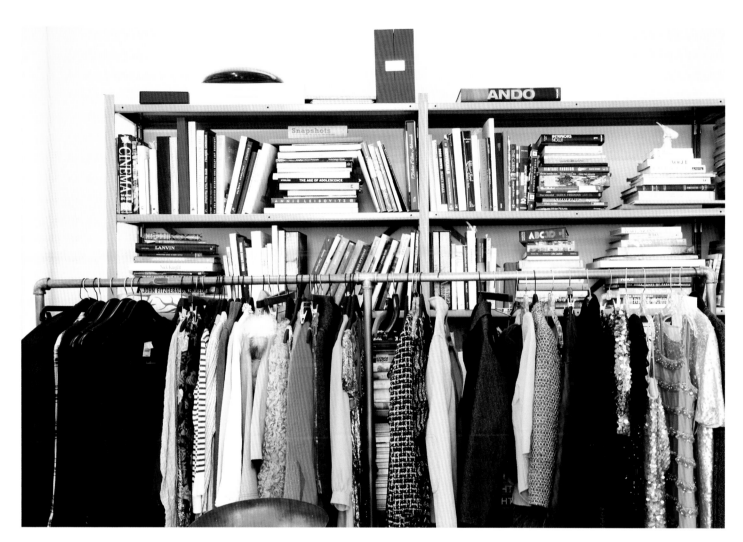

"I love coming to work and at this point it's part of me."

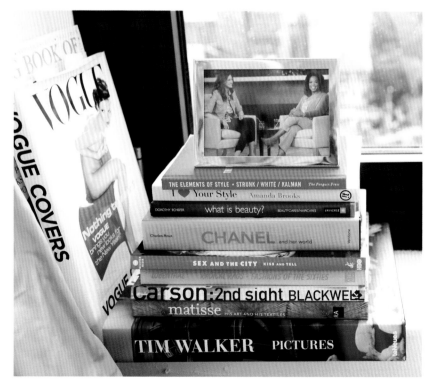

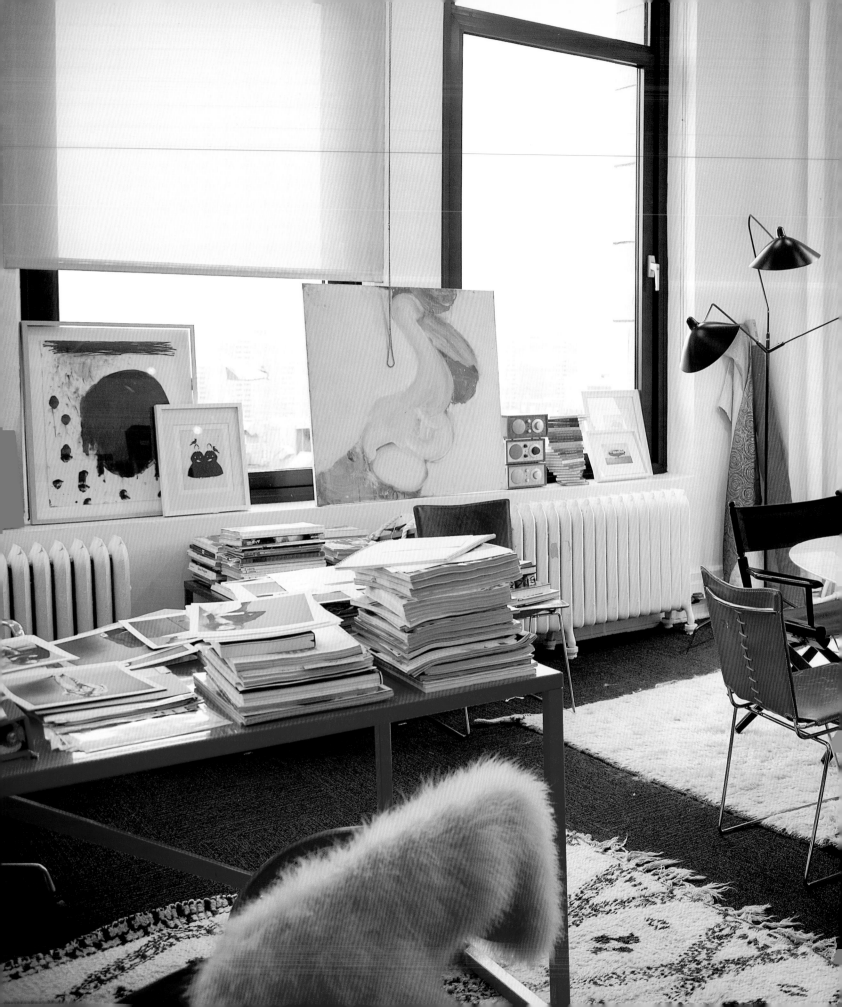

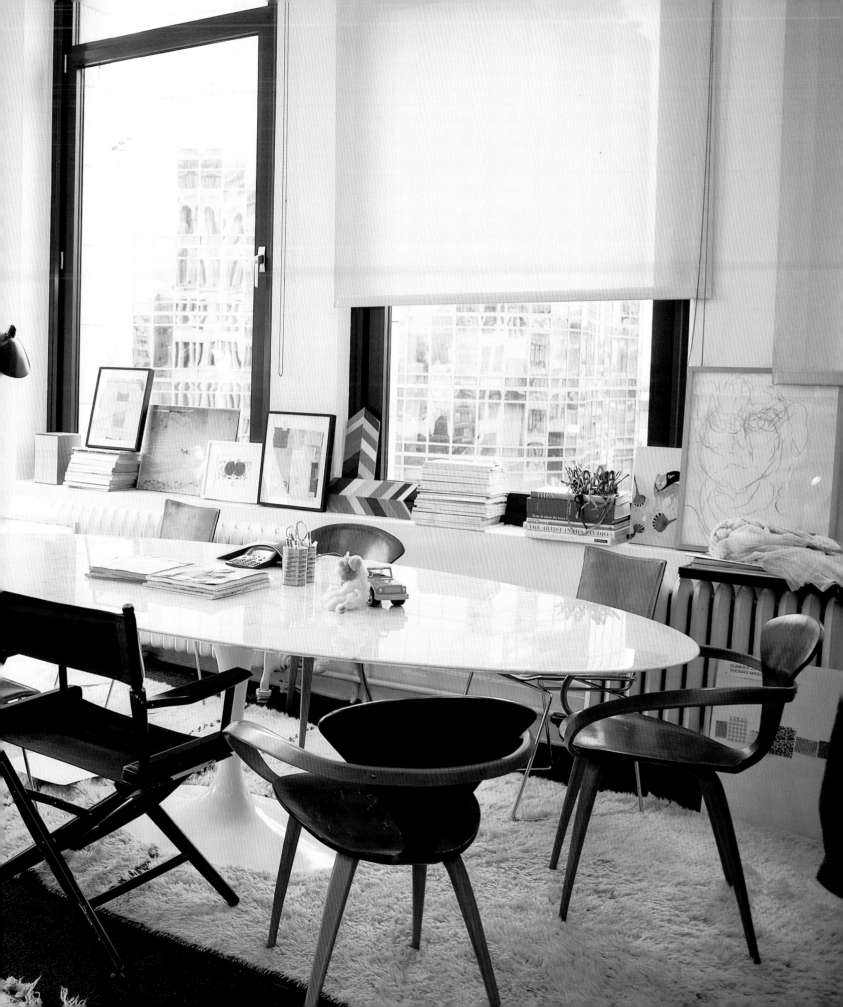

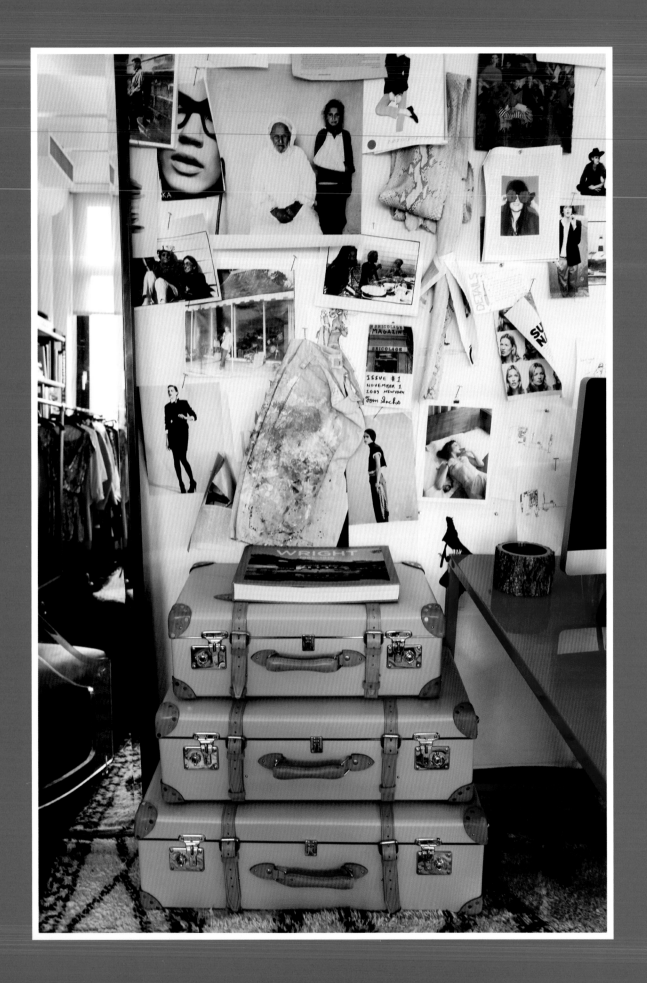

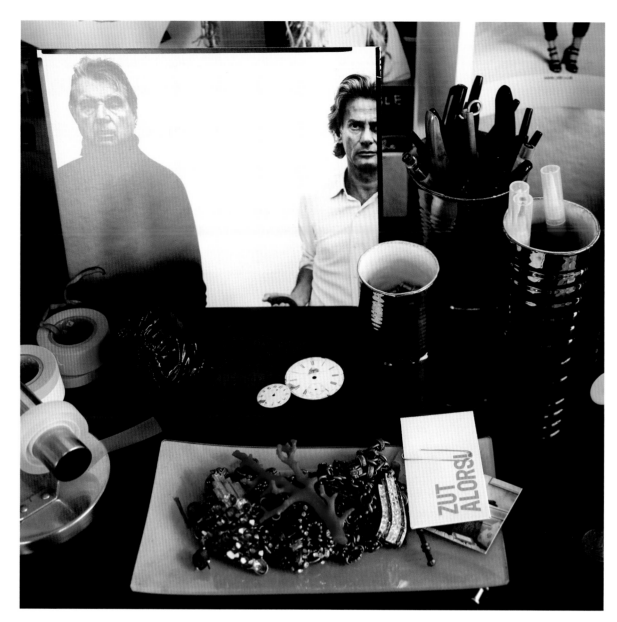

"*Lucky for me fashion changes.
Every season is different. It never
gets boring; it never seems like
the same thing. There is always
a new way to look at things.
I am so happy to be working in
an industry that never stops.*"

"This too shall pass."

Proverb

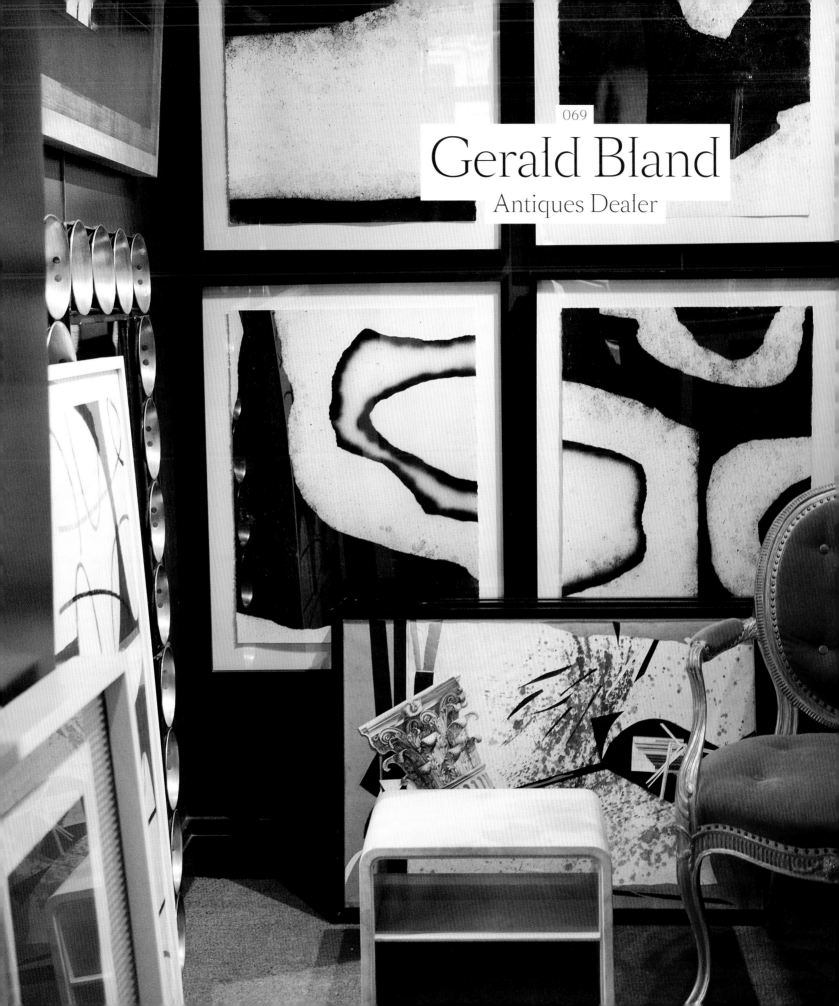

Gerald Bland

Antiques Dealer

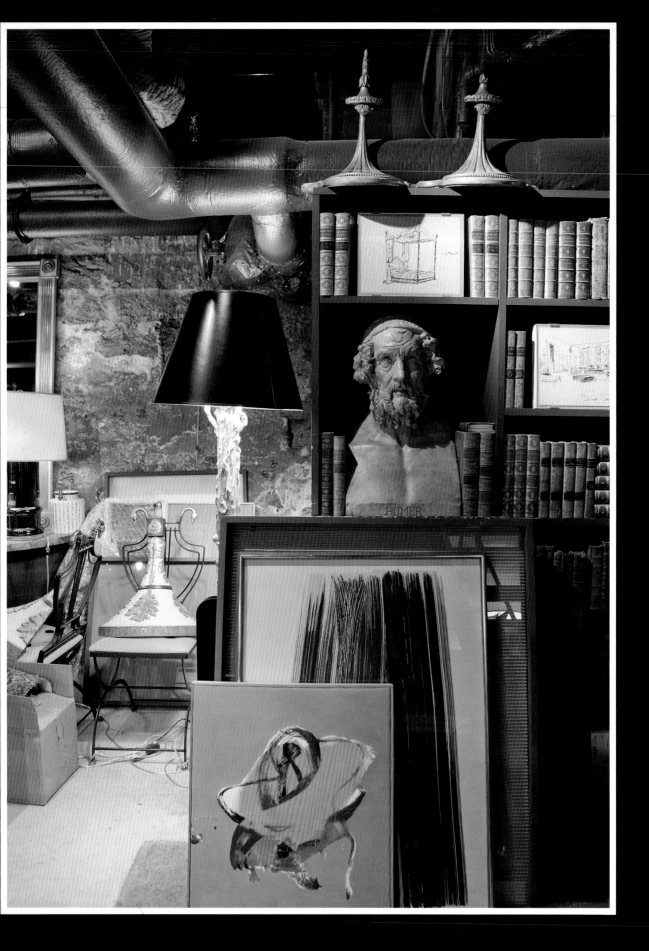

was first introduced to antiques dealer Gerald Bland when I went uptown to see some drawings by interior designer Albert Hadley that he was selling. It's not your grandmother's antiques shop, and I immediately felt at home. The mix of modern and contemporary artwork with newly upholstered antiques enables you to envision how it will all look in your own home. Gerald Bland is not intimidating—unlike many antiques dealers in New York—and stopping by is always a pleasure. To be honest, I can't actually afford his pieces just yet, but it's definitely the first place I'm going when I can.

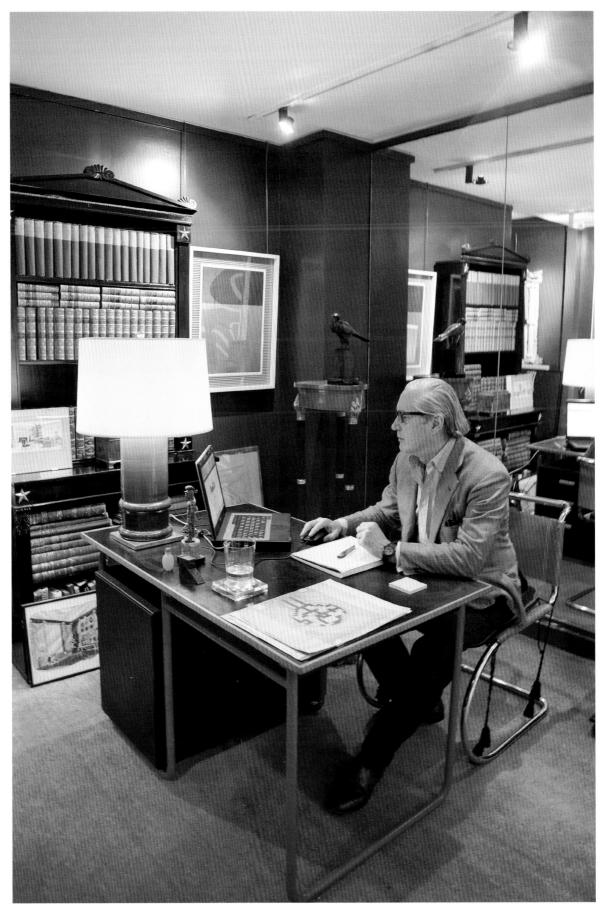

073

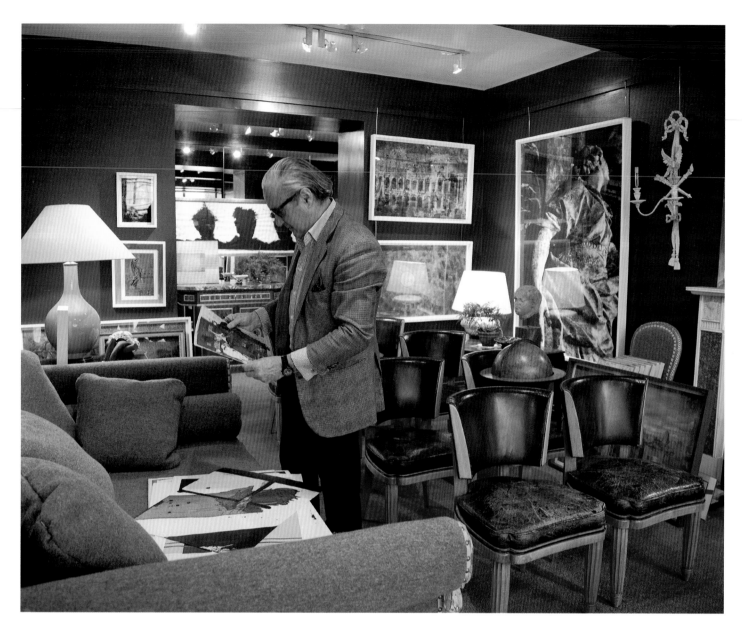

I was always interested in architecture and antiques but short of architecture school wasn't sure how to proceed. The summer of my last year of school, while working on Nantucket Island, I met someone who worked for Sotheby's. Intrigued and armed with an introduction I arrived in New York, walked into Sotheby's, got a job, and was sent to London for training. It was a great fit and it changed my life.

In 1987, with nearly ten years of auction house experience and three years of retail, (running Stair & Company), the timing seemed right to embark on a venture of my own brand of retail. More London, less New York. Academic but also stylish.

I can't really credit anyone with planting the idea of my particular mix of antiques and art; a result of changing taste, the economy, personal evolution, and zeitgeist. I will cite a neighborhood dealer, Karen Present of Past and Present who was exhibiting antique furniture with modern art long before it became a general trend. She was ahead of her time.

I think that anyone with a creative, open mind will find inspiration without going anywhere. Travel helps of course. Houses, social life, and books are always an inspiration. Magazines quite often recycle old ideas (I keep old ones). Web sites exhibit what others are doing. The web can make anyone a brilliant researcher. With exceptions, many discoveries and revelations on blogs are ones my contemporaries and I discovered when we were the bloggers' ages. So while I don't see much that is totally new it's always great to see good old stuff blogged about and that people are still interested.

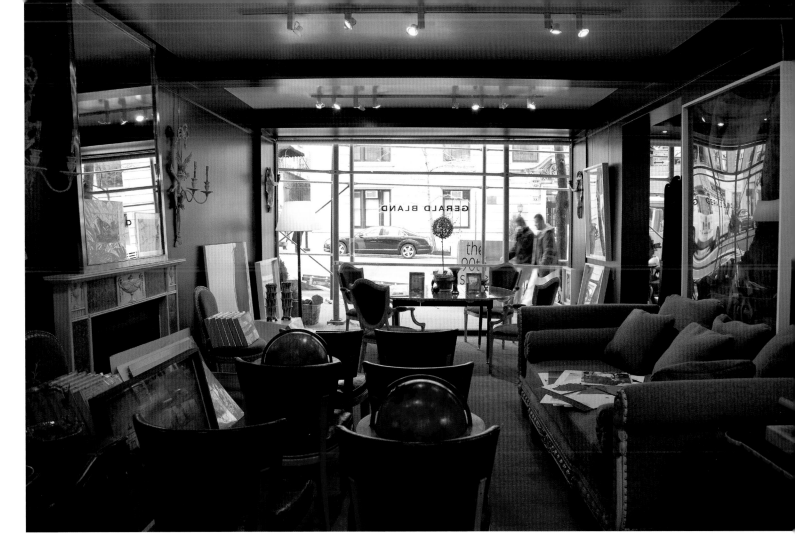

"*The 'younger generation' is ready for antiques.
Just not the way their parents used them.*"

Albert Hadley is whom I admire most. I have just finished cataloging the contents of his New York apartment and his house in Connecticut. His life has been all about design. He has never let labels get in the way. It has always simply been a matter of what is appropriate.

Creativity is what still excites me about my job, especially on the furniture side of my business. Whether it is fully realizing the potential of an antique through restoration and upholstery or creating contemporary furniture which is nearly always inspired by the antique. Also legacy. Everything that is not new has been owned by someone else, some famous, some infamous, some we will never know.

I like telling the story. Lastly, the clients, both the buyers and the sellers, are generally an interesting and amusing group.

Likes and dislikes are cyclical. The "younger generation" is ready for antiques. Just not the way their parents used them. A good dealer's job is to make antiques relevant. Combine with contemporary, treat as the special objects they are, present to show form. Never exhibit as "period." Isolate.

I am reminded of my initial instructions from Robert Woolley for whom I worked at Sotheby's. "To be a success in this business, think Yiddish, speak British."

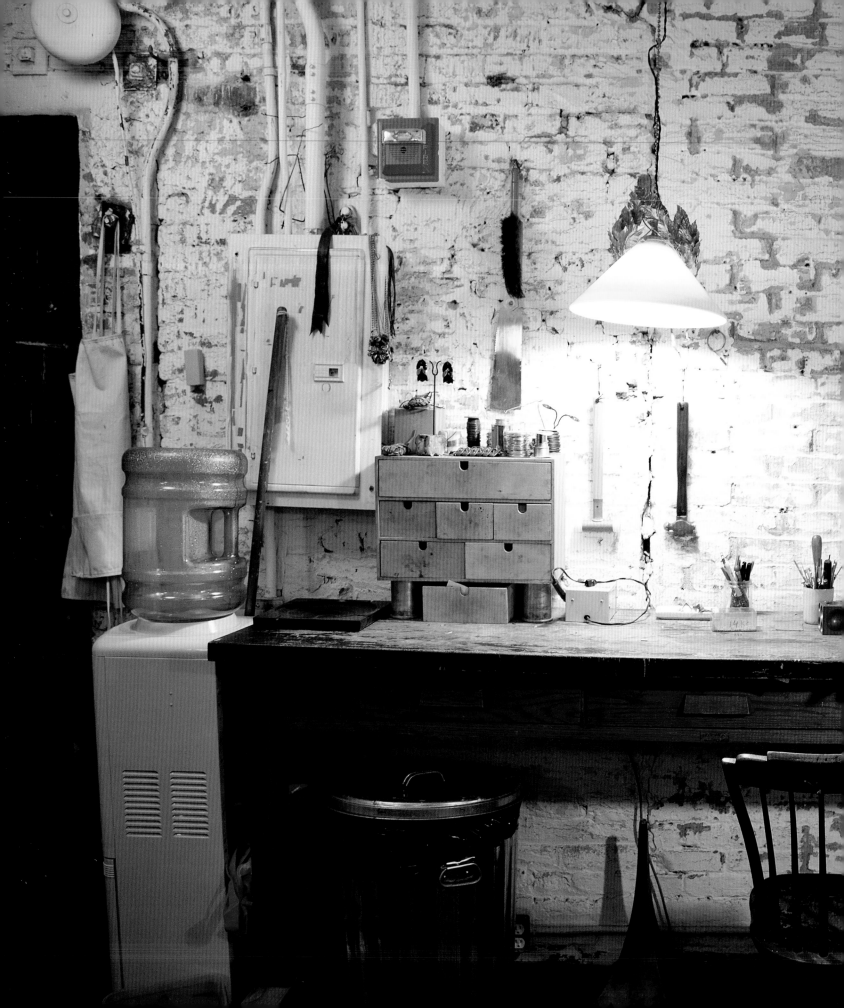

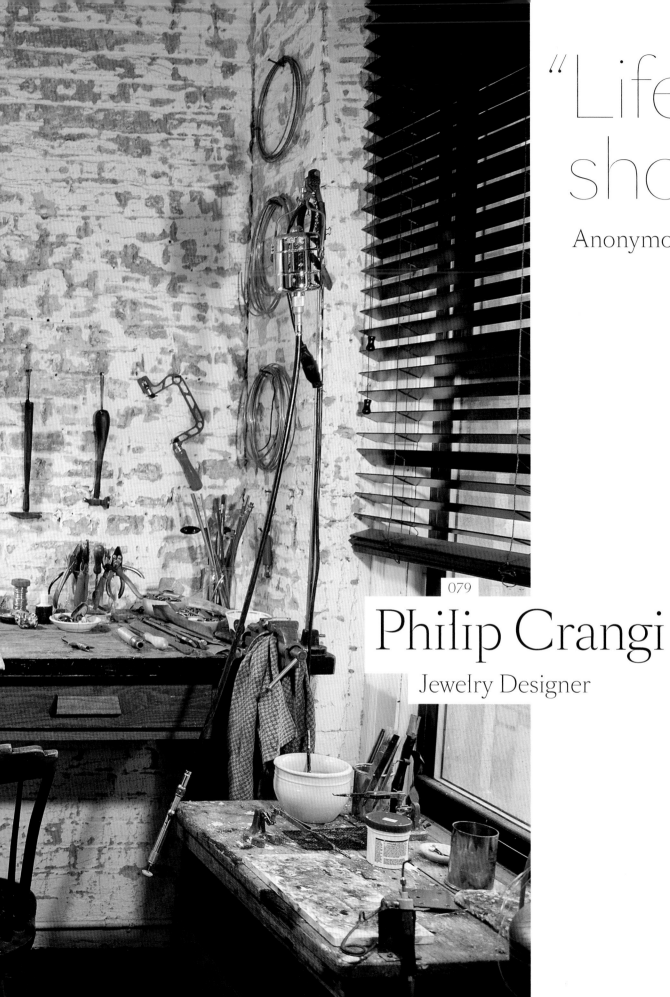

"Life is
short."

Anonymous

079

Philip Crangi

Jewelry Designer

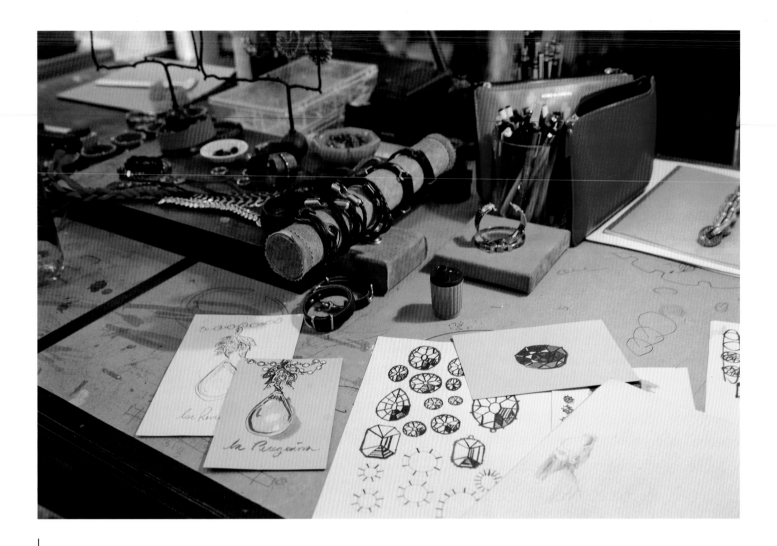

I was excited to shoot Philip Crangi, but also very nervous. I had seen Philip at flea markets a few times looking a little intimidating with his tattoos and serious demeanor. Now I chalk it up to him having his "New York face" on, because he could not have been nicer when we finally did meet. The moral of this story is don't judge a book by its cover. His parents both taught art history which was my major and we bonded over art and jewelry. Watching his inked hands flip through a book of Cartier jewelry was one of my favorite moments of this process. His Giles & Brother collection may be known for its railroad spike bracelets and hard edges, but I think that some of his answers will reveal that Philip Crangi has a really soft heart.

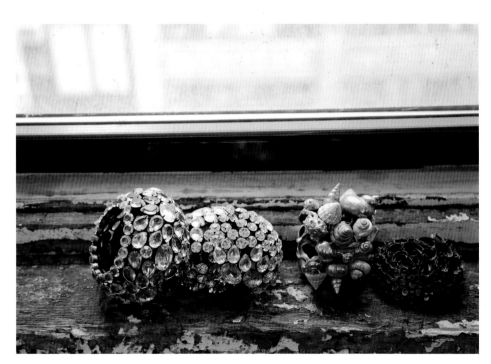

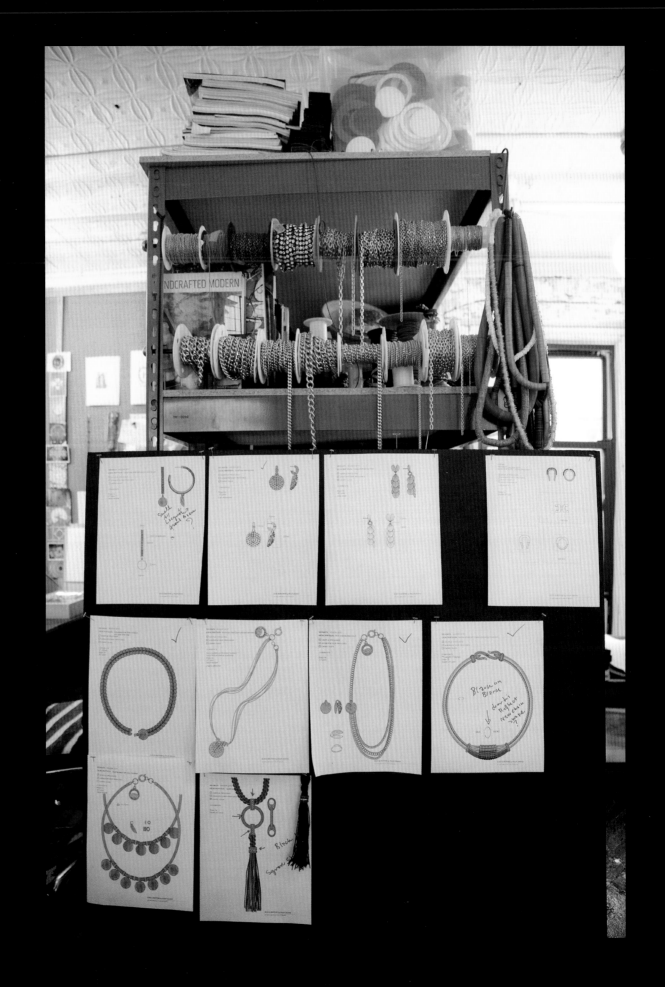

I discovered jewelry by accident in art school. I fell in love with the studio and tools and I immediately realized that it was my life's passion. Now I am lucky enough to do it for a living.

My parents, being both artists and art history teachers, taught me to look at the world with a creative eye. It influences my work every day.

Some of the best pieces I have ever done I designed for my sister Courtney to wear to special events and they found their way into the collection. She is very much a muse to me in many ways.

I always look to both art and history for my inspiration, as well as travel. I try to keep a very open mind and cast a broad net. I try to look at absolutely everything and art plays a big role in that. But I always start with books—books are like magical portals.

Ted Muehling has always been a huge inspiration to me along with people like Dries Van Noten. He has such a unique vision and a purity to his approach to design.

Every day there is some new amazing piece that I have yet to discover how to make.

Make only the work that you can make.

I would most like to see Michelle Obama wearing my jewelry. She is so chic.

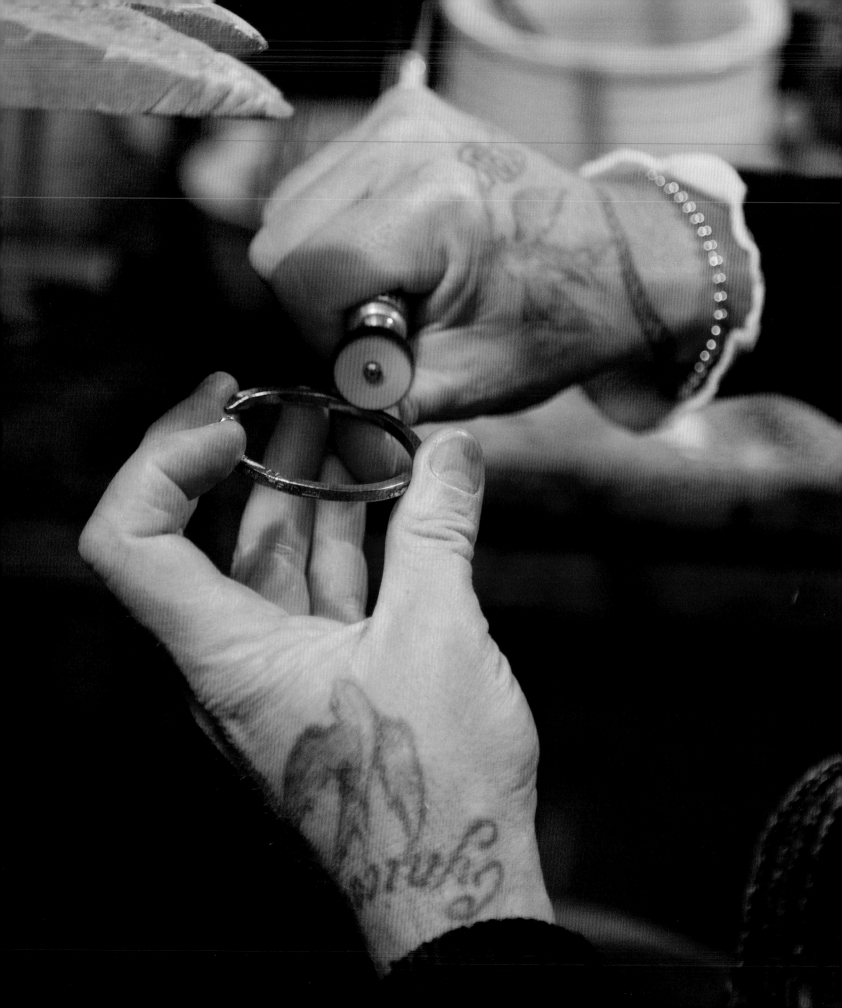

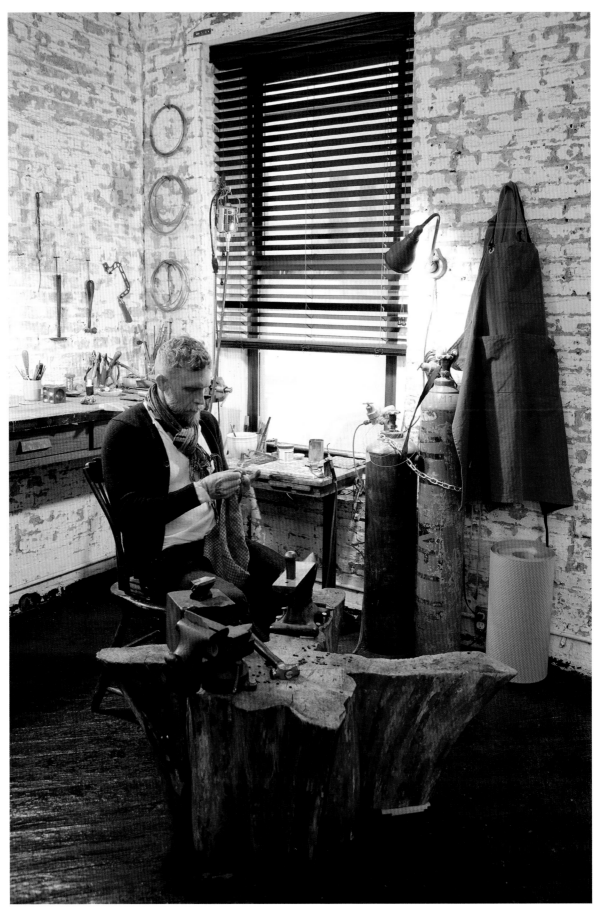

"The world is before you and you need not take it or leave it as it was when you came in."

James Baldwin

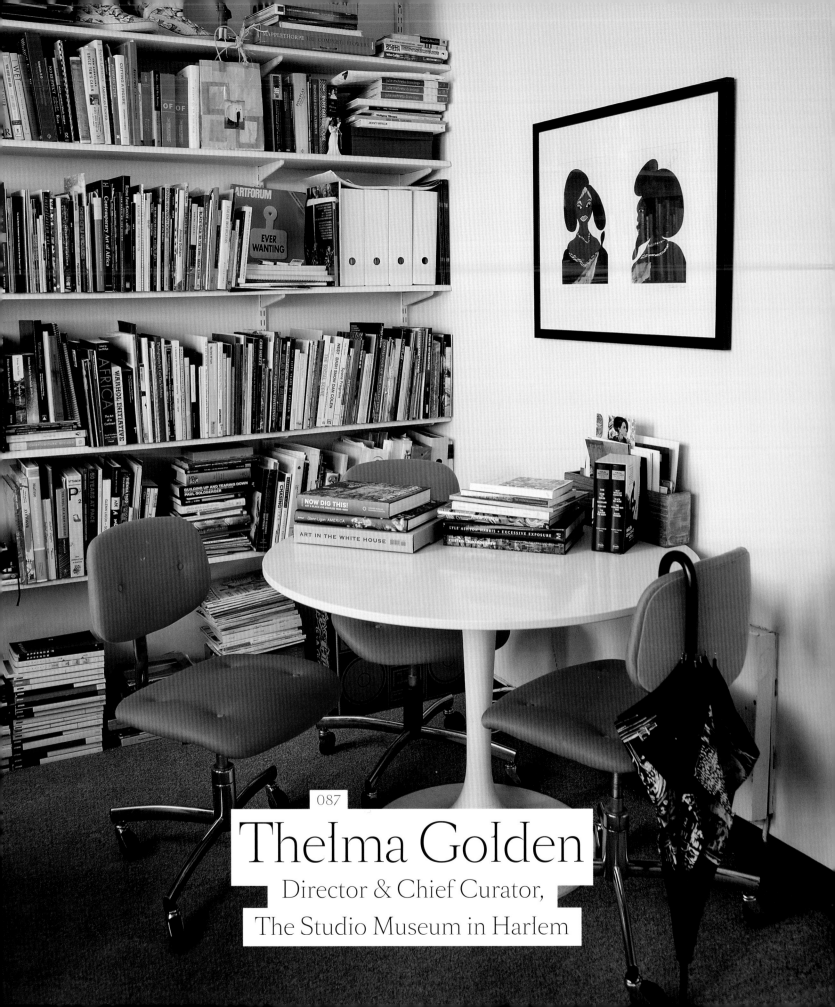

087

Thelma Golden

Director & Chief Curator,
The Studio Museum in Harlem

E—— very child has ideas of what they want to be when they grow up, but there are probably few children who dream of becoming a museum curator and actually make it a reality. Thelma Golden, the director and chief curator of The Studio Museum in Harlem did just that. It probably helped that she grew up in New York, where museums and art are an integral part of the city itself. Since she joined The Studio Museum in Harlem in 2000, she has put together many exciting shows and supports the work of contemporary artists like Lorna Simpson and Glenn Ligon, as well as emerging artists, and the community of Harlem. She also manages to make her marriage to fashion designer Duro Olowu a success even though he's based in London and she in New York. But it doesn't surprise me since she's been making everything happen the way she wants since she was little.

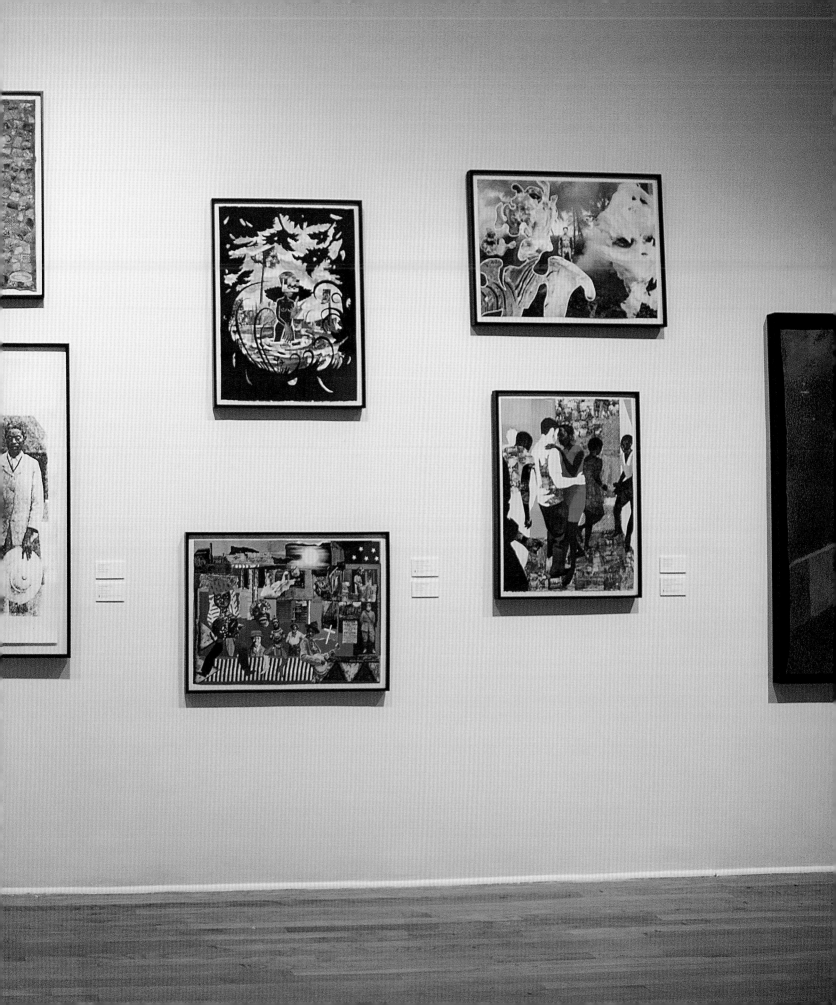

*Growing up in New York, I was so
fortunate to have access to incredible
cultural institutions, and very early on
I recognized the power of great art to
provoke transformative experiences.
Before I even knew what a curator was,
I knew that I wanted to be surrounded
by, and work to promote, art and artists.
So, once I realized that this was a career,
it was a natural fit.*

*My first big break was being accepted into
the apprentice program, the high school
internship program at the Metropolitan
Museum of Art.*

*I have learned most in my career from
artists, but additionally I have had the
opportunity to work with several amazing
art professionals, including Dr. Mary
Schmidt Campbell, Dr. Lowery Stokes
Sims, and David Ross, who each offered
me an unparalleled opportunity to learn
from their example and experience.*

*My favorite exhibition is the next one.
The process of discovering new art and
artists, new connections, and new
perspectives is so thrilling to me. Even
though I imagine I will continue making
exhibitions through the rest of my career,
I feel like the most important exhibition
I have made was Black Male, presented
at the Whitney Museum of American Art
in 1994.*

*The Studio Museum is incredibly
important to the Harlem community,
and being in Harlem is incredibly
important to the Studio Museum. We
support and nurture emerging artists
through our residency program, care for
and display the work of over 400 artists
in our permanent collection, provide
opportunities for learning and
engagement through our educational
programs, and create a space for
dialogue about art and culture in our
contemporary world—globally,
nationally, and right here in Harlem.*

"Even when in doubt, be fearless."

it is what
it is

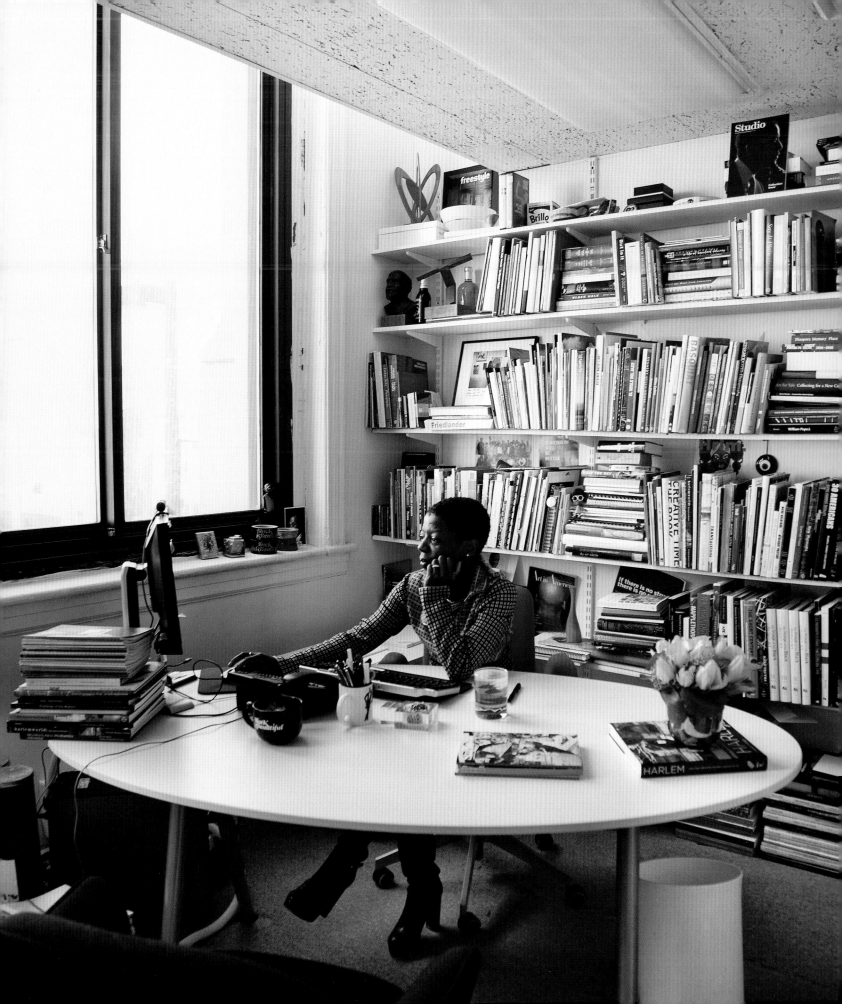

"Those who don't believe in magic will never find it."

Roald Dahl

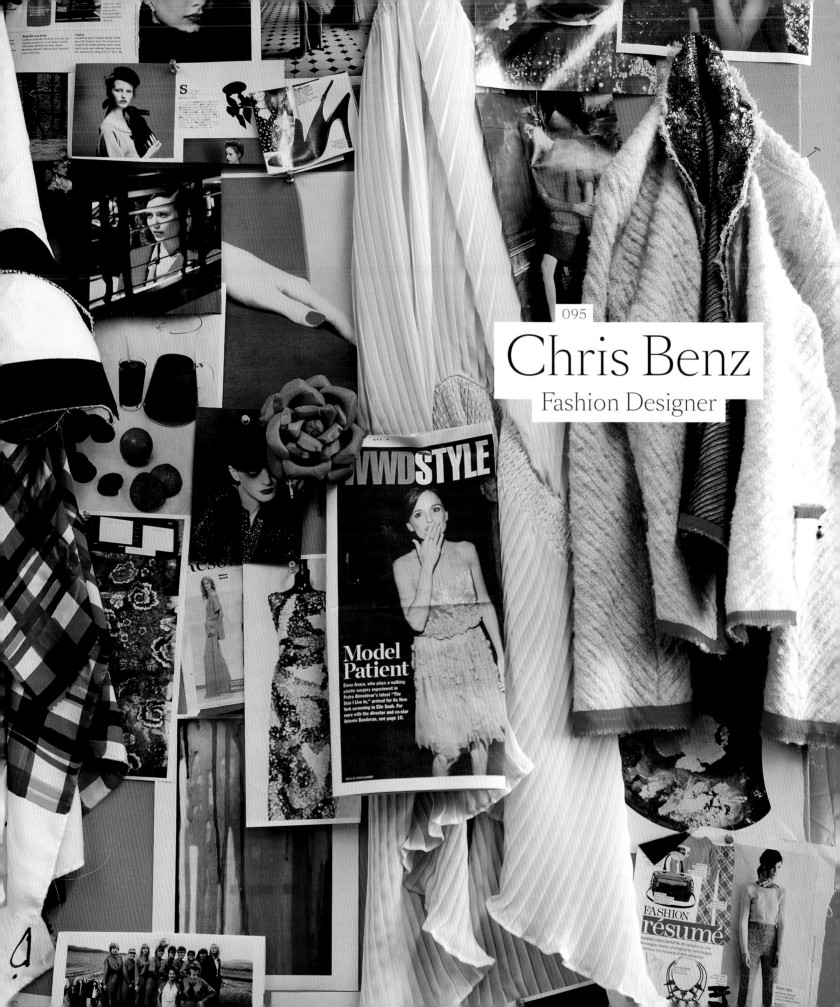

095

Chris Benz

Fashion Designer

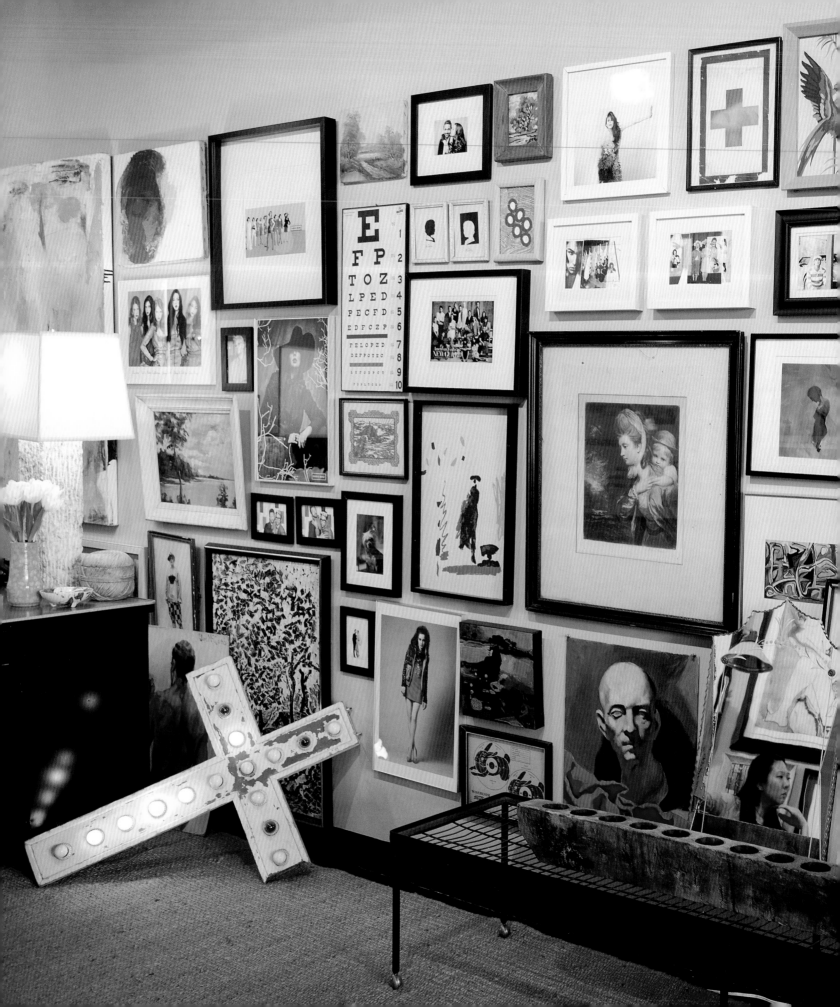

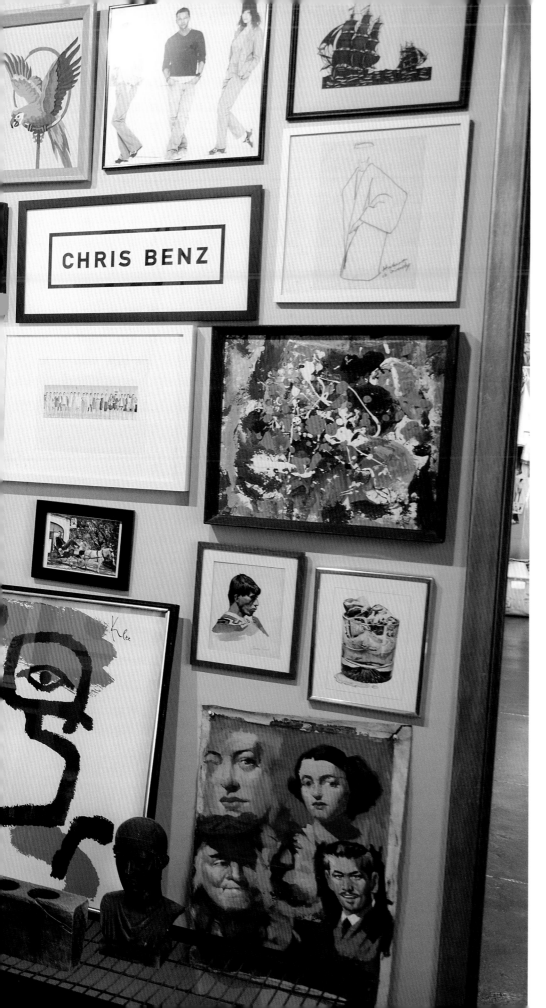

I first met fashion designer Chris Benz many years ago at after-work cocktails through a friend who worked with him at Marc Jacobs. Never in my wildest dreams did I ever imagine I would be featuring him in a book someday but it definitely feels like it was kismet. Don't let his pink hair fool you, Chris Benz is one of the most talented young fashion designers working today. He is known for his fun take on ladylike looks and amazing prints. Just when he was beginning to be associated with a bold use of color, he went dark the next season, so he knows how to shake things up. In the past few years I've already seen him grow and I wouldn't be surprised if he ends up being bigger than his former mentor Marc Jacobs someday.

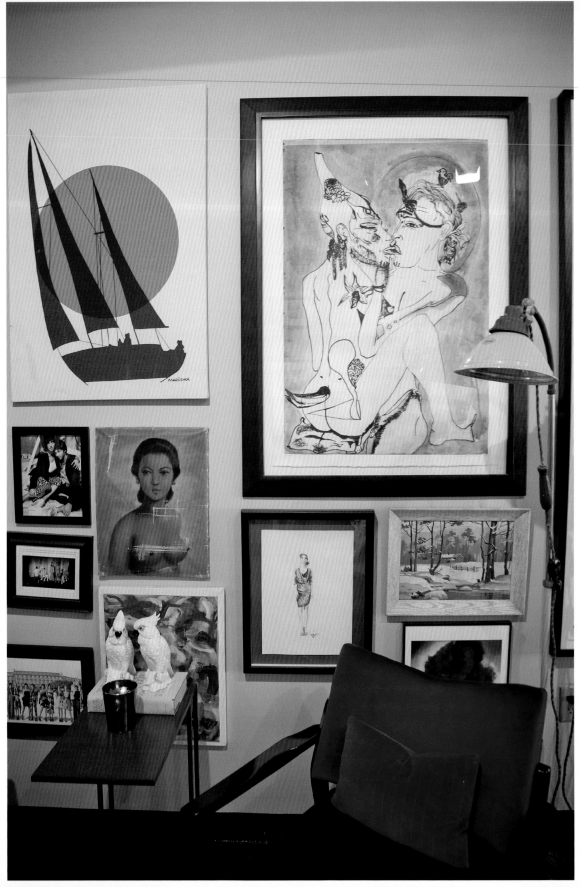

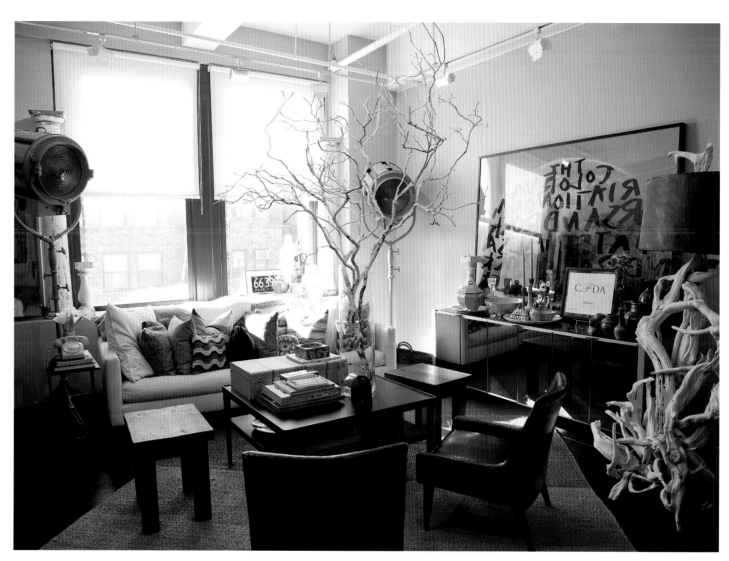

"My life is really my work and my work is my life and I wouldn't have it any other way. I've never understood how to keep them separate! I think you have to commit to that from the moment you start your own company."

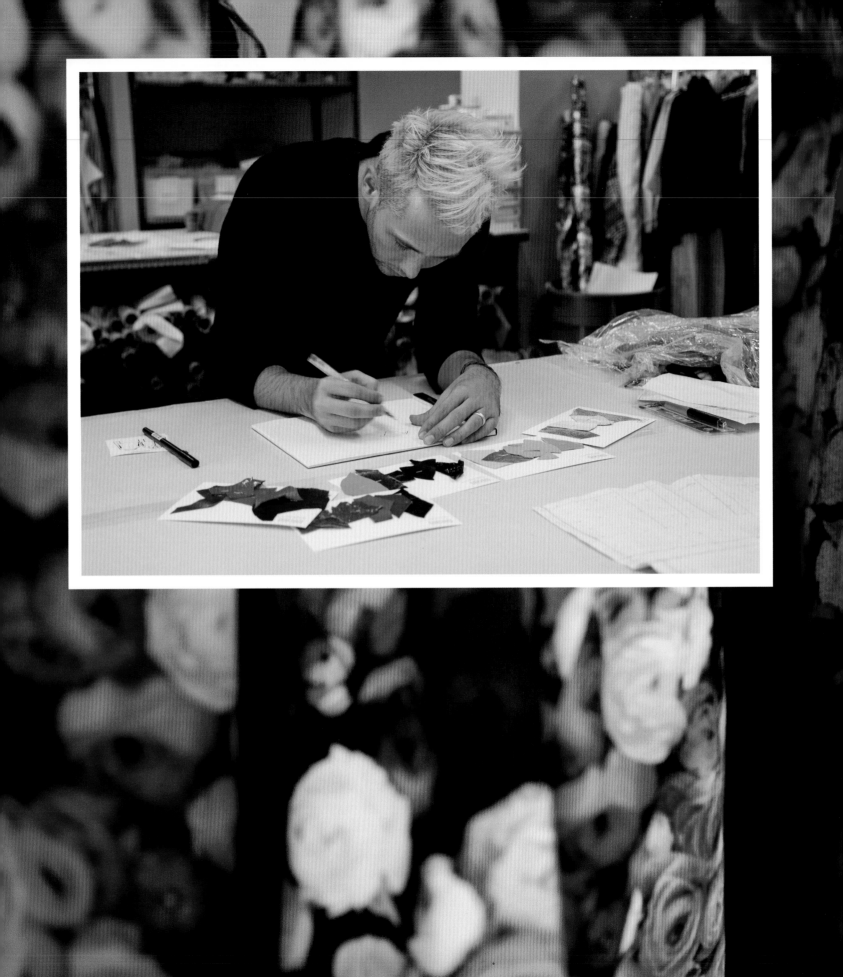

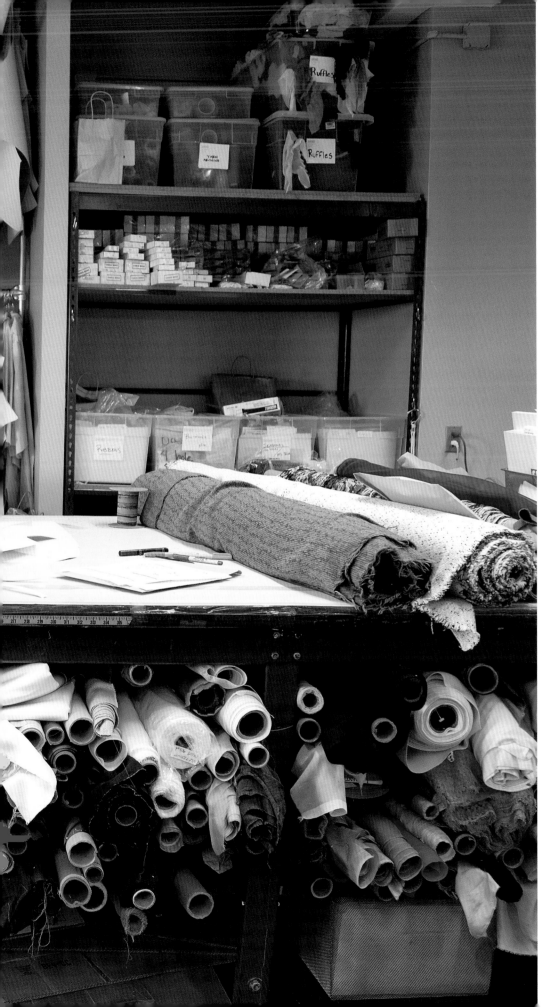

"It's those that are behind the scenes that I have the most admiration and appreciation for... the patternmakers, the interns, the sample sewers."

I feel like in one way or another I've always wanted to be a designer. I grew up reading so many magazines and books. You have to allow yourself to follow the path of what the universe has in store for you.

I actually can't believe that my parents let me move to New York City when I was 17 to attend Parsons. Growing up on Bainbridge Island in the Pacific Northwest was, for such a visual kid, eclectic eye candy, a perfect cross section between the preppy "water and sailboats" crowd and the dark grunge of Seattle, with a hippie constituency in the mix.

I really count myself so fortunate to have been a part of two very unique American design teams. At Marc Jacobs you learn high fashion and creating one-of-a-kind pieces with beauty, and at J.Crew you learn to create items for any woman to wear. With that mix, you can learn to create something amazing and make it fit for any woman, which is really the balance we strive to achieve with the Chris Benz collection.

I feel like I'm living the idea of a big break. I've always lived my life with a strong work ethic and "the best is yet to come" mentality, which I hope has helped me to steer clear of resting on any proverbial laurels.

I find inspiration from strange places. Oftentimes an inspiration is a muse or a painting, but it can truly be anything for me, even a pattern in the light reflecting in the back of a taxi. You will find inspiration when you least expect it and it can change everything about a collection.

Seeing the way clothes can truly transform how a woman feels is so exciting and gratifying for me. I think about the magic in that in every step in the development of the collection, from design all the way through to production.

Work hard. Be nice. Don't stop. Keep going. See more. Do more. Be prepared to fall on your sword. Be thankful.

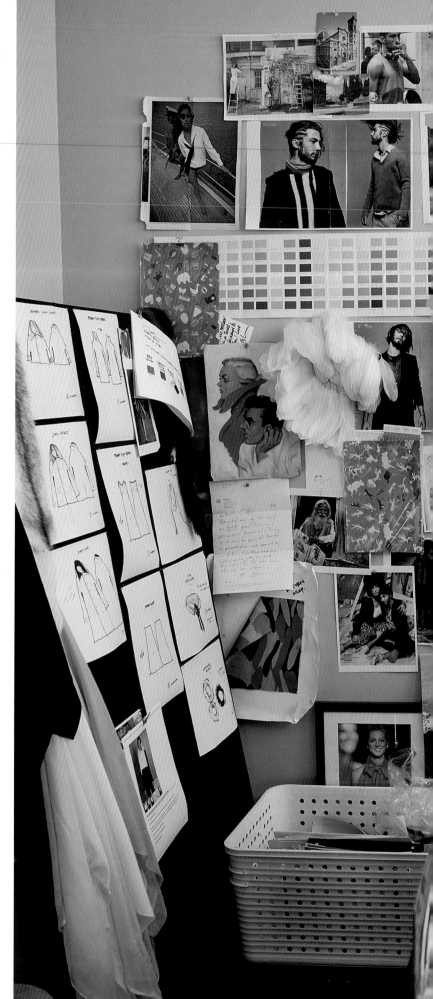

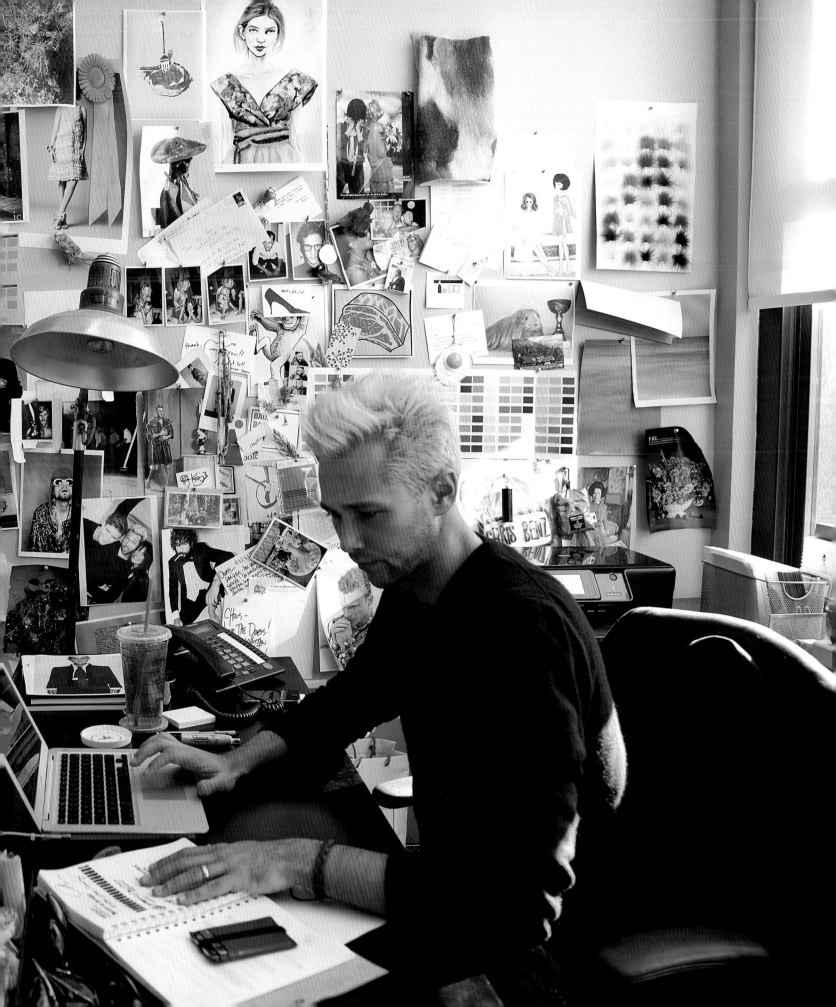

"If you stand for something, you will always find some people for you and some against you.
If you stand for nothing, you will find nobody against you, and nobody for you."

Bill Bernbach

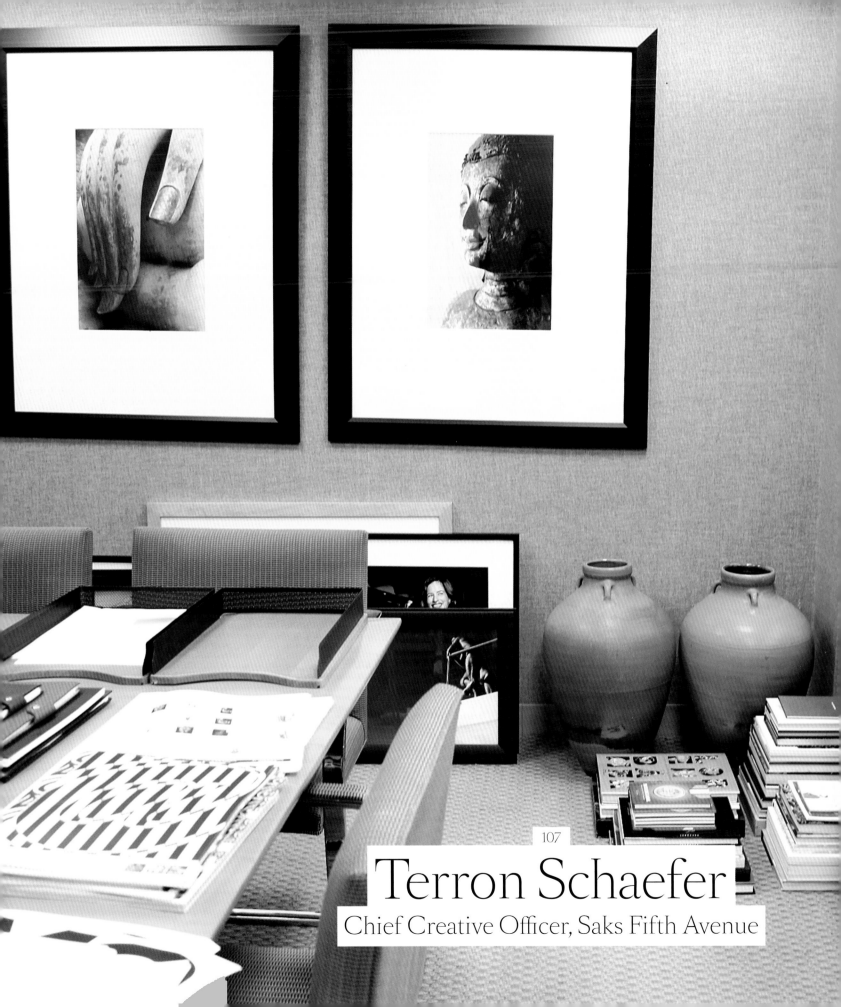

107

Terron Schaefer
Chief Creative Officer, Saks Fifth Avenue

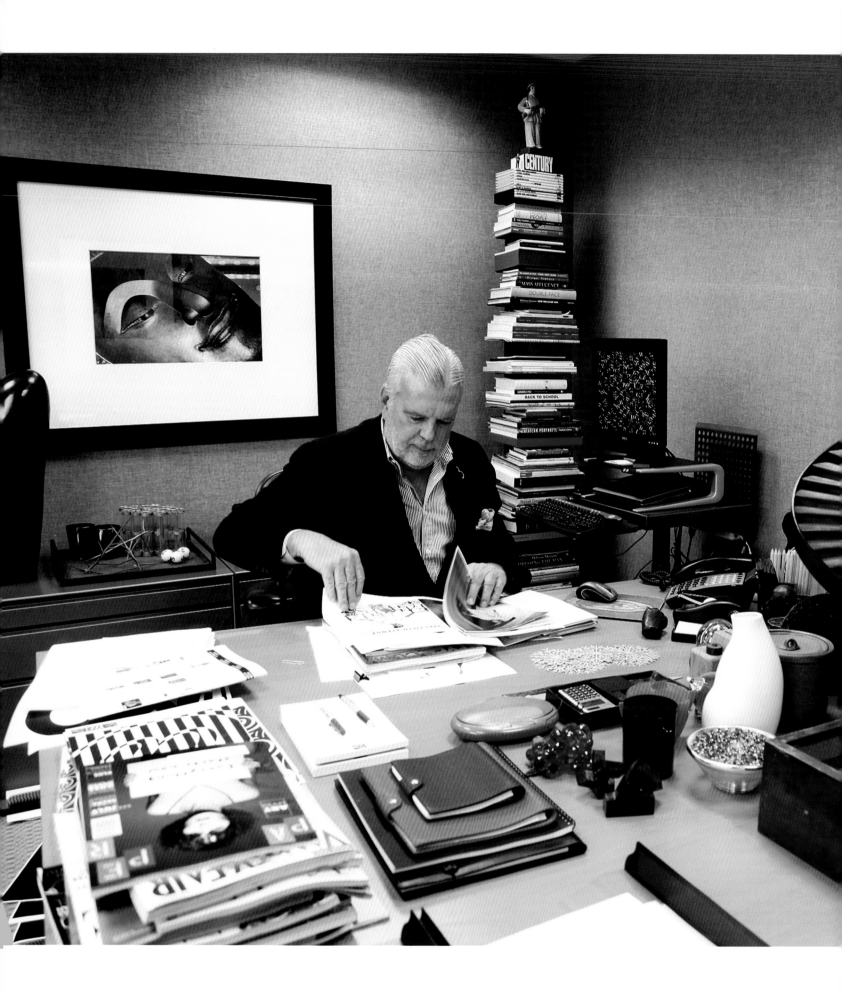

first noticed Terron Schaefer sitting front-row at fashion week. He is hard to miss with his debonair suits and distinguished silver hair. As chief creative director of Saks Fifth Avenue, he is charged with the design and image of everything that carries the Saks name. He is more than adequately experienced to hold this position having worked at the famous advertising agency Doyle Dane Bernbach. He could really be described as one of the original "Mad Men." But knowing Terron, I'm sure his tenure involved a lot less drinking and carousing. He is as much of a gentleman as he looks and one of the most interesting and intelligent people I've ever met. I think this is due in part to his Brazilian upbringing and a life spent traveling the world, which have imparted on him the ability to speak with anyone about anything. It's too bad Don Draper isn't more like Terron Schaefer.

112

I'm responsible for everything that carries the Saks name, from labels to marquees to store design and all the catalogs and advertising. Anything that has to do with the image of Saks Fifth Avenue.

I am fortunate to be multilingual and grew up speaking several languages which helps me now, as I travel for work. Anytime you are out of your element in a foreign culture, it always helps you.

Three people taught me the most along my career. The first is Bill Bernbach of Doyle Dane Bernbach. It was his ethics and commitment to doing breakthrough creative work. He used to say, "It's only creative if it sells." He also said "Don't show a man standing on his head just to gain attention unless you have a product that keeps the change from falling out of his pockets."

Massimo Vignelli always said good design starts with geometry: circle, square, triangle. And if you look at everything we do at Saks, it's all about pure geometry.

I also think Frank Gehry is a genius in terms of how he perceived problems and solutions.

I'm a voracious reader of magazines. I love Wallpaper and The Wall Street Journal and read Hola, the Spanish gossip magazine. It's an incredible magazine. It's very voyeuristic and everybody reads it, but nobody admits they buy it.

I don't know if I have balance in my life but am I happy? Yes, I'm happy.

I'm very ecumenical and fair and curious. I think my greatest strength is my curiosity.

It's been flattering to be photographed on the street. It can't be anything but flattering that people still want to take pictures of you.

I continue to get excited about making things happen.

Jerron Schaefer
folds a mean
pocket square
£8888

"We are all a little weird and life's a little weird, and when we find someone whose weirdness is compatible with ours, we join up with them and fall in mutual weirdness and call it love."

Dr. Seuss

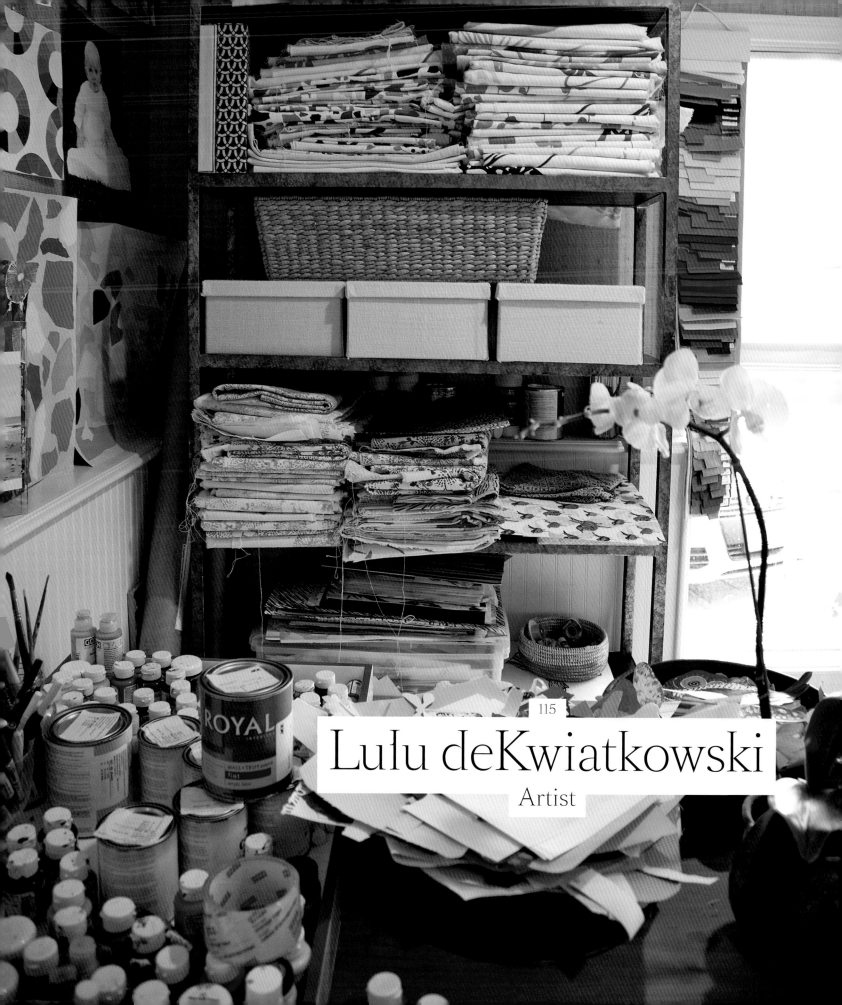

Lulu deKwiatkowski
Artist

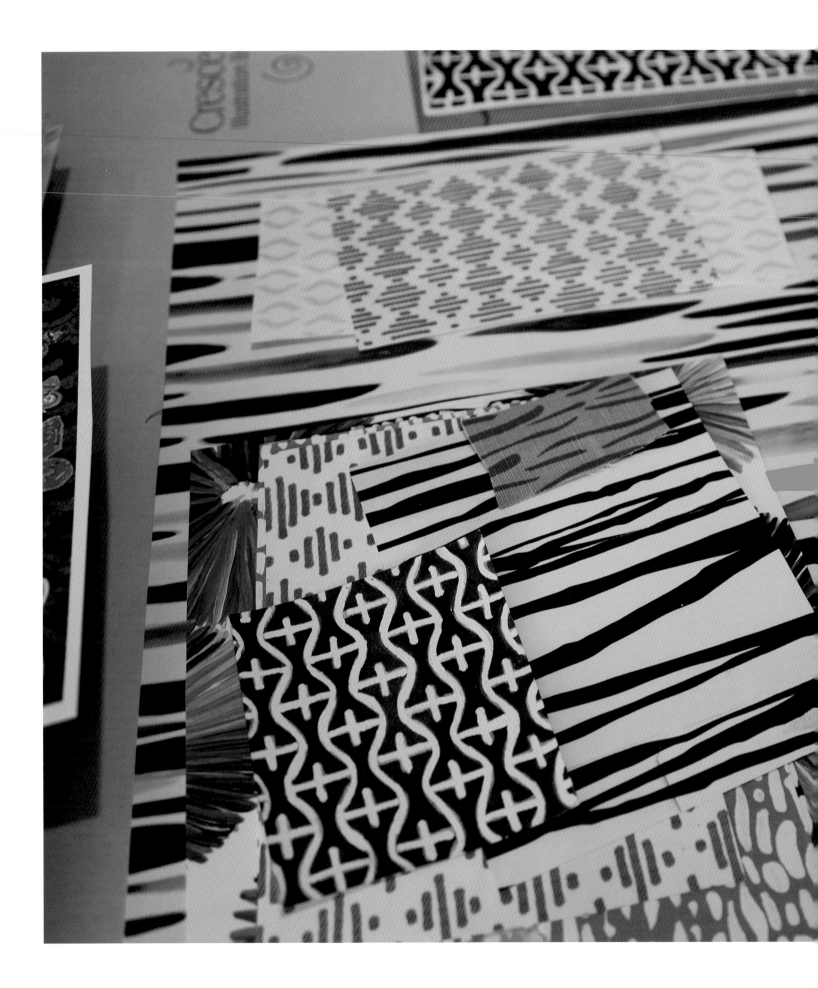

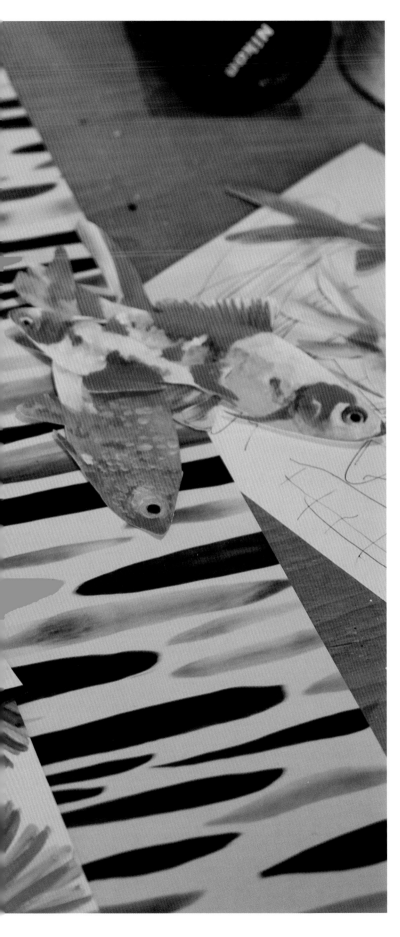
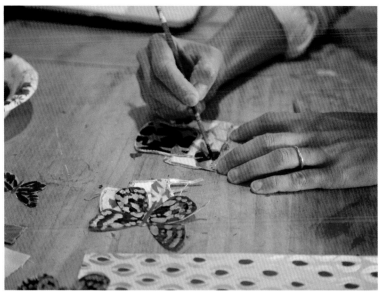

I first remember seeing Lulu de Kwiakowski's artwork in a shelter magazine that featured her New York apartment. She had painted some of the walls in overlapping squares and I thought it was the most creative treatment I had ever seen. It was clear from the decoration that travel played a large role in her life and influenced her artwork. She's since moved to Los Angles where she has a proper studio in which to spread out. It's been wonderful to watch her progression from fine art to textile design and to see her publish a book of her work. Art is a medium that seems ever evolving for her and I look forward to seeing what she tries her hand at next.

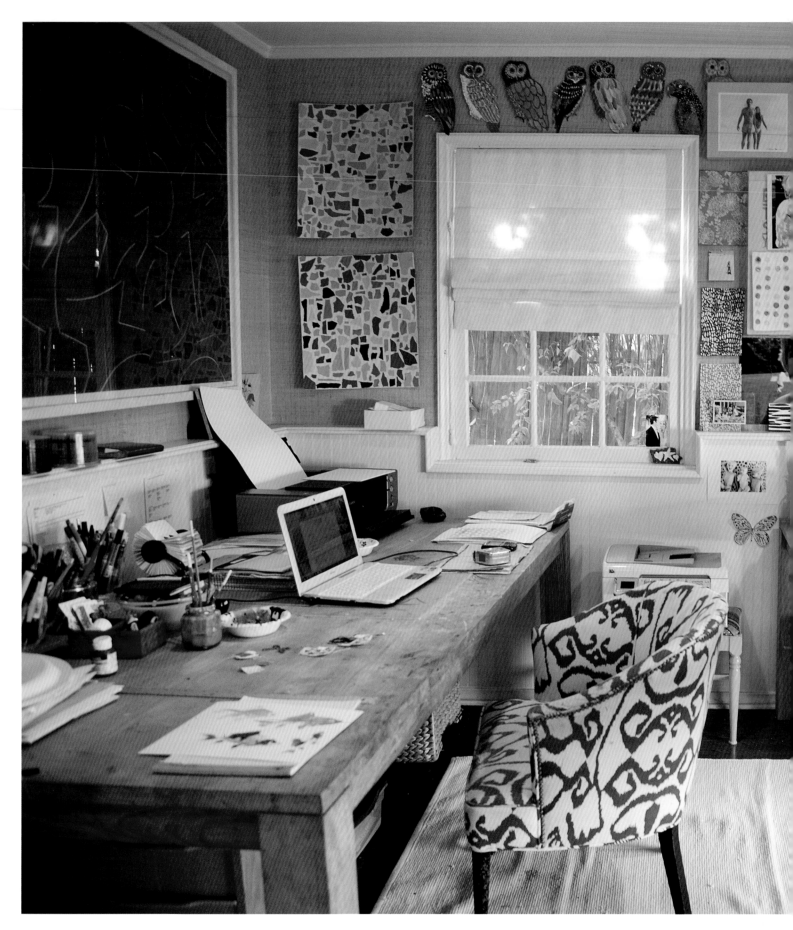

CREATIVITY AT WORK – LULU DEKWIATKOWSKI

I am the youngest of six children; my sisters always drew and painted next to me and I got the bug. I remember always painting as a child but there was one moment when I painted this face of a girl and it was really amazing. I was about eight and I knew I had found what I wanted to do forever.

I actually went to Parsons to study fine arts or fashion and ended up graduating in interior design. I later studied tromp l'oeil and took my career in that direction. Studying tromp l'oeil at an intensive Parisian school was the best thing ever because it taught me to mix so many types of mediums together, which a lot of fine artists don't do. This really gave me the knowledge to be fearless in my creativity.

I have a great studio in Los Angeles which is a big difference compared to New York where I used to work on my kitchen floor.

I have always been inspired by nature. When I travel, the first thing my eye goes to is local nature, color tones of the trees and flowers. Every continent shines a little differently, and all this lush beauty ultimately find its way into my artwork.

I find inspiration in travels I have taken, images from my childhood, old interior books from flea markets, a museum walk with my children. A little of everything.

I am the only one who creates for Lulu DK. I don't have assistants or other creatives so it opens up the possibility to constantly be working and creating, which I love!

I am continually excited by how much fun I have every day doing it, the joy it brings my sons. I am not saving the world, but my work makes a lot of people smile, and I like that.

I find balance by the skin of my teeth.

"Design is so simple, that's why it is so complicated."

Paul Rand

Jack Gerson
VP, Print and Pattern, Coach

FALL 1964

LIFFIN
TION
89383

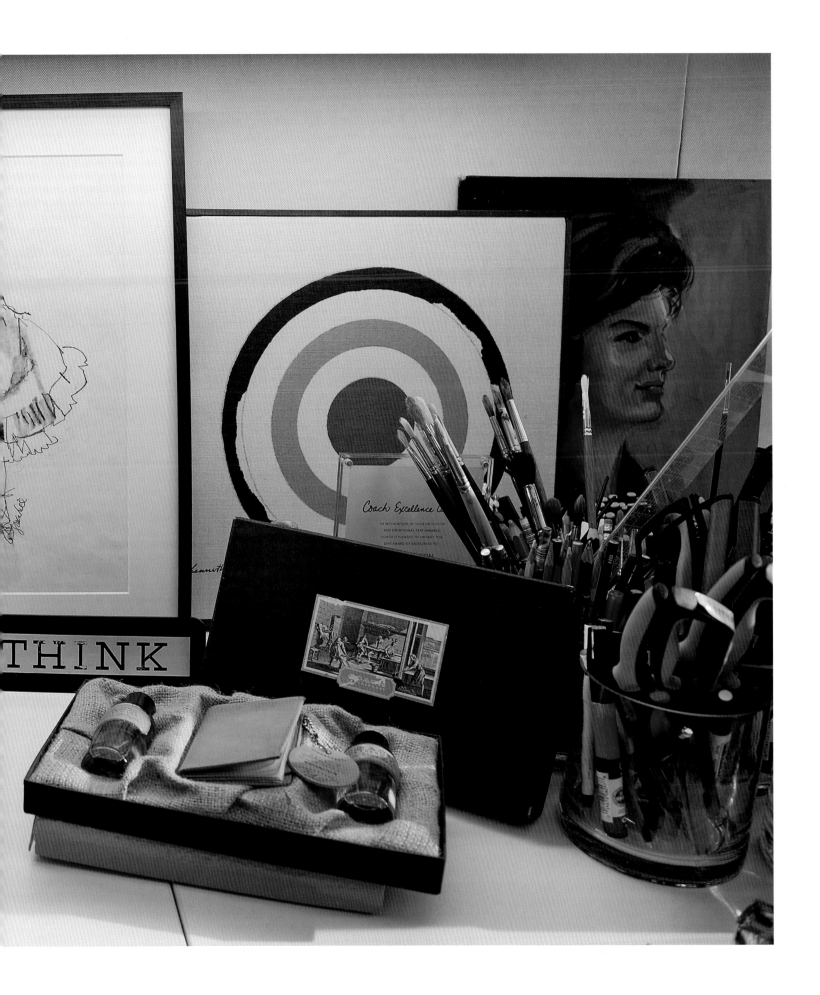

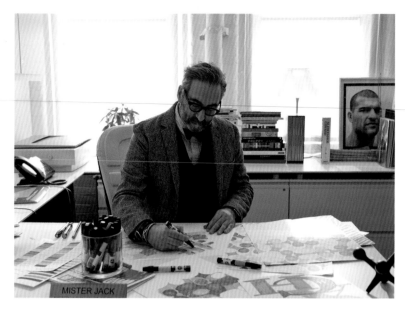

Sometimes you meet someone who looks so creative that you can't wait to find out more about them. That was the case with Jack Gerson, the divisional vice president for print and pattern at Coach whom I met at a party at the store Flair Home. He has a way of combining tweed and denim so it looks like he didn't try at all yet somehow it manages to make him the best dressed man in the room. He's another designer I look forward to catching a glimpse of at the flea market where he often goes on Sunday mornings. He might even find a vintage Coach bag designed by Bonnie Cashin to add to the archives—a treasure trove of inspiration I was lucky enough to see. It's a place that his own designs might end up someday.

126

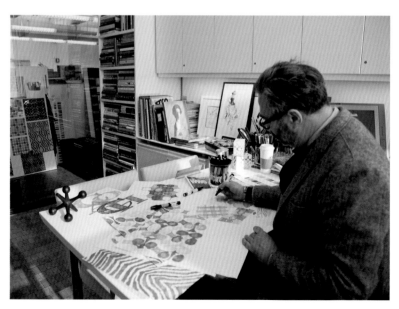

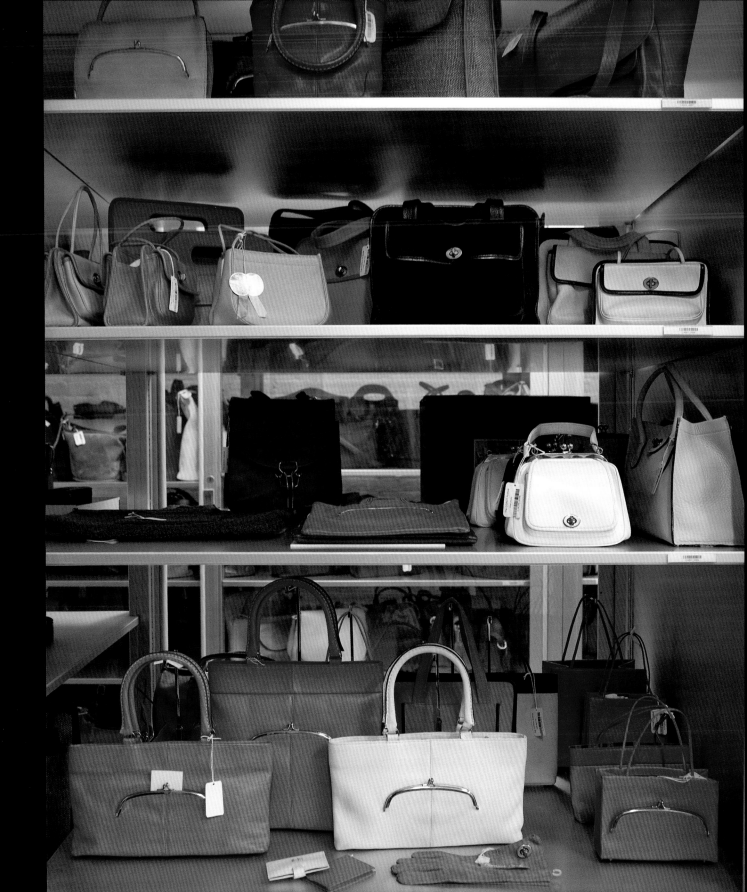

Before I even knew there was such a thing as a "designer," I felt most comfortable with a brush or marker in my hand.

I studied illustration at FIT as well as taking as many classes as I could at other schools including Parsons and SVA. My first career-defining job was at J.Crew.

My first big break was doing illustration for Fairchild Publications.

I love working for a company that continually encourages innovation and originality in textile and graphic design and this commitment excites me on a daily basis. I'm also lucky to be working with people who like the same things I like.

I've been very fortunate to have had many mentors and teachers including great illustrators, photographers, and designers such as Steven Meisel, Jack Potter, Barbara Pearlman, Emily Woods, Sid Mashburn, and Reed Krakoff.

As someone who has a great love of what has come before to help inform the new, my admiration starts with the giants who paved the way in the fields of design, photography, and illustration. These include Richard Avedon, Irving Penn, Carl "Eric" Erickson, René Bouché, Kenneth Paul Block, René Gruau, Yves Saint-Laurent, Cristóbal Balenciaga, Paul Rand, Saul Bass, Alexey Brodovitch, and Alexander Girard, to name a few. I am continually inspired by the vast body of work they created, how timeless it seems to me, and how it remains the gold standard of what it is possible to achieve.

Weekends usually find me scavenging flea markets for inspiration and oddball artifacts. I'm a big fan of vintage packaging, signs, and graphics and am always searching for art director's annuals and extinct books on graphic design and typography.

Balance is overrated.

It's not what you put in, it's what you leave out.

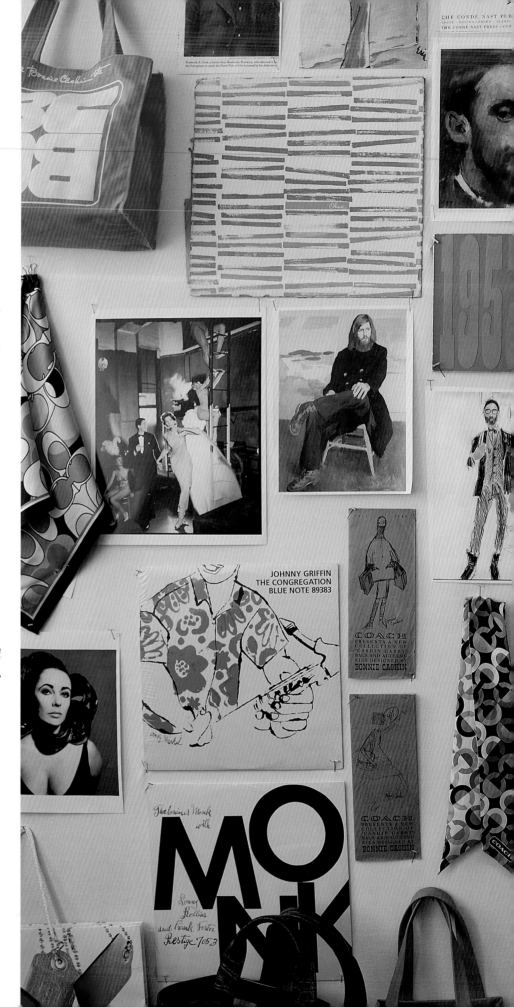

EGON SCHIELE

COACH

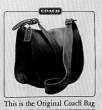

BAZAAR

COACH

This is the Original Coach Bag

BONGOS
+
BRASS

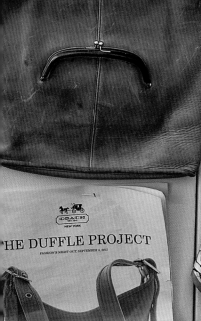

THE DUFFLE PROJECT
FASHION'S NIGHT OUT SEPTEMBER 8, 2011

Thom McAn
MELITEX
HOSIERY

BONWIT
TELLER

555
BARBARY COAST
THE
HERMAN·MILLER
FURNITURE COMPANY
Founded
1905

OPENING 20 OCTOBER
1958

"Everything you can imagine is real."

Pablo Picasso

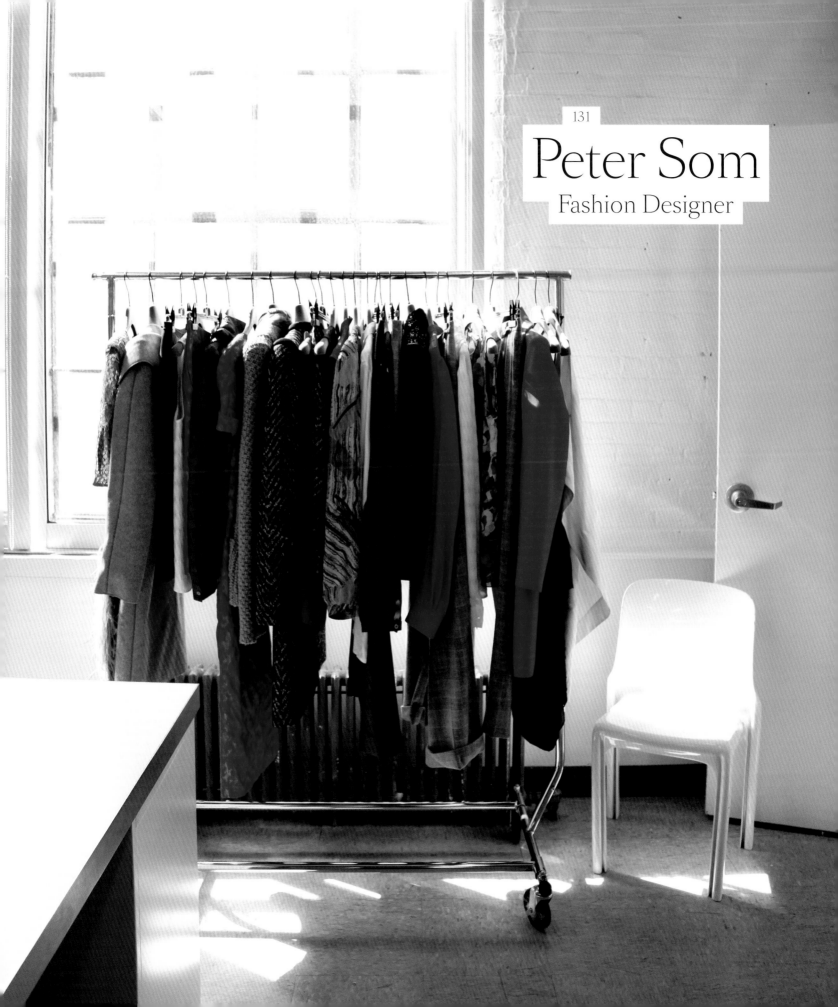

Peter Som
Fashion Designer

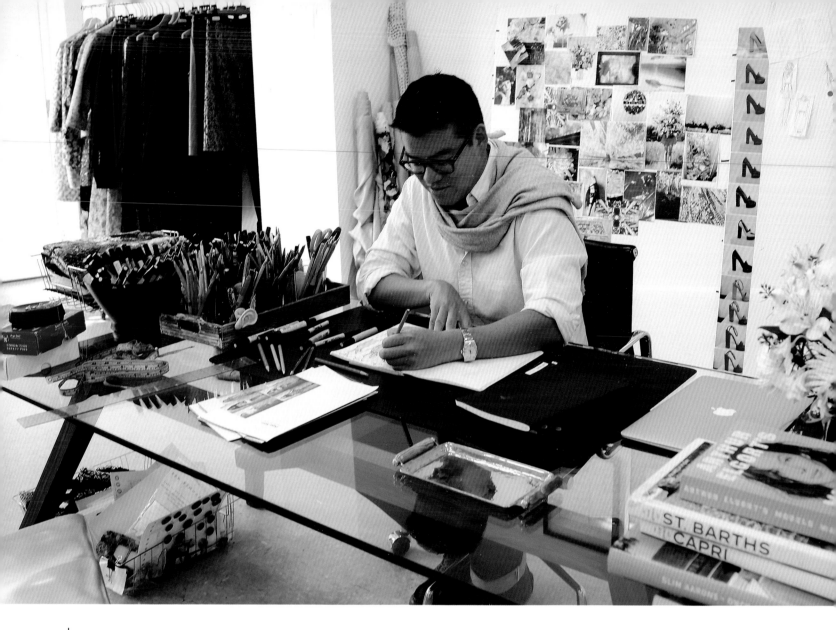

I have my upholsterer at the Furniture Joint to thank for introducing me to Peter Som after I mentioned seeing him enter the Decoration & Design building as I was leaving. It was after that introduction that I learned he already read my blog. That was one of the first moments someone whom I had long admired told me they enjoy it. A pinch me moment for sure.

I believe there is little separation between fashion, design, and art and Peter Som is a great example of a designer for whom this is also true. Both of his parents are architects who encouraged his artistic endeavors and fashion career. He earned his degree in art history and whenever I look at his beautiful prints, I can't help but think he is truly on par with the great artists he studied. He is also a wonderful amateur chef. I wouldn't be surprised if a cookbook with perfectly styled food is also up his sleeve.

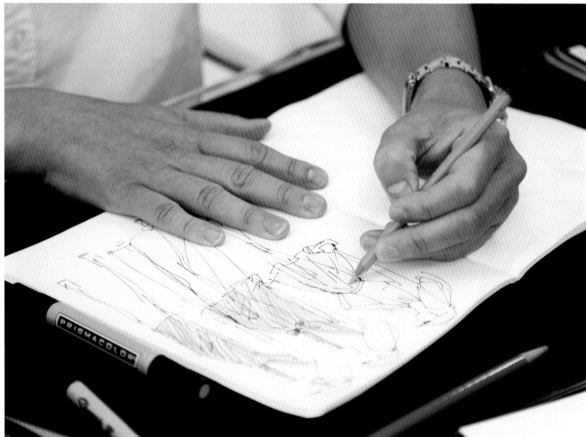

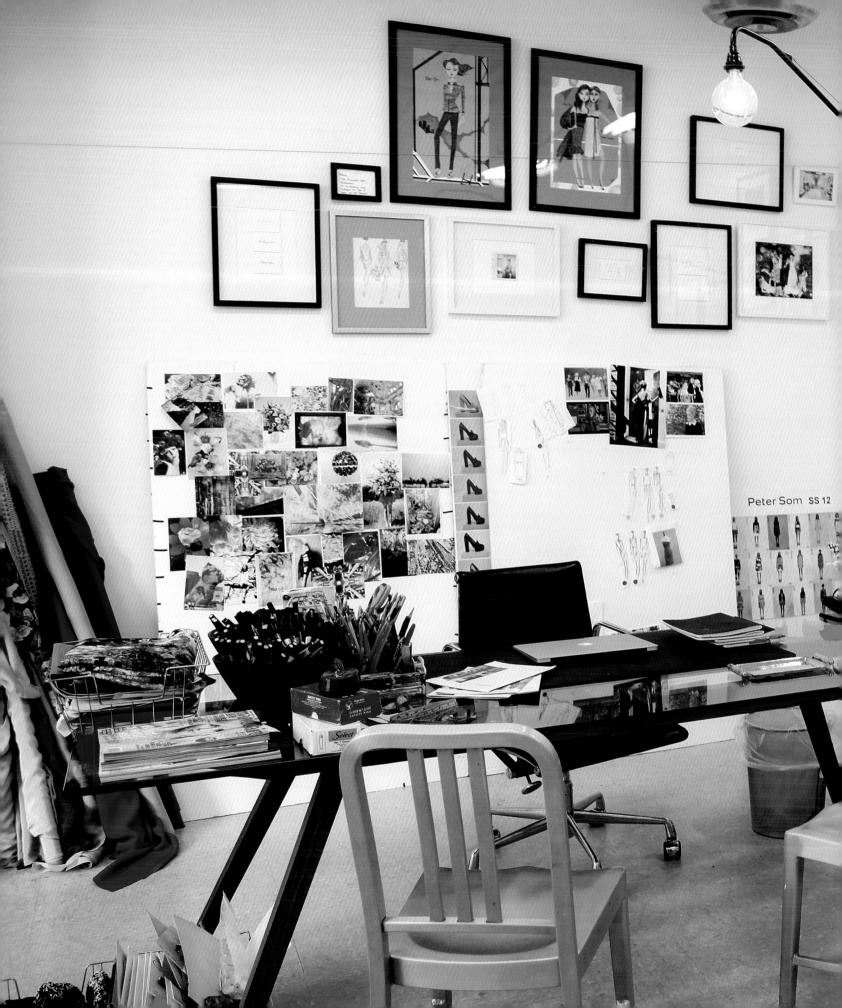

Peter Som SS 12

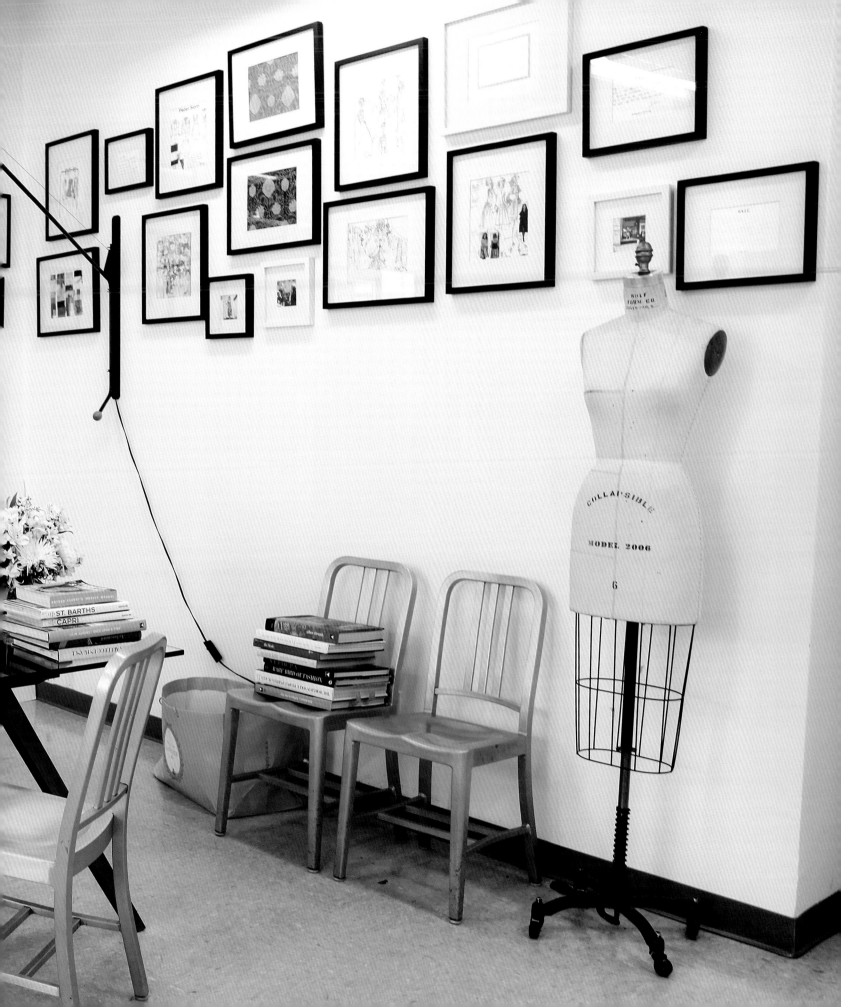

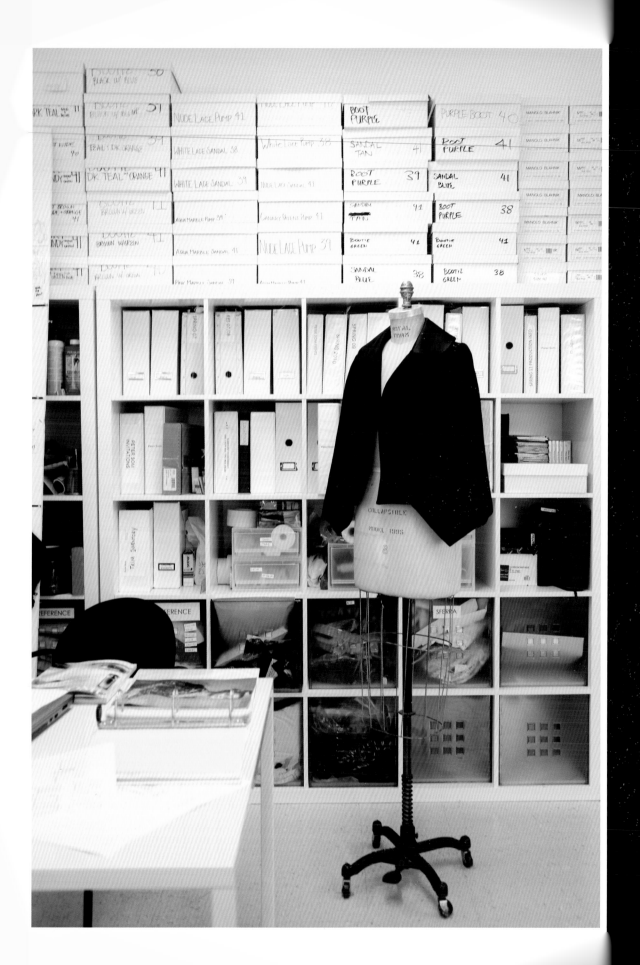

I realized I wanted to be a fashion designer in fifth grade. My family had taken a trip to France where my sister bought Paris Vogue and L'Officiel. I opened those pages and was swept away. I had always loved to sketch—and had started very young—at first drawing my mother, which then evolved into drawing clothes. But opening those pages made me understand that I could do what I loved as a career.

I grew up in a very creative and design-oriented family. There was no pressure to be a doctor or a lawyer or something more traditional. My parents were always supportive—I was continually encouraged to try a new kind of pencil or a different kind of paper. However I was most happy using the back of their old blueprints.

My big break came with my first mention in Vogue! Need I say more?

My first job upon graduating Parsons was at Bill Blass. He taught me so much about not only the industry, but on the importance of conducting oneself with elegance.

I find inspiration in everything, but especially travel, movies, and art—as an art history major in college it is a real passion. And at the end of the day, sometimes it's just walking around New York and seeing chic women with amazing individual style that can inspire.

The process is very organic—it sometimes starts as a mood or a feeling that I want to convey. Other times I'm inspired by an old textile or a mosaic from my travels.

It's a ton of work—but I never take for granted that I'm doing something I love and which makes me happy.

My mother's advice is what always sticks with me— "mind over matter." It's like her version of Nike's "Just Do It."

"Good design is
as little design
as possible."

Dieter Rams

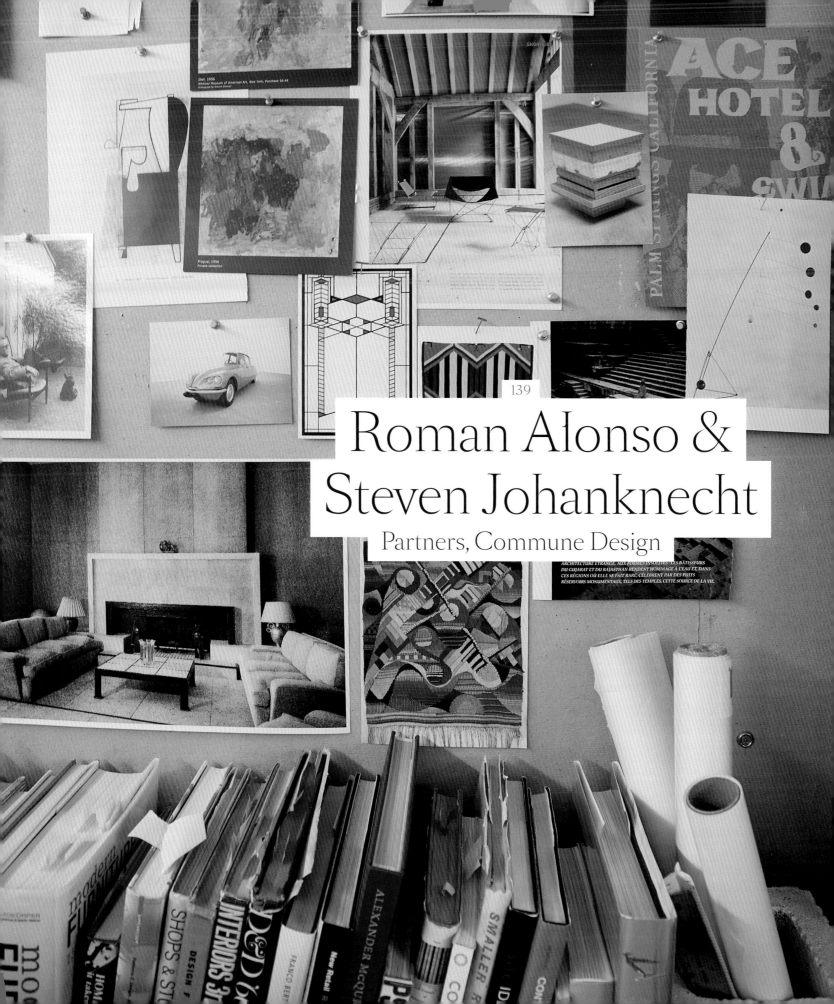

Roman Alonso & Steven Johanknecht

Partners, Commune Design

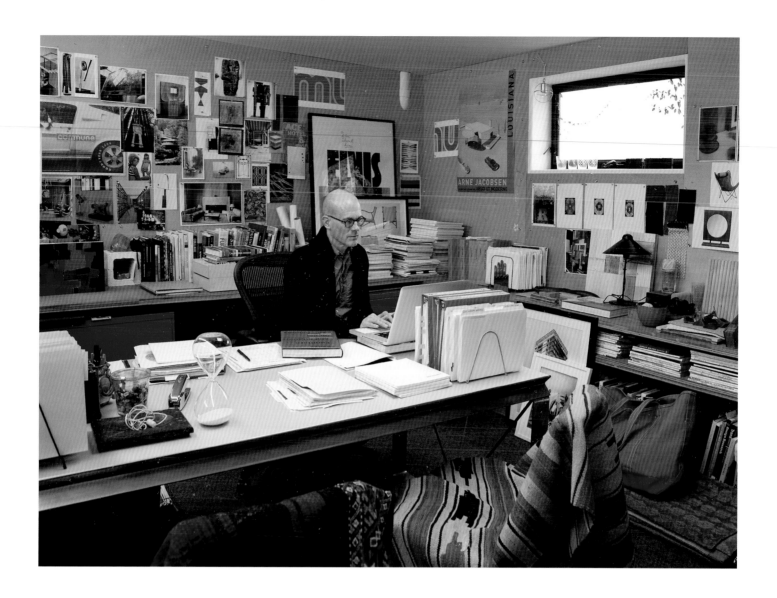

As someone who works alone at home most of the time, I'm always jealous of those who work with partners. Roman Alonso and Steven Johanknecht both began their careers in New York but ended up moving to Los Angeles where they founded the design firm Commune. They work as a team along with partners Pamela and Ramin Shamshiri in an office bustling with activity. Commune is a unique concept, based on collaboration that looks at each design project, whether residential or commercial, as an entire entity right down to packaging and branding. It makes complete sense and has led to very successful projects for Ace Hotels and Heath Ceramics to name a couple. Roman and Steven are so happy, and enjoy what they do so much, that they definitely make me want to find some partners and join them on the West Coast.

CREATIVITY AT WORK – ROMAN ALONSO & STEVEN JOHANKNECHT

We met at Barneys in 1998 during the Pressman family era. It was a highly creative period there and a great school. We were part of what was called creative services. Advertising, publicity, store design, and display worked very closely together. We both did a lot of work interfacing with artists and designers. Now we realize what an impact that period had on our creative process today. As for Commune...it started with four friends coming together with a desire for a new, more holistic way of approaching design.

We came to LA for a better quality of life. It's a much more human place to live and there's a sense of freedom that is different from New York. Anything can happen in New York, but you can be anyone you want to be in LA. We don't feel limitations here. There's a lot of room to look inwardly, for exploration and reinvention.

The name comes from our love of the Bauhaus and its philosophy of merging design, art, craftsmanship, and manufacturing. The school is a constant source of inspiration. But, of course there is more than a touch of California in there...after all some of the most influential designers in creating the "California lifestyle" came from the tradition of the Bauhaus.

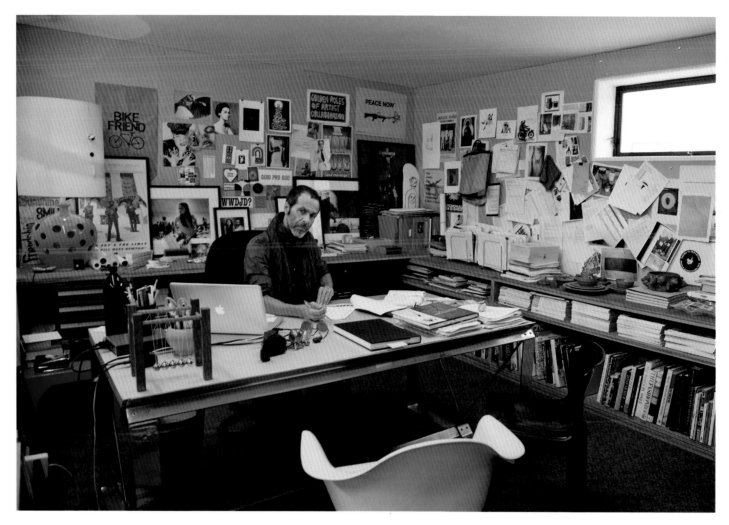

The only way we knew how to work was looking at all sides of the problem and collaborating to find a solution. Pam and Ramin were production designers and worked with film directors, and we worked with designers and fashion brands. In all cases it was about finding ways to interpret and communicate the clients' vision in an effective and relevant way. It doesn't matter whether it's a residence, a hotel, a graphic, or an object—it's the same process. We work well with clients because we tend not to impose our own aesthetic, although more and more they come to us for it. Our intention is always to help them develop their own.

We couldn't do what we do without each other. Four brains are better than one in any situation and collectively we have over 50 years of experience in a variety of areas. At the end of the day, it's really important to have a trusted, well-informed opinion.

We all have great libraries. Of course we all travel and that always informs our work, but books are our education and biggest source of inspiration. Also, it's impossible not to be inspired by California: its physical beauty and openness and great tradition of frontiersmanship.

We admire the craftsman and artisan—the people who inject design with a soul through their expertise and the work they do with their hands. It's our greatest desire to keep their tradition alive.

We are excited by the never ending possibilities... one day we are designing a hotel, the next a villa in Napa, or a chocolate bar, or a cottage in Malibu, or a tile collection, or a restaurant, or a book, or a tile factory, or a room scent...it's endless what can and does come through our studio. It's the basic enjoyment of making things.

Best advice: Sleep on it!

"You only live once, but if you do it right, once is enough."

Mae West

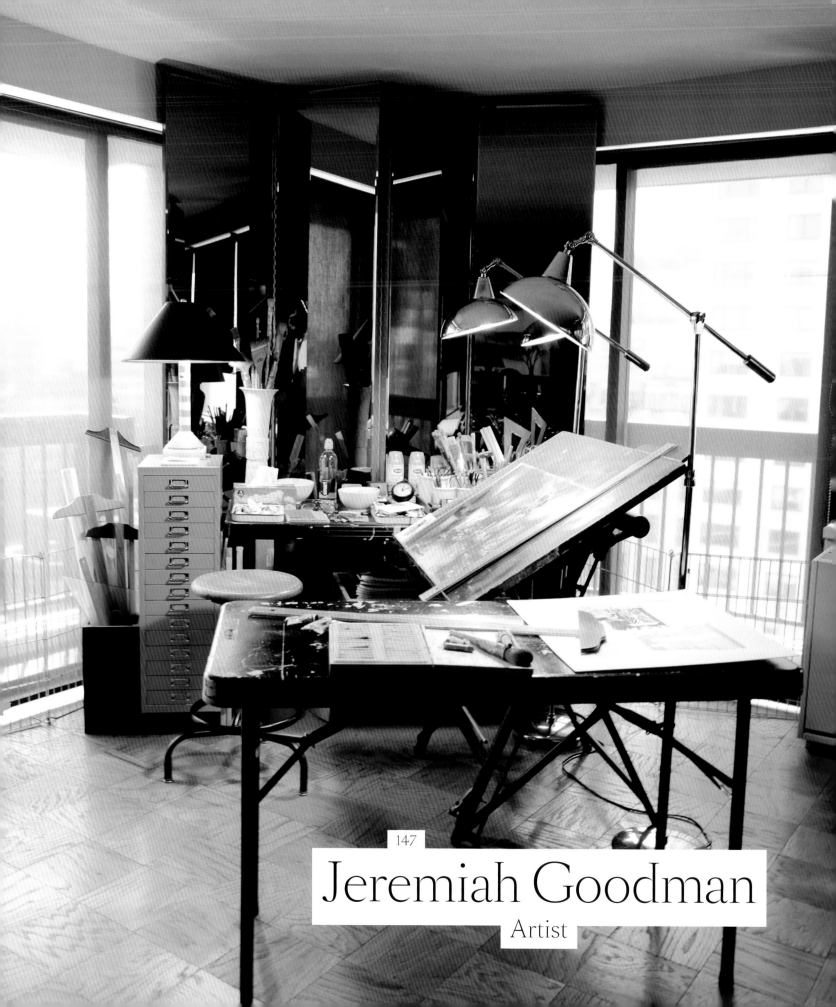

Jeremiah Goodman

Artist

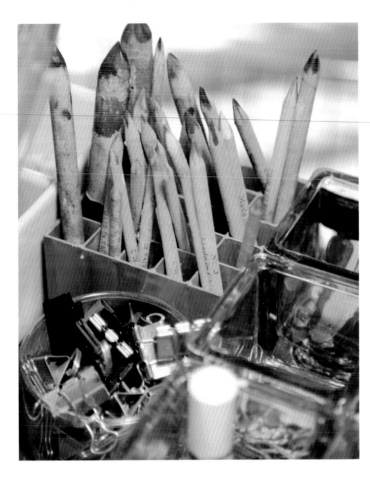

148

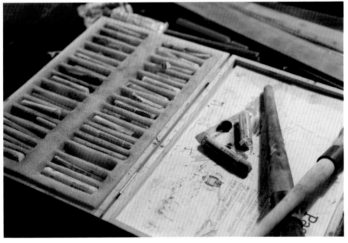
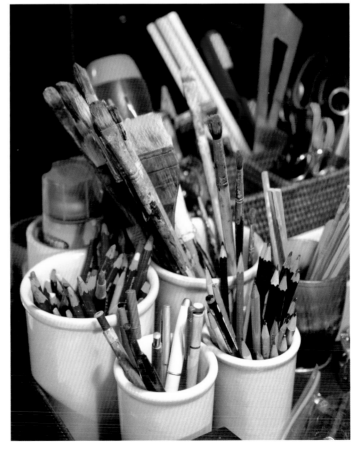

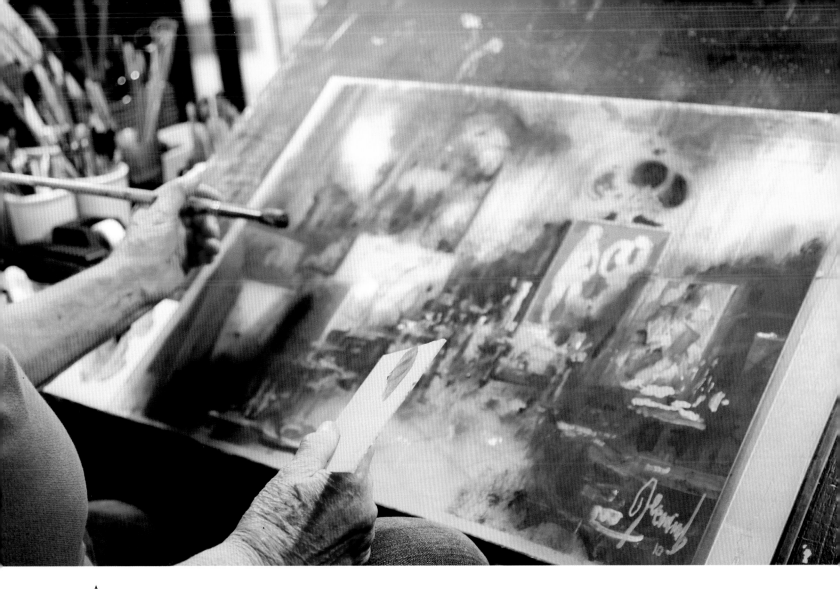

Artist Jeremiah Goodman has been commissioned to create his gorgeous watercolor interior illustrations for some of the most glamorous people in the world including Carolina Herrera, Elsa Schiaparelli, Bruce Weber, Gianni Agnelli, Billy Baldwin, and Reed Krakoff. Many become great friends, like Bonnie Cashin who created Coach and Dorothy and Richard Rodgers. It was Richard Rodgers who told Jeremiah that what most impressed him about his work was that Jeremiah created a painting of how he thinks about the room, not how he sees it.

Jeremiah says he gets up to work everyday because he lived through the Great Depression and he thinks every commission might be his last. I say his art is what gets him out of bed and keeps him young. At 90 years old, he is certainly entitled to slow down, but when you love what you do, it doesn't feel like work.

"The world has taught me the most. If you are curious and keep your eyes open, they are a camera for the mind, a record to be used at the 'needed' right moment."

It was 1938. A friend of my sister worked for a labor union. She hired me to do ten strikebreaker signs at five dollars each plus a free lunch. It took all day to accomplish. The Buffalo Evening News *photographed the men picketing with my signs on a snowy day. It was my first published "artwork." I had arrived!*

The Lord & Taylor furniture artist for the newspapers was on vacation, they needed a replacement—me! I stayed on for 30 wonderful years. (It's called being at the right place at the right time!)

A favorite commission was Elsa Peretti's collection of homes— penthouses in New York and Rome, a Barcelona apartment, the "tower" at Porto Ercole with its incredible views of the Mediterranean Sea, Sant Martí Vell, restoration of village buildings in Spain-displaying her brilliance as an architect, and her amazing collection of decorative objects and jewelry. A true reflection of their unique talent that it all adds up to "one!"

The world has taught me the most. If you are curious and keep your eyes open, they are a camera for the mind, a record to be used at the "needed" right moment.

I am constantly looking for inspiration and sometimes it finds me—a postcard from a faraway place, a gift of flowers, art book sent mysteriously at the right moment.

It may seem superficial but there isn't any one person I admire in my industry. We all deal in creating dreams of the beautiful life, leaving all thoughts unpleasant about our world behind (for the moment).

At 90, I feel creative and can still hold a brush and see beauty in this world of ours!

Stick to the drawing board!

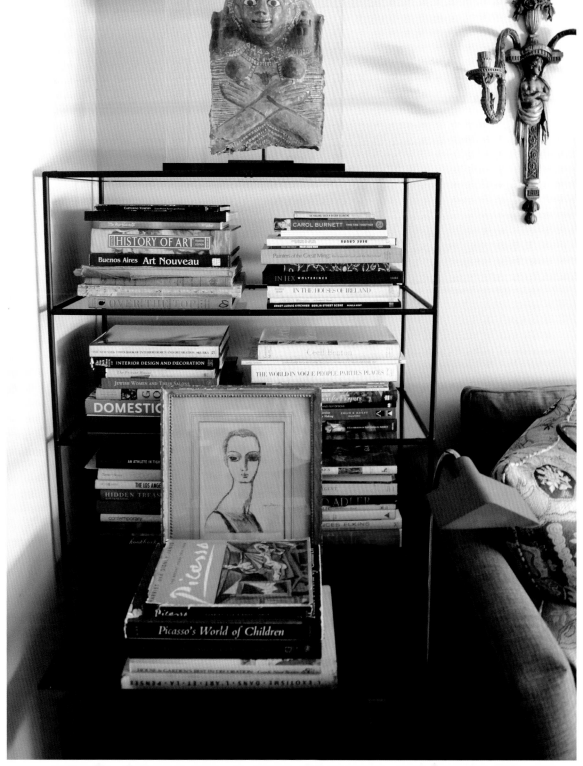

"Chic is where you find it."

Bonnie Cashin

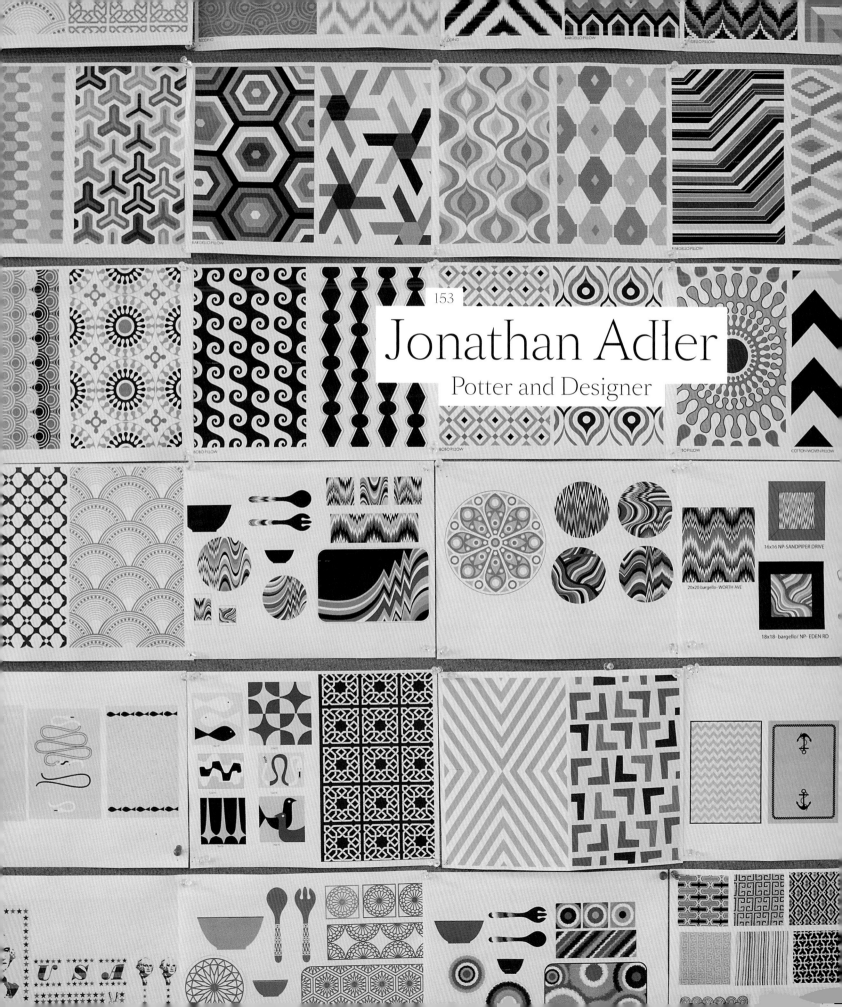

153

Jonathan Adler
Potter and Designer

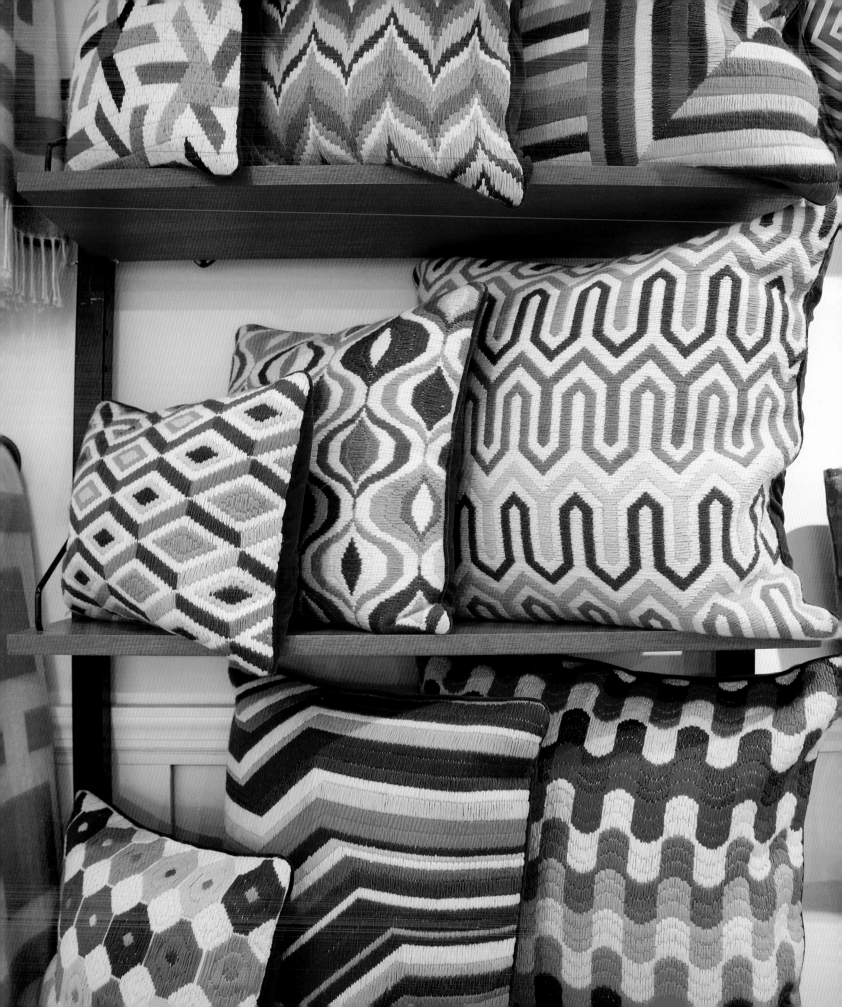

Jonathan Adler is the perfect example of someone who managed to turn his hobby of pottery into a career. That's not to say the road was easy or quick but his perseverance and positive attitude paid off in the end. His "Happy Chic" company makes not only pottery now but bed linens, pillows, tableware, furniture, and more, in bold colors and patterns. Even the studio is fun and colorful. His employees are allowed to bring their dogs to work and you can tell that they enjoy coming to the office each day. The company manifesto states, "WE BELIEVE minimalism is a bummer" and that perfectly sums up Jonathan Adler, the man and the brand.

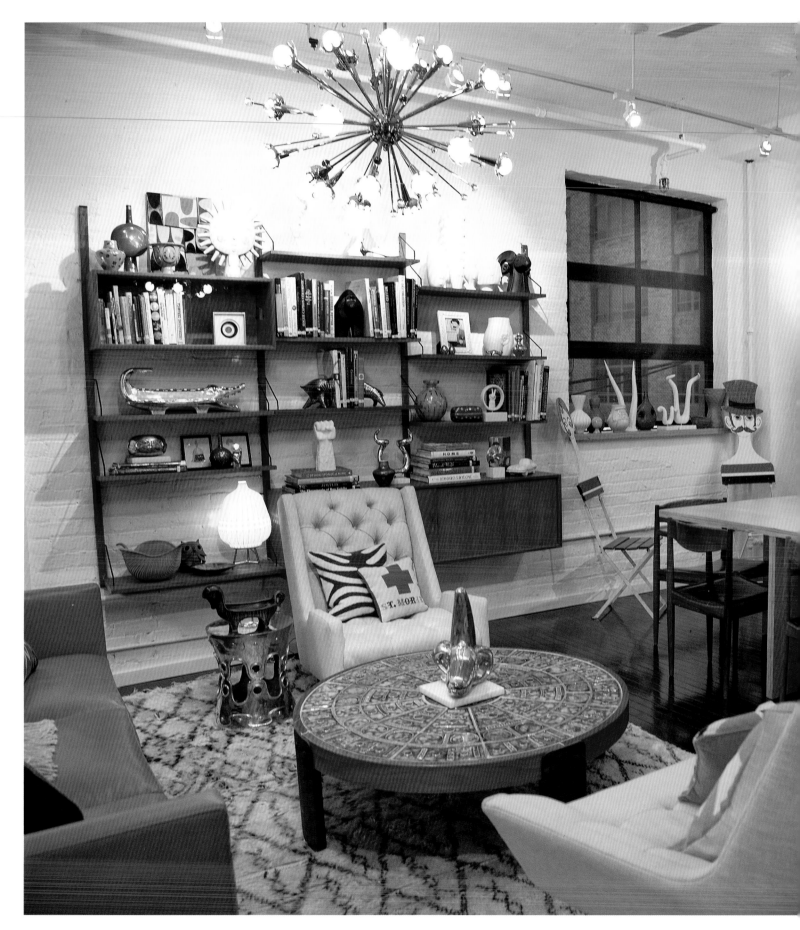

156

"It ain't a job, it's a pleasure."

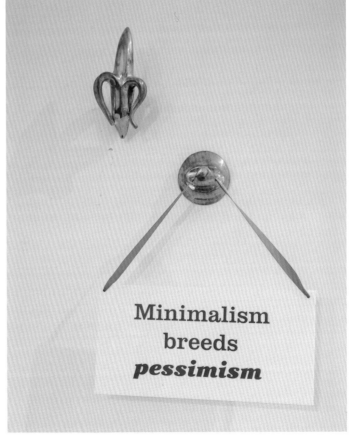

Minimalism breeds *pessimism*

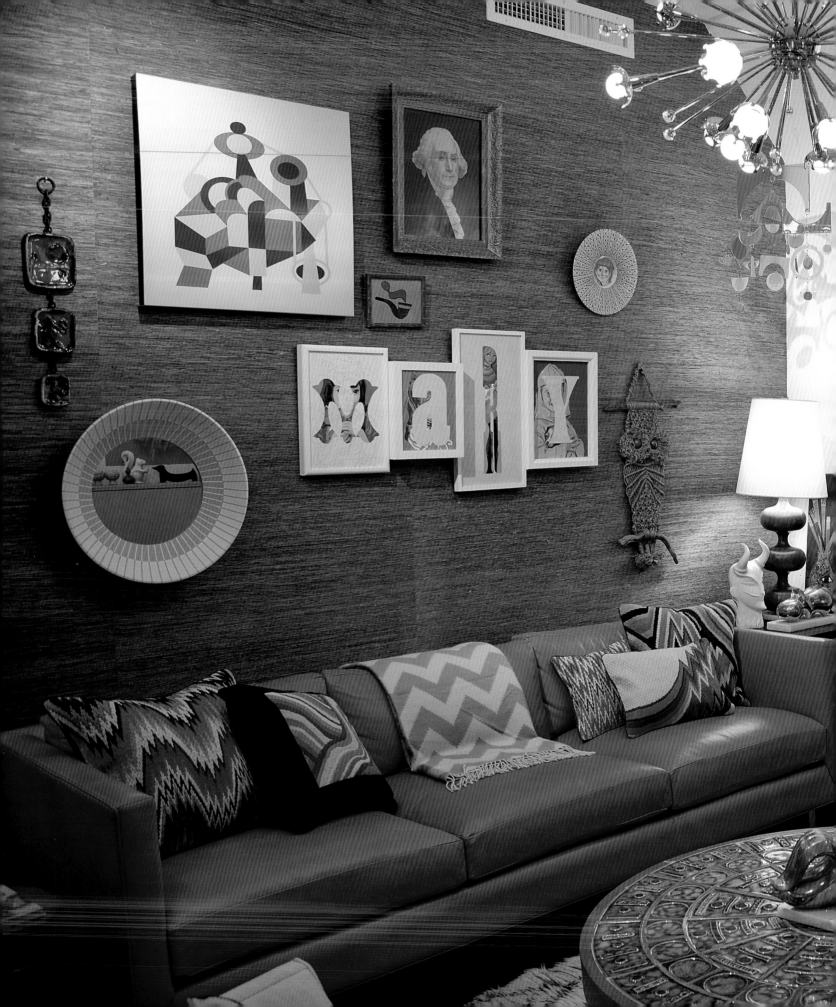

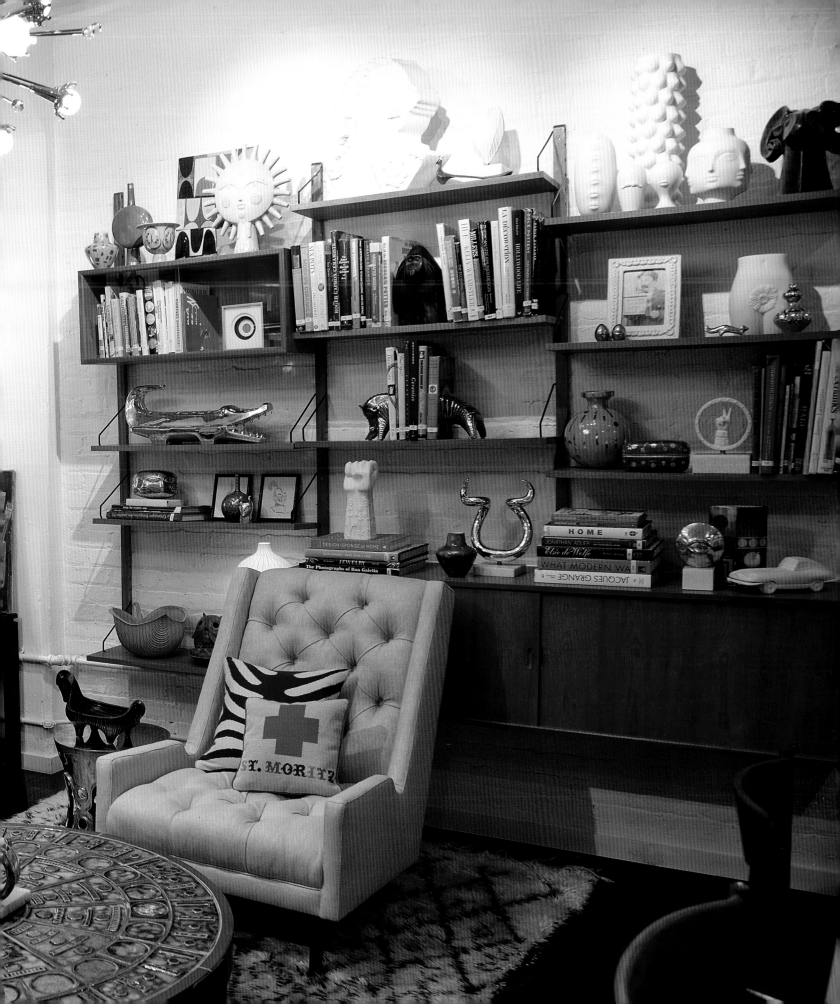

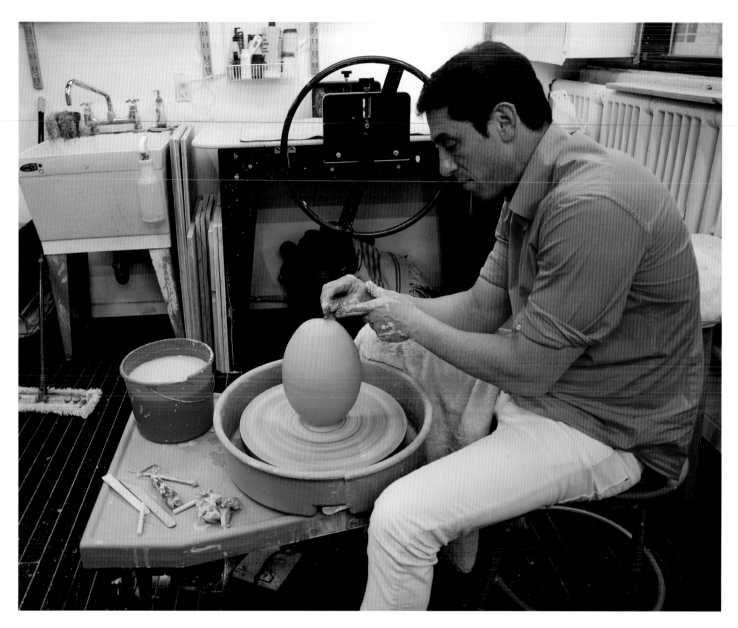

I am incredibly serious about what I do. I work really hard and strive to create work that is beautiful. My inner dialogues ain't always too upbeat. I'm very self-critical and analytical and there's often a lot of thought and struggle that goes into my work. I appear to be glib, but I'm very rigorous.

I never know where my next idea will come from. I try to keep my eyes and my mind wide open.

I'm proud to have worked with artisans in Peru for almost 15 years and to have created hundreds of job opportunities for really talented Peruvian craftspeople. But it's a symbiotic relationship—their skills and sensibility have definitely informed my work. I get stuff made all over the world now, but my relationship with Peruvian artisans is definitely the most important to me.

I don't think that I have balance in my life. I'm constantly working and constantly playing and I couldn't be happier about it.

I loathe people who present themselves too seriously. I hate pretense in art (and life!) and I feel incredibly lucky to get to do what I do. I'd feel like an idiot if I shared too much of my angst about making a pot when there are people struggling to cure cancer or fight poverty. Sometimes I think that I do a disservice to my work by not being more heavy and theoretical, but c'est la vie.

As for the spirit of my work, I believe that design is communication and that design can make you feel good. I want to make stuff that's beautiful and uplifting. And a bit of humor never hurts.

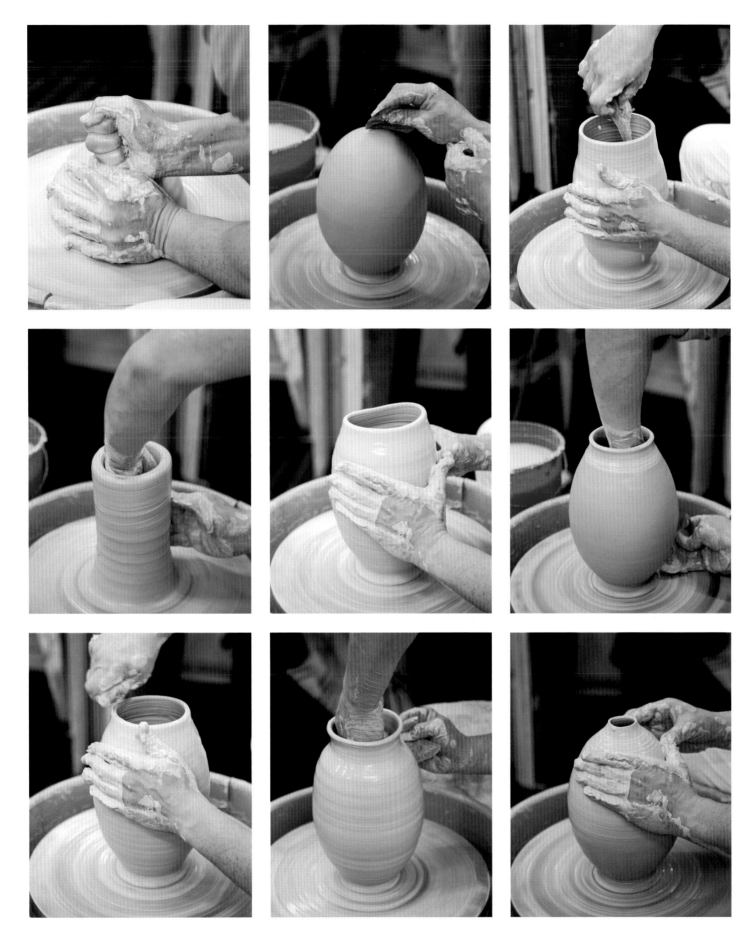

CREATIVITY AT WORK – JONATHAN ADLER

"Style is a simple way of saying complicated things."

Jean Cocteau

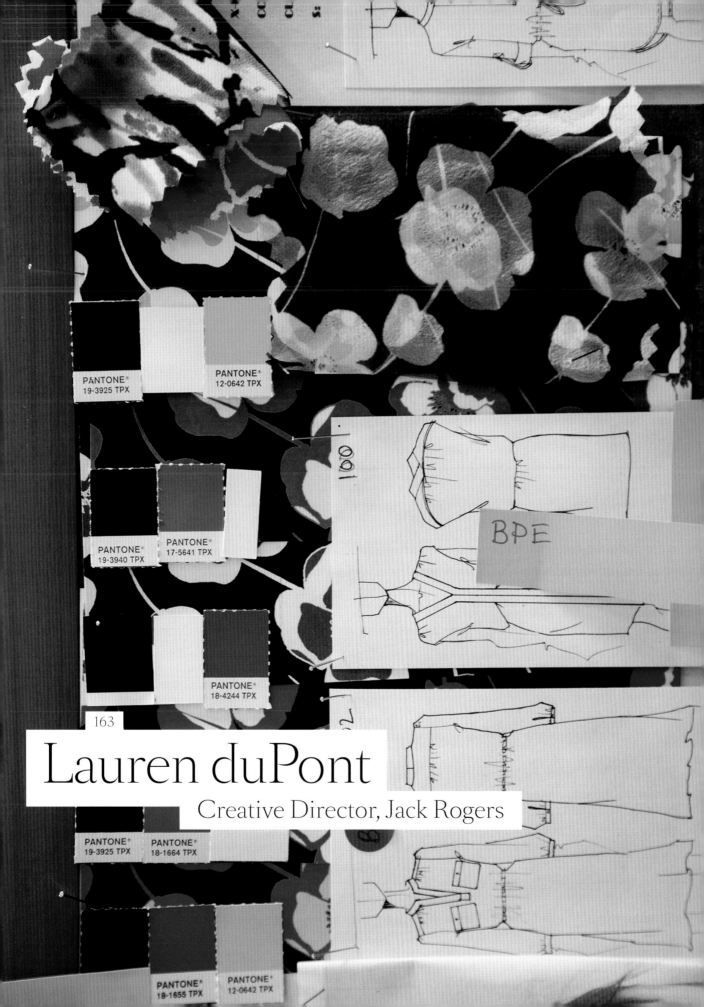

163

Lauren duPont
Creative Director, Jack Rogers

Lauren duPont has such great personal style it's no surprise brands would hire her as a consultant. Perhaps it is her background working for *Vogue* magazine and Ralph Lauren that honed her eye. The current beneficiary of her golden touch is Jack Rogers, where she serves as creative director of accessories. Most days, she can be found in her office cutting leather samples and trying to update the iconic footwear brand without alienating its long-standing customers. In addition to footwear, they now offer ready to wear clothing and handbags. I've owned dozens of pairs of their famous Navajo sandals over the years and under Lauren's watch, I have a feeling that I might be adding some dresses and skirts from Jack Rogers to my closet.

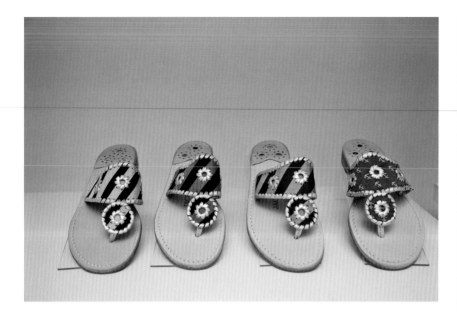

CREATIVITY AT WORK — LAUREN DUPONT

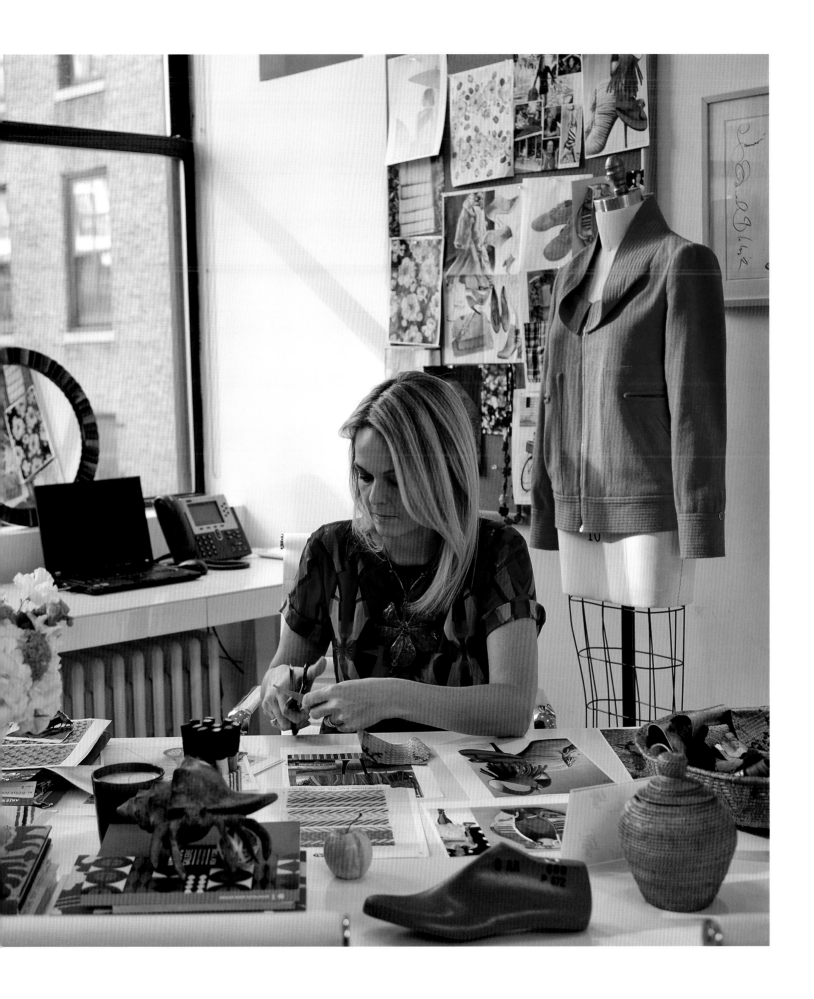

I loved the idea that so many people knew Jack Rogers, but really it was only known for the Navajo sandal. The brand has such great heritage and people have a soft spot for it because it usually reminds them of happy things like travel, being on holiday, the sun, and the ocean.

It is all about being effortlessly chic and casual, yet polished. I think expanding the line to include other classic items beyond the Navajo that can be worn in different seasons will both bring in new customers and retain our long-standing ones.

I love the idea of sisters wearing Jack Rogers. Maybe the Fanning sisters or Sienna and Savannah Miller.

Anna Wintour, Grace Coddington, Ralph Lauren and all of the different editors I have worked with have taught me the most.

My sources of inspiration: vintage shows and stores, print shows, vintage magazines, my storage space, Vogue archives, museums, art exhibitions, and books.

I admire people who have a clear, strong vision and never waver.

You should always be nice to everyone.

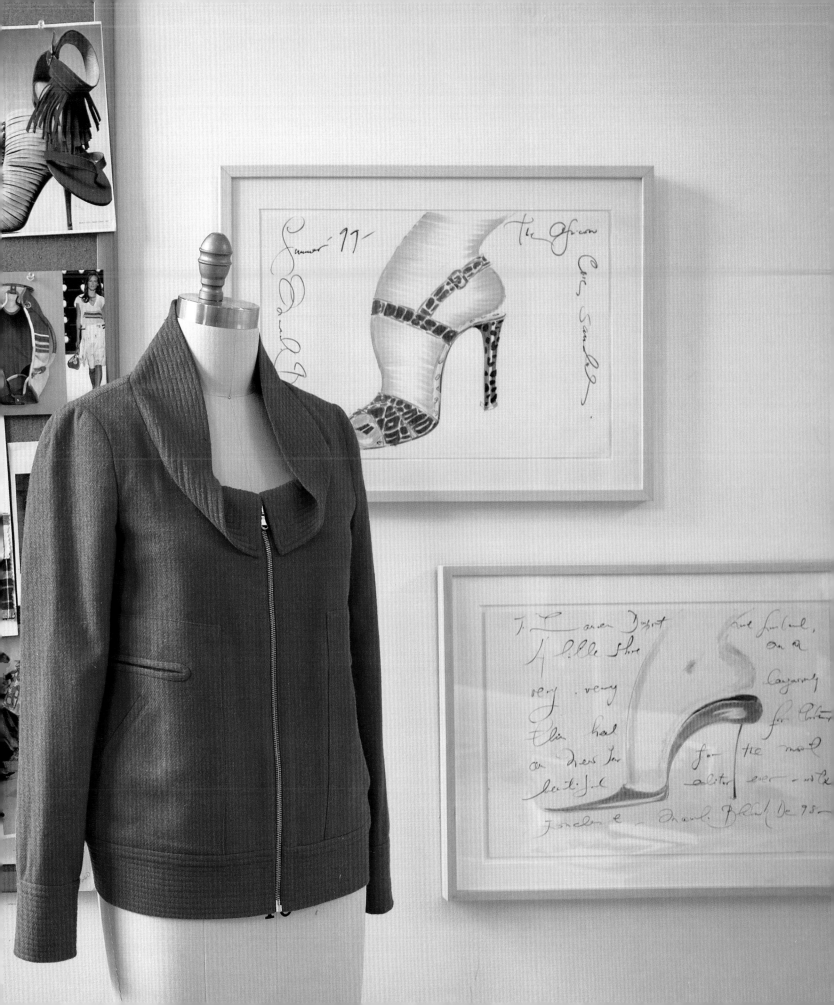

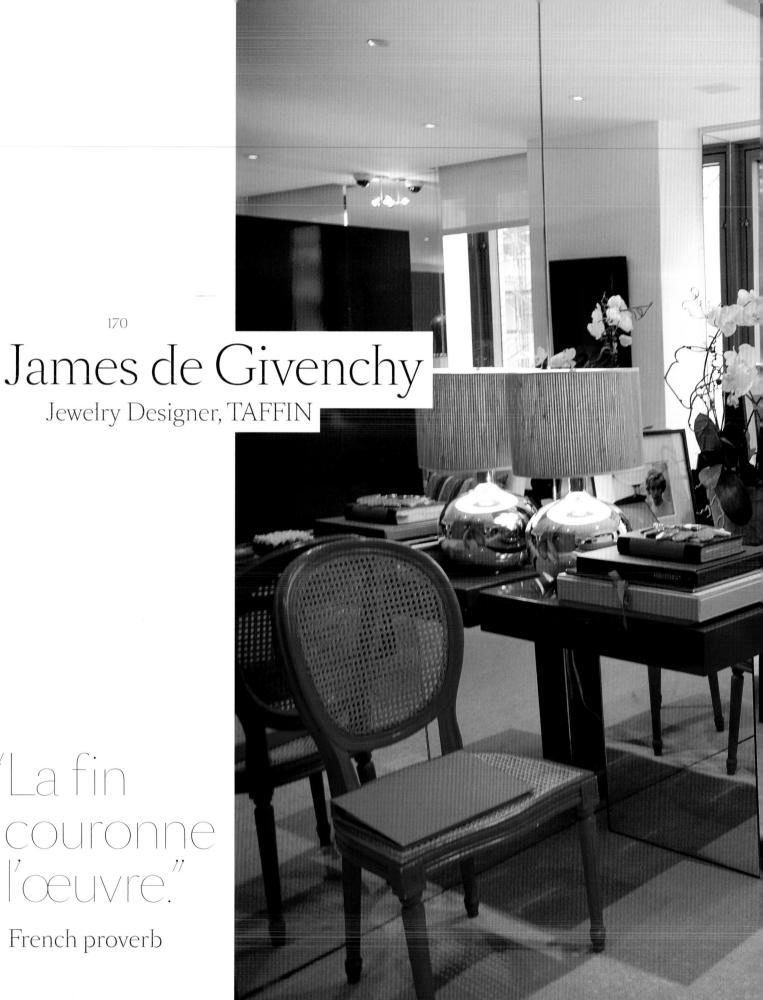

James de Givenchy

Jewelry Designer, TAFFIN

"La fin
couronne
l'œuvre."

French proverb

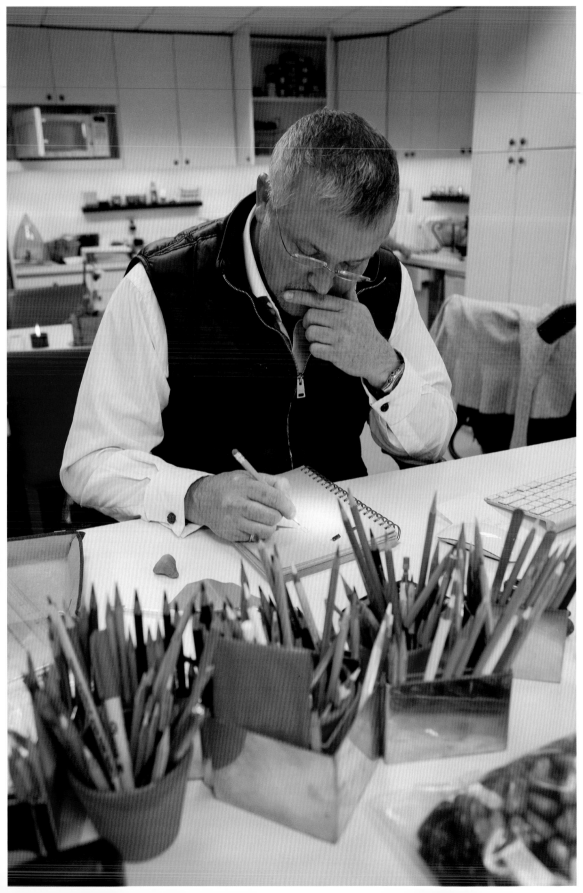

James de Givenchy was born into a family of creative people, the most famous of whom was his uncle, couturier Hubert de Givenchy, but you can tell that he is not living in anyone else's shadow. His gorgeous jewelry designs are sought by collectors and dreamt about by most everyone else. After working for Christie's and Verdura, he set out on his own to design jewelry that is rooted in the past but completely contemporary. He likens the structure of each piece to designing a building, and you can tell that the process is just as enjoyable as the finished result. It's also fitting that his showroom should be its own jewel box.

"I find inspiration everywhere I look. It often comes when I think I see something and realize it is something else. It can come from a building or a bridge, an object, a plant, or even a shadow."

I started making pieces when I lived in Los Angeles and was heading the West Coast jewelry department at Christie's. When Verdura offered to move me to New York to work for them I was very excited and thought the job was going to be focused on creating new designs... but it wasn't so. When I left Verdura in 1996 after less than one year as vice president, I decided to give my own business a go.

I will travel as far as India and as close as 47th Street to find the stones and I try to attend as many gem shows as possible. Every find makes me feel like a child who just discovered treasure!

From design to completion I usually do not take more than a few hours... unless it is a necklace.

I find inspiration everywhere I look. It often comes when I think I see something and realize it is something else. It can come from a building or a bridge, an object, a plant, or even a shadow.

I do not like representational jewelry.

JAR (Joel Arthur Rosenthal) has changed the way we think of jewelry and has given the next generation of jewelers a new vocabulary that it is impossible to create without.

Thinking of new designs and seeing them realized never gets old.

My brother Hubert taught me how to persevere.

The best advice I've received, but rarely follow: Enjoy the moment!

176

"A person with a real flair is a gambler at heart."

Billy Baldwin

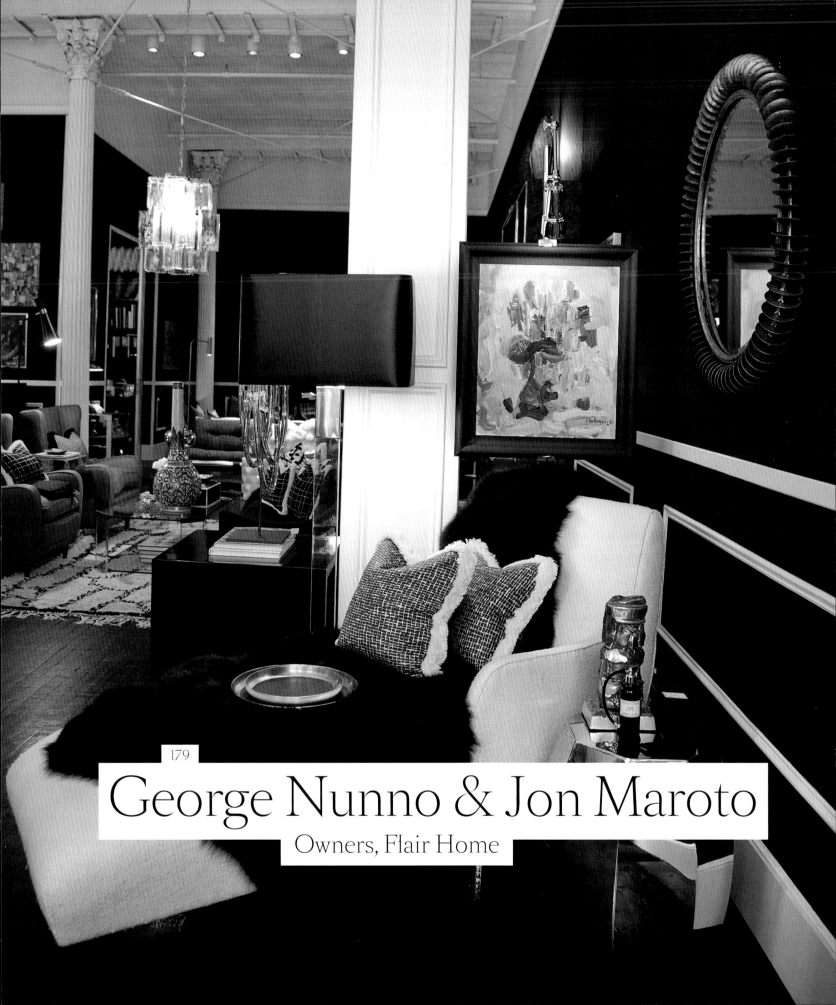

179

George Nunno & Jon Maroto

Owners, Flair Home

Everyone who visits the Flair store wants to move right in. The sexy, dark walls are the perfect backdrop for its chic mix of vintage furniture, modern art, and new pieces created in Italy. The first time I met the owners Jon Maroto and George Nunno, it felt like I had known them forever. They have actually known each other for what feels like forever, having started at J.Crew on the same day over 20 years ago.

I shop at Flair for clients but also stop in just to say hello whenever I'm in SoHo. They also email me occasionally to tell me how much they loved a blog post. I actually started posting more "for the boys" just for them. They are so successful as a team that they make me want to pair up with someone for business. But mostly, I want them to take me on as a third partner. Or at least install a bed in the store so I really can live in Flair.

ALCHEMY COLLECTION

We have worked together for over 20 years.

Right out of school, we began our careers at J.Crew, starting on the same day. Working there for ten years was an amazing experience in brand building, teaching us the discipline required to create a strong brand image and the building blocks of running a business.

In 1999, we both moved onto jobs at Coach. We were instrumental in shaping the processes and managing the team that brought about the rebirth of the brand. While there, we travelled every six weeks to work at our design office in Florence, where we stumbled across the original Flair store, were impressed by the style and concept, and became customers, and later, friends of the owners Alessandra and Franco Mariotti. Out of that friendship grew the idea of opening a Flair store in New York and they remain an eternal source of inspiration for us because of their off-handed, casual elegance.

Your brand has to tell a complete and compelling story that people want a piece of.

We are fortunate to have complementary skill sets and definitely use each other as a sounding board for our ideas.

For us, no project is too big or too small, it's about the relationships. We feel it is our job to enable our client's personality to shine through within the context of our style, so the relationship needs to be based on mutual respect and genuine affection.

Be true to your vision but flexible enough to listen to your customers.

Fashion is a big inspiration and helps inform many of our creative endeavors. We are equally inspired by our travels, which take us all over the world in search of unique and interesting products. Vintage interior, art, and photography books are always amazing reference. We look at interiors, art, and fashion magazines and of course also read as many blogs on those subjects as humanly possible on a daily basis.

If you love what you do, everything will balance itself out.

It's not a good day unless at least one customer says "I wish I could just move right in here..."

DECORATION USA

Innovative Furniture in America

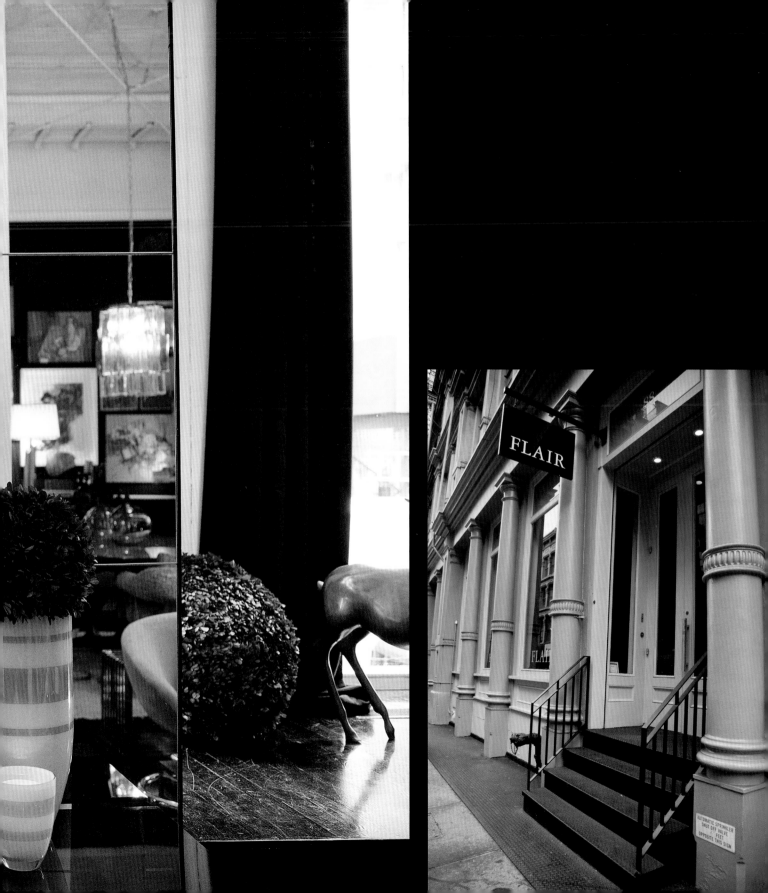

"The only thing that separates us from the animals is our ability to accessorize."

Clairee Belcher, *Steel Magnolias*

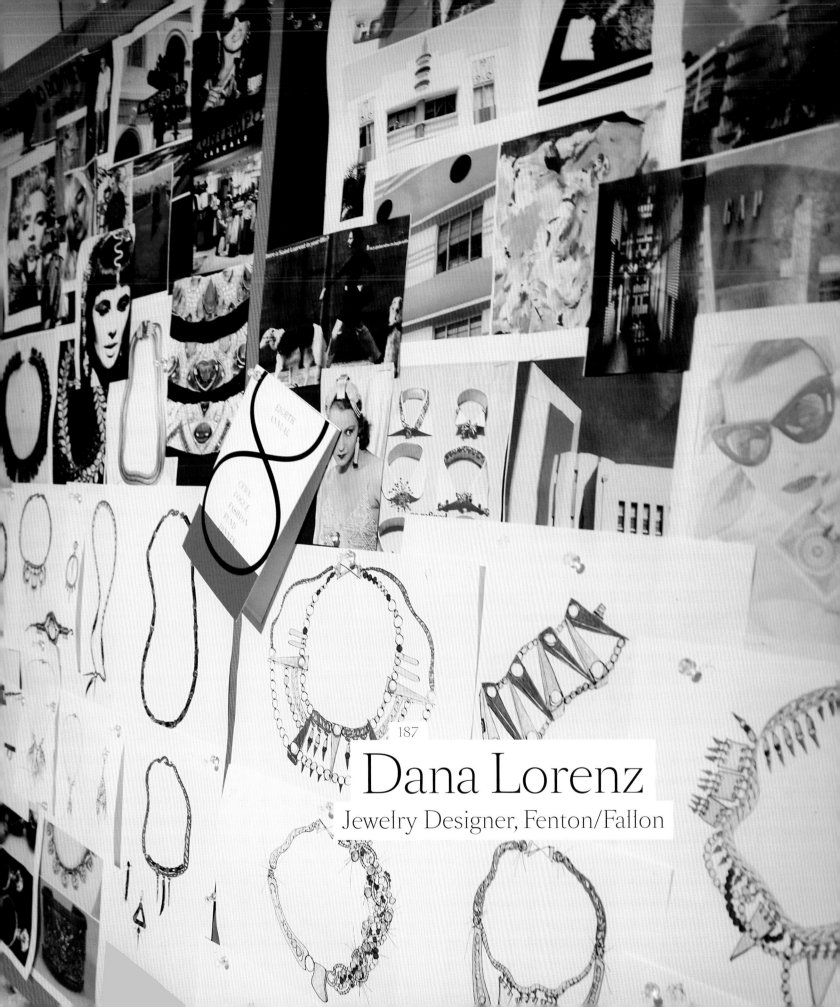

187

Dana Lorenz
Jewelry Designer, Fenton/Fallon

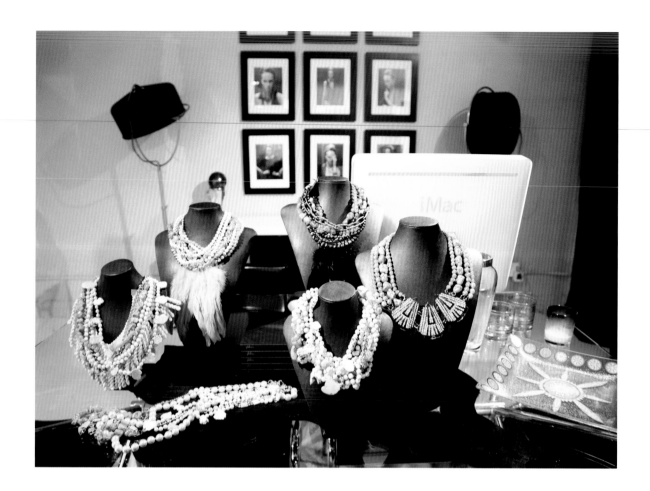

As someone who worked in retail management after graduating with a degree in art history, I can completely relate to jewelry designer Dana Lorenz's realization one day that she needed to make a change. She left her job in luxury retail and turned her personal love of jewelry-making into a business. Now she loves what she does every day. Her sometimes edgy, yet always beautiful pieces, are a favorite with magazine editors and, thanks to a collaboration with J.Crew, real girls on the street. If more people followed their passion like Dana, the world would probably be a much happier place.

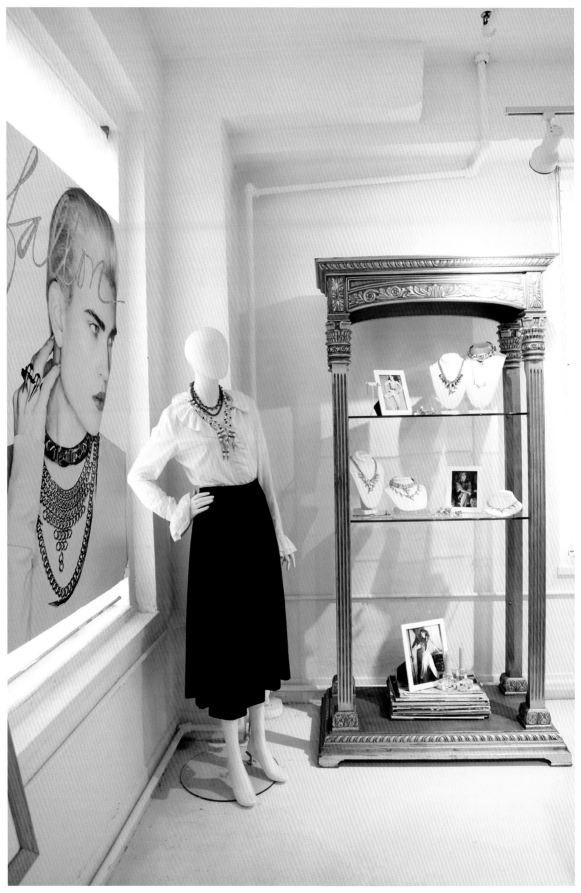

"My big break was an interview with Vogue right after I finished my first 12 pieces. You really can't launch a collection better than that."

Aqua Sash

Copper Tone

Garcia Marble

Banana Fudge

Dark Glitter
Royal

Lilly Sash

Chaos

Sand Sash

Mocha Melt

Blackstone

Rusted M...

Strangely enough, designing jewelry wasn't always my dream.
I have two degrees in painting and I ended up in luxury retail
after graduation. I got a job at Gucci in the late 1990s when
Tom Ford was changing the landscape of fashion. I started
making serious money selling beaded, flare-leg jeans and
python-print sack dresses and I became the ready-to-wear
specialist there. I was then recruited to Donna Karan in NYC.
One day I realized I didn't want to find myself 40 years old and
in black pointy pumps standing in a shop window on Madison
Avenue so I stopped to enjoy New York City for awhile. I started
making jewelry as a personal endeavor which led to a runway
collaboration, which sparked calls from Barneys and Vogue.
It was then I knew.

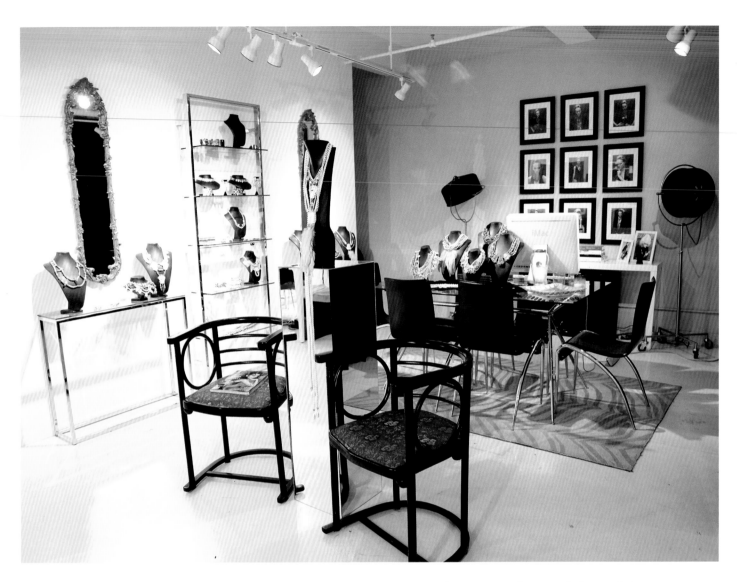

I feel I approach jewelry-making with very few limitations and boundaries. With painting and jewelry I am always adding and subtracting, or editing to find the perfect composition.

My big break was an interview with Vogue right after I finished my first 12 pieces. You really can't launch a collection better than that.

Mickey Drexler has been such a mentor to me since my collaboration with J.Crew. He's a realist with great taste. Neither of us was born with a silver spoon, and I can relate to that in him.

I have been collecting inspiration for art and fashion since high school and somehow it all makes its way into the collections. But I'm not someone that is like, "I'm going to Capri, and next season will be inspired by Capri." You can find inspiration anywhere and everywhere, and I do. I find it most when I'm not looking for it.

I most admire Anna Wintour. She really does hold all of the cards. Working with the CFDA/Vogue Fashion Fund, I realized how much she really cares about the future of fashion.

The initiative is such a huge opportunity in every way. It's not just about the competition and the "win." You are immediately tapped into the pulse of Vogue and industry insiders, and they are happy to help you. It is an experience like none other.

Do not concern yourself with the frauds and imitators. I used to get so bent out of shape with all of the copies out there of my work! I was driven to tears most times! But frauds move on to someone else if you ignore them.

With commercial success you'd think the main reward would be the money, but it's the realization that the average cool girl in, say, Nebraska takes her paycheck and chooses to spend it on jewelry I made. I'm most excited when I see that the girl in line in front of me at Starbucks is wearing my ID bracelet.

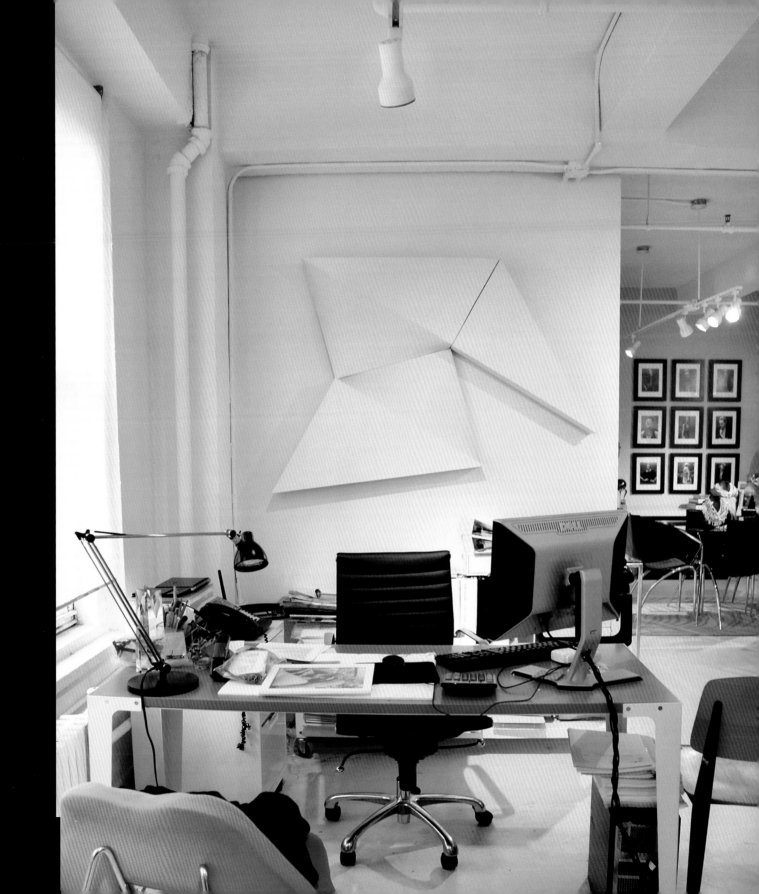

Mickey Boardman
Editorial Director, *Paper*

"Life's a banquet and most poor suckers are starving to death!"

Auntie Mame

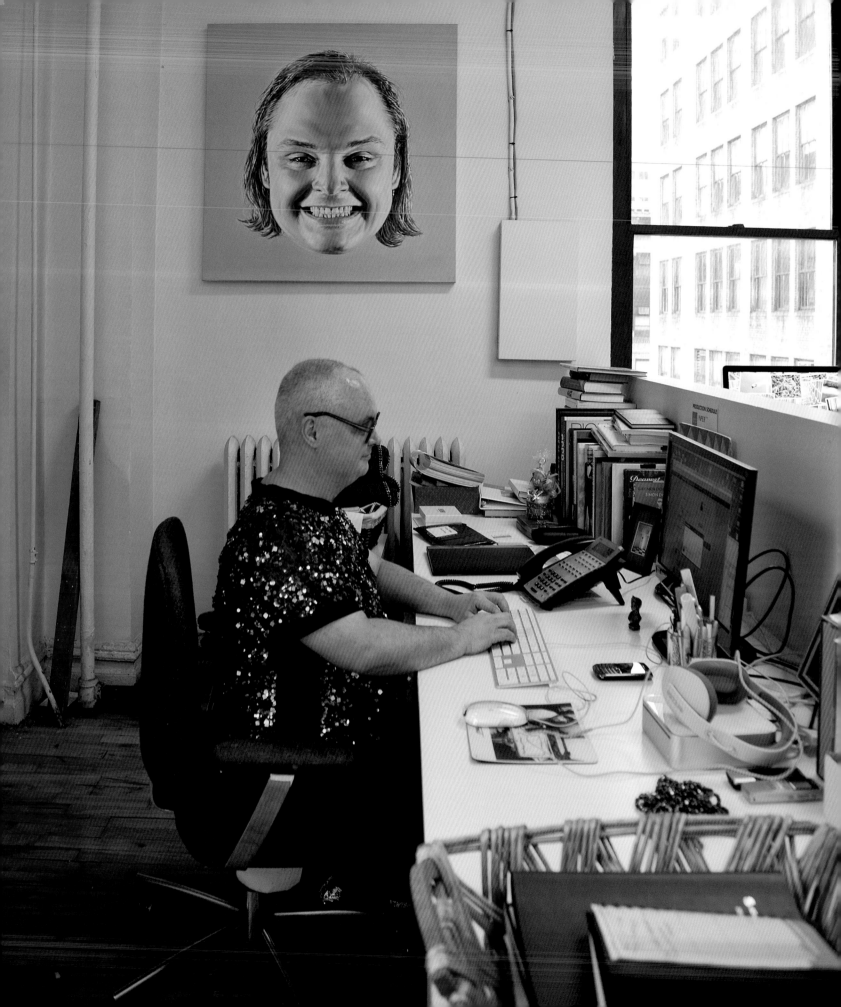

remember seeing *Paper* magazine editorial director Mickey Boardman on various television programs dropping bon mots and funny commentary. To me, he seemed to epitomize old-school, Studio 54 New York. Never did I imagine that I would not only get to meet him but actually get to know him all because of Twitter. He's the person that I enjoy running into most at a fashion show or event. He is the life of the party who also gives his time generously to charity. He's a fashionista who is usually wearing a sparkly necklace, and has a heart of gold to match. New York could use a few more people like Mickey Boardman.

"I'm the type who finds a place he likes and stays."

Paper was my favorite magazine and I was friends with the best friend of the managing editor. I never even really knew about internships until she suggested I apply for one. She was also the person who gave me my first writing assignment, which seemed strange since I wasn't a writer! I interviewed Rupert Everett on the roof of the Peninsula Hotel. He was wearing a swimsuit and a mesh tank top. I never looked back!

For me there's nothing more inspiring than travel. I don't care if it's a drive upstate to visit Val-Kill, my idol Eleanor Roosevelt's house, or a round-the-world jaunt to the jungles of India. There's something about a journey that gets my juices flowing. Plus you're eating new things, shopping in new places, and just generally plopped into new surroundings, which is always good because it makes you pay attention to what's going on around you. I even get inspired by the candy store in any country I visit. I can look for an hour at the candy counter in London. And the magazine stands!

I really love, adore, and admire Simon Doonan. First of all he's a total doll and I think in the fashion business we're encouraged to be cunty and shady which is something I hate. There's no reason why everybody can't be nice and Simon has always been a pussycat. Plus he's such a worker bee! He churns out books and columns like his little English ass is on fire! And he doesn't take himself or his work too seriously. I wish more people were like him.

I get to meet so many interesting and inspiring people. I've been around for decades so I've seen amazing kids come work at Paper as interns and now they're rock stars and business powerhouses! Also my job allows me to work with, write about, and meet people from all walks of life from photographers to musicians to models to philanthropists to movie stars to crazy unknown freaks.

Be yourself. So many people think you have to be a certain way to be a success. You have to dress a certain way or like certain things. I'm a clown. I can pretend I'm not but that's what I am. I might as well embrace it and make the most of it. If people are looking for a clown, they know who to come to!

I love feeling like a real part of New York and I think all of us who come to NYC to follow our dreams are an integral part of the city. Excuse my language but I fucking love New York City.

I've got a million career highlights. One was interviewing my all-time favorite musical act Salt-n-Pepa for Paper TV and then having them pull me up on stage to dance with them while they sang "Whatta Man!" Another was very Sixteen Candles. *You remember that scene where Molly Ringwald walks out of the church and everyone is gone and Jake Ryan is across the street waiting for her and he waves? She looks behind her to see who he's waving at but it's her. Well I have an experience like that (minus the church and bridesmaid's dress) with Diane von Furstenberg and I still get excited thinking about it.*

I'm a cockeyed optimist. Life is so fun and amazing and I feel compelled to point that out to people. I think a lot of people don't stop to realize how great things are. I do think that being upbeat and fun to be around is a big reason why I'm successful. And I do work on it. If you invite me to your party I go with the goal of doing my part to make it a success and helping make it as enjoyable as possible. I wish more people did that.

Nothing is more fulfilling than helping other people. It's so easy to make a difference. I'm not moving to India to work in a hospital but I do parties for a living and love doing clothing sales, so I take my talents and apply them to a good cause. For some reason I love India and my favorite charity Citta builds schools, women's centers, and clinics in India and Nepal. What my friends and I raise in one party or one celebrity sidewalk sale can make a huge difference. I think we all need to find a cause that speaks to us and where we can make a difference. I'm proudest of the charity work I've done, more proud than I am of any success I have.

I'm the type who finds a place he likes and stays. I love to wander the globe in my travels and when it comes to food I'm a grazer (I like a lot of little things to nibble on) but for my home and job I like something permanent and dependable. Then again if Royalty Monthly called begging me to be their editor, I might not be able to say no!

"Happiness is a shortcut to mediocrity."

Anonymous

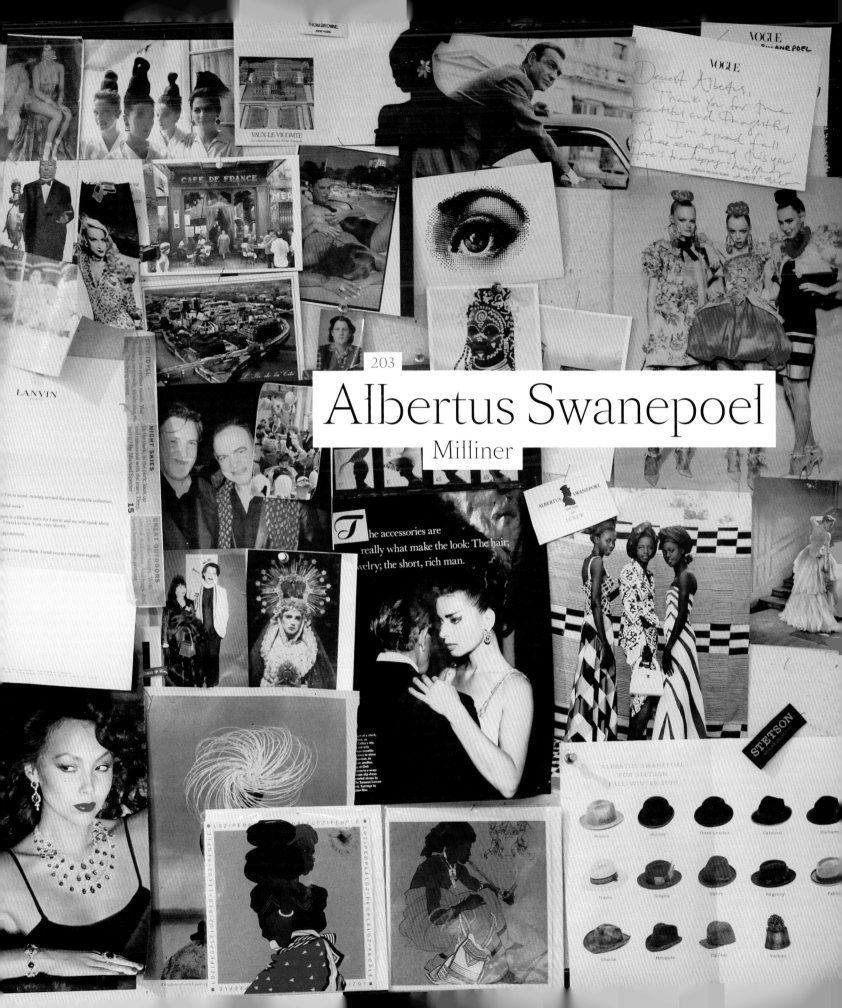

Albertus Swanepoel

Milliner

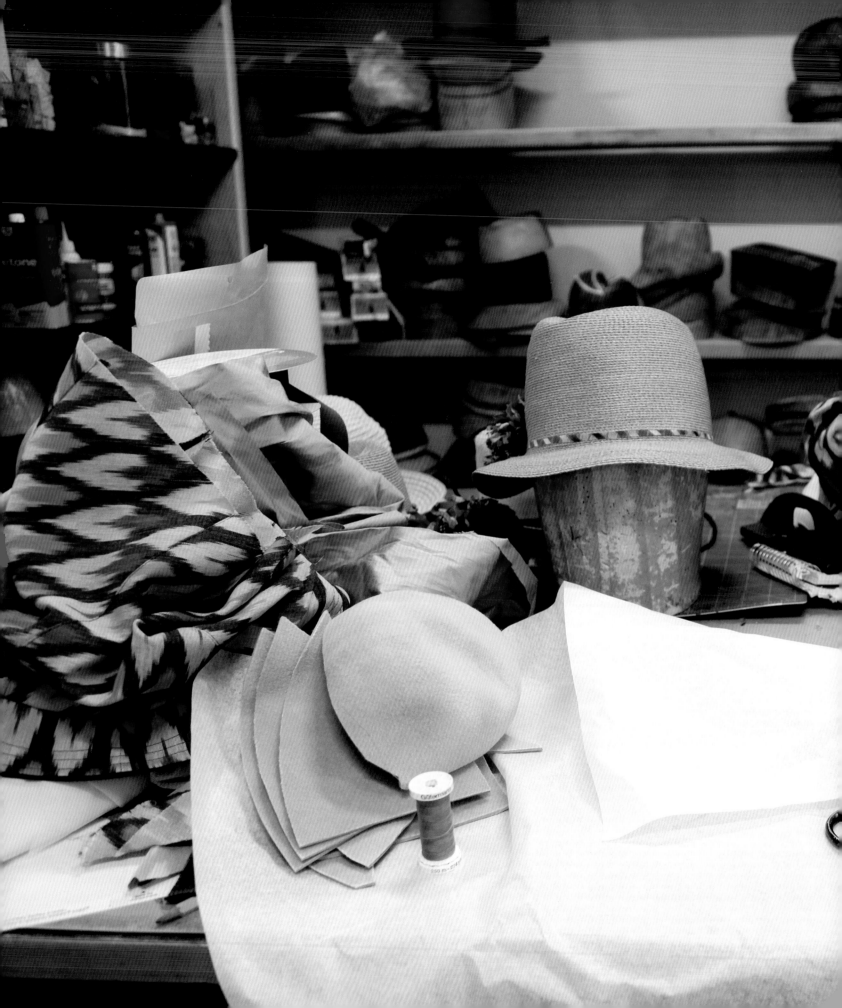

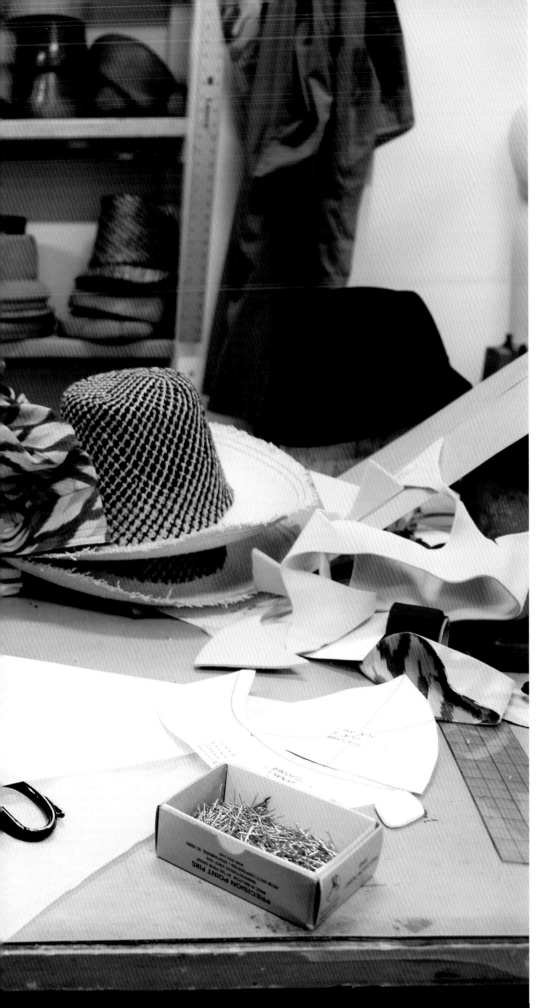

People don't wear hats every day like they used to, yet milliner Albertus Swanepoel has continued to build a successful business despite that fact. He has created hats for some of the world's leading fashion designers including Carolina Herrera, Derek Lam, Peter Som, Diane von Furstenberg, and Tommy Hilfiger. He has also collaborated on a collection for Target, which is how we met.

Visiting his work space is like stepping back in time. A wall of ribbon greets you and vintage wooden hat forms line the shelves. Stacks of hats await decoration and completion. Fashion week is his busiest time but he also works on commissions for private clients. Though few people wear hats these days it's clear that even less would were Albertus not keeping the tradition of hat-making alive and well in New York.

"*Street fashion fascinates me, as well
as the haute couture shows in Paris.
I also love old movies.*"

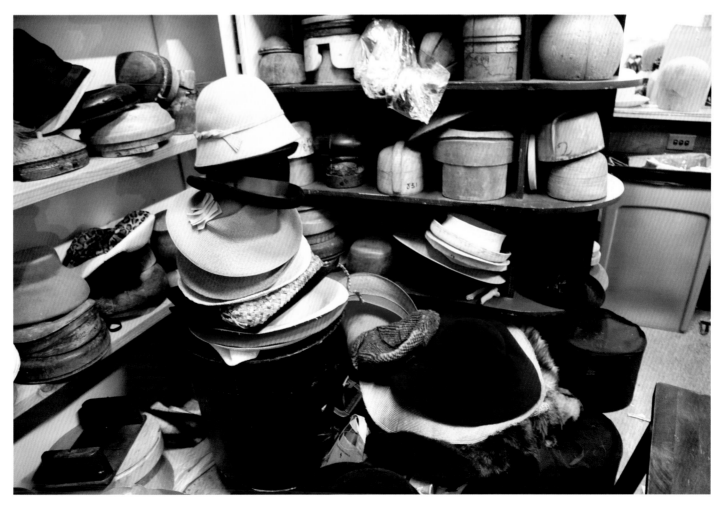

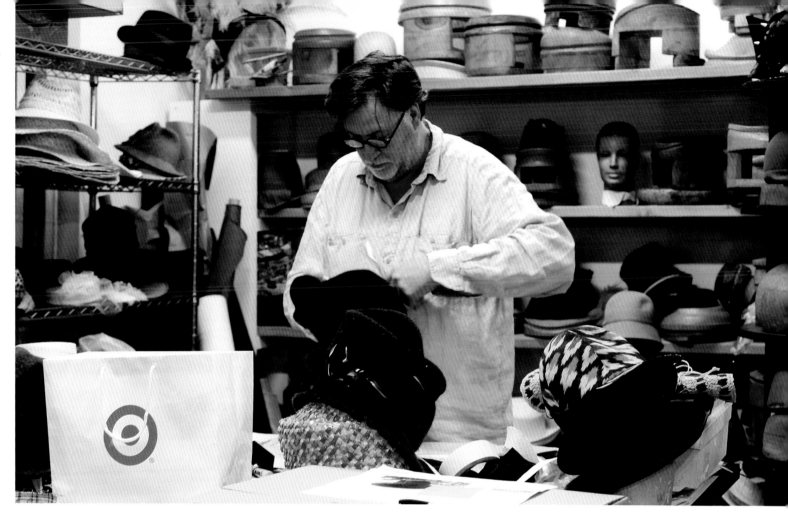

I was a graphic, and then fashion, designer for many years in South Africa. In 1989 I came to New York, got a job offer, and stayed. The job fell through after a year and so my ex-wife and I started a glove company. As it was only a seasonal business, we had to get income in the summer so I took evening classes at FIT for a year, while interning for Lola, an esteemed milliner in New York.

It was a natural progression from gloves. Being a hands-on person, I love the craft aspect of hat making, working on a smaller scale than clothing, and the challenge to create modern looking hats.

In 2004, I was asked to do the turbans for Proenza Schouler's first runway show. Marc by Marc Jacobs followed the next season and my career changed.

I'm a big opera fan. I connect with it on an emotional level, and the costumes, sets, colors, and the larger-than-life music and drama. I travel back to South Africa yearly, which really inspires me. Street fashion fascinates me, as well as the haute couture shows in Paris. I also love old movies.

I don't really look at websites or magazines much. I find it too easy to be inspired from that.

I admire Stephen Jones for sure. He is an amazing milliner, technically brilliant, very sweet person, and is always pushing the boundaries. It is important for me that hats are wearable (on a daily basis) and he succeeds in doing just that.

I also admire Philip Treacy, Dai Rees, Noel Stewart, Lola, and then of course I have a very fond place in my heart for people like Cecil Beaton, Claude Saint-Cyr, Mr. John, and Lilly Dache.

I like the challenge of creating something new. I'm pretty hard on myself (my Calvinist upbringing!) and take what I do very seriously. (I know I'm not saving lives though!)

Working with the NY designers on their runway shows are fantastic, as it is almost always a technical challenge and I love making their vision come true.

Hats are such a niche market, and one has to make peace with that, I guess!

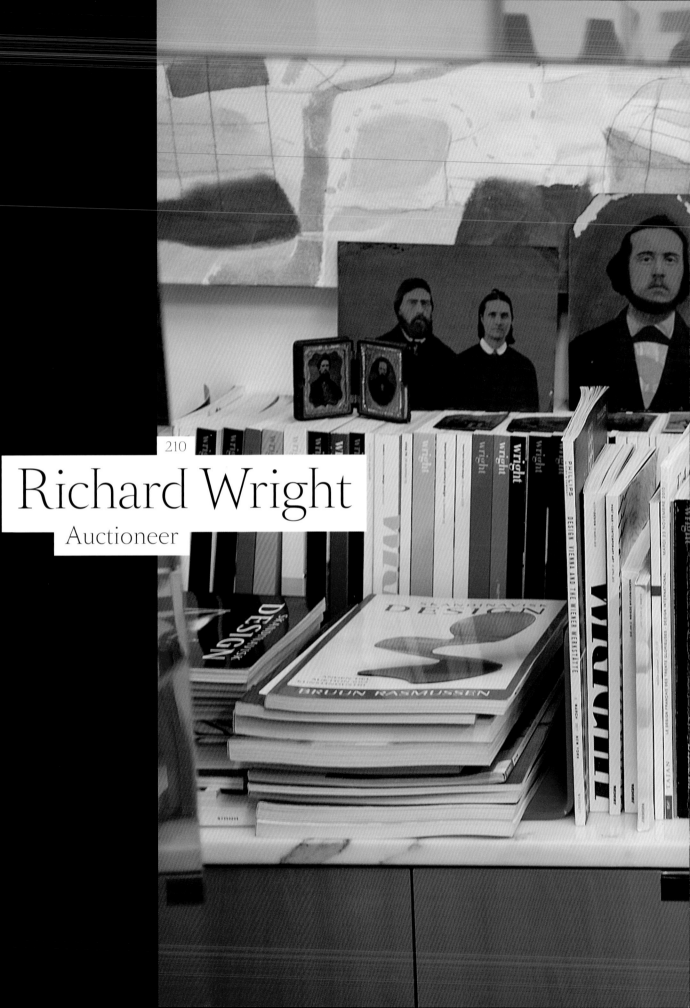

Richard Wright
Auctioneer

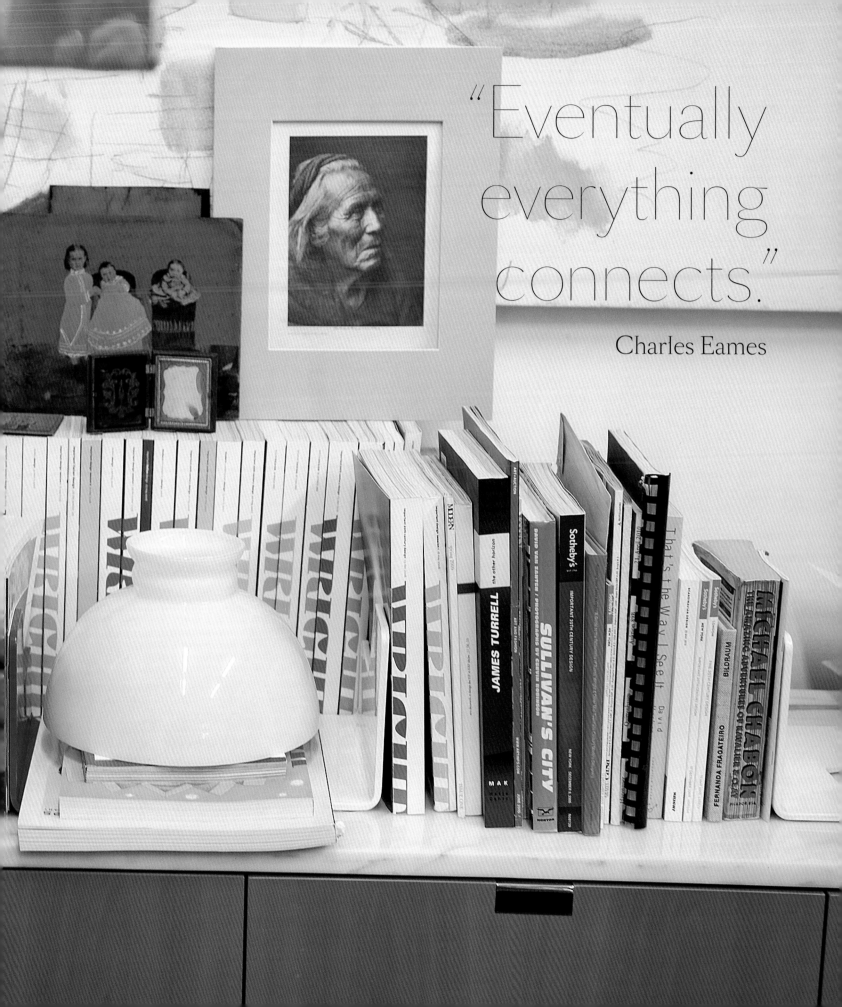

"Eventually everything connects."

Charles Eames

When I was planning a trip to Chicago last year, first on my list of places to visit was Wright Auction. They are known for their focus on 20th and 21st-century furniture, and owner Richard Wright is recognized as a leading expert on modern design. Wright Auction catalogs can be found in the offices of all the leading interior designers and architects next to those from Sotheby's and Christies. While he could have probably gone to work elsewhere, his shy and unassuming demeanor seems perfectly suited for the Midwest. In Chicago he can focus on the work of finding the best of the best for Wright Auction without distraction. But with absentee and phone bidding, his clients can live anywhere in the world, which works out perfectly.

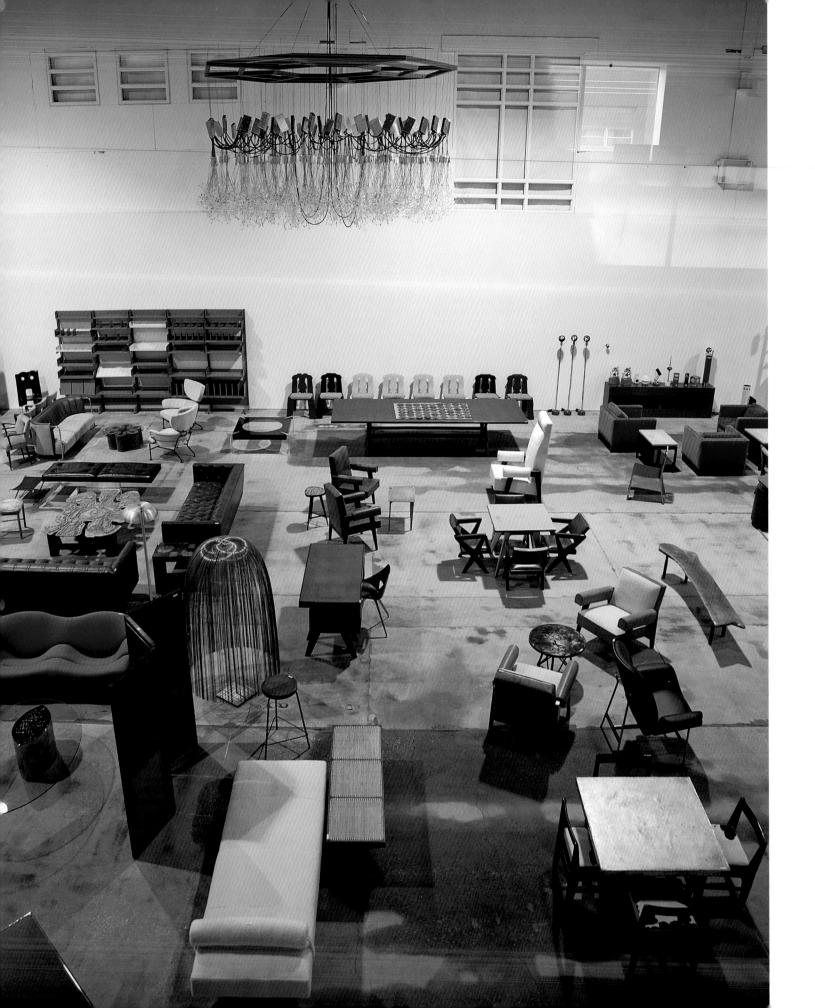

I got into the auction business the long way. I worked my way up from flea markets and antique malls to working for another auction house and then eventually started my own firm. I took many steps and in the end they were all necessary.

My first auction was $400,000. It took two years to break one million, it took four years to sell my first piece for over $100,000. I firmly believe you make your own luck and small breaks add up in the end.

Modern design is a big and creative category. It is visual and does not follow a small, refined palette of forms. Modernism is about breaking with the past even when the past includes itself – so the field is full of contradictions and reactions. It is open to exploration.

In the early days, the most powerful dealers were in New York. Mark Isaacson and Mark McDonald taught many of us through their pioneering gallery Fifty/50. They would buy the best you had and then tell you afterwards! Robert Swope and Michel Hurst taught me how to look closely and evaluate condition. Michael Glatfelter taught me that the world is small and to never burn a bridge. I am grateful for all their advice.

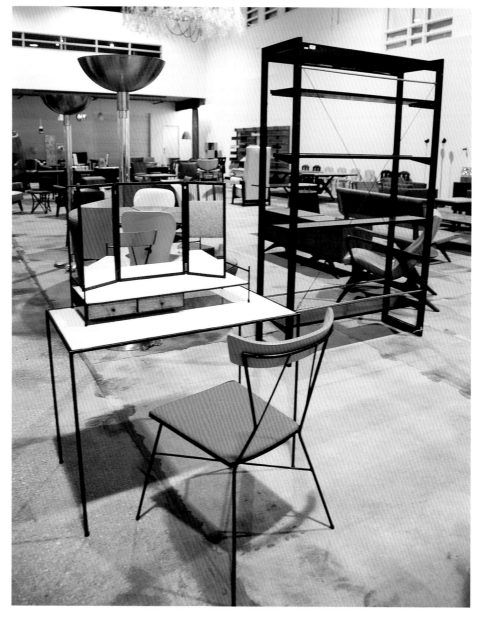

215

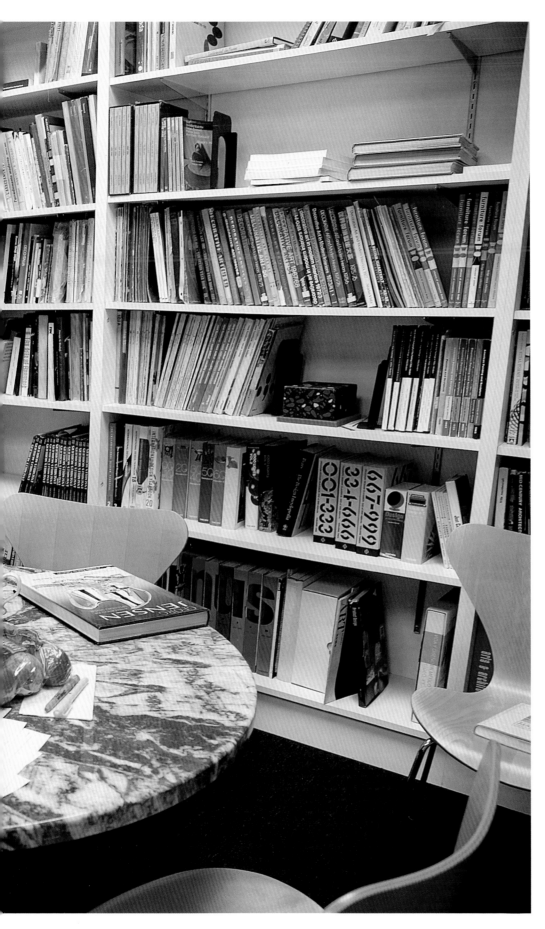

Travel is the best inspiration. It shifts your visual and mental space, yet it always feels good to come home.

I admire the consistent level of presentation that Patrick Seguin brings to the field. He has evaluated French design. I would like to see more dealers in America follow that model.

I love my job, and the cast of characters, and the amazing range of historical items we get to handle. I love documenting the past and presenting new works to the world.

Julie Thoma Wright, my late wife and business partner, taught me to dream big. It was scary at first but it was the best advice I ever received.

Chicago has been very good to me. I have access to fresh material here in the Midwest and was able to build my business on a shoestring—something that is very hard to do in New York. I grew up in Maine, I was never destined to live in LA—it is too easy!

"All is flux, nothing stays still."

Heraclitus

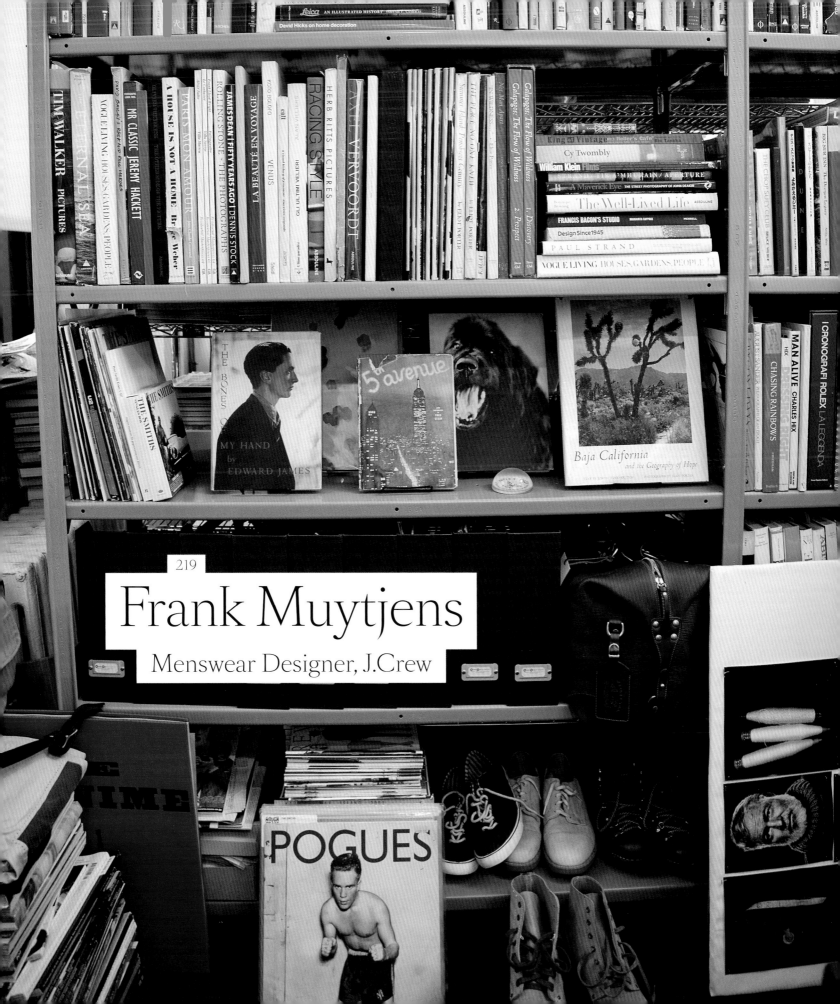

219

Frank Muytjens

Menswear Designer, J.Crew

Usually menswear is the redheaded stepchild in the fashion world, but not at J.Crew. In the four years that Frank Muytjens has been the head of men's design at J.Crew, it has become just as watched and acclaimed as their womenswear. With stand-alone men's shops such as the Liquor Store and 1040 Madison Avenue in New York, the male customer can now peruse the racks while enjoying a drink or feeling like he's in a cabin upstate. It's an aesthetic that looks like it might have been influenced by Frank's own office full of vintage flea market finds and old books.

Frank was born in the Netherlands but his take on fashion is probably more American than many designers actually born in the U.S. That just might be the secret to his and J.Crew's menswear success.

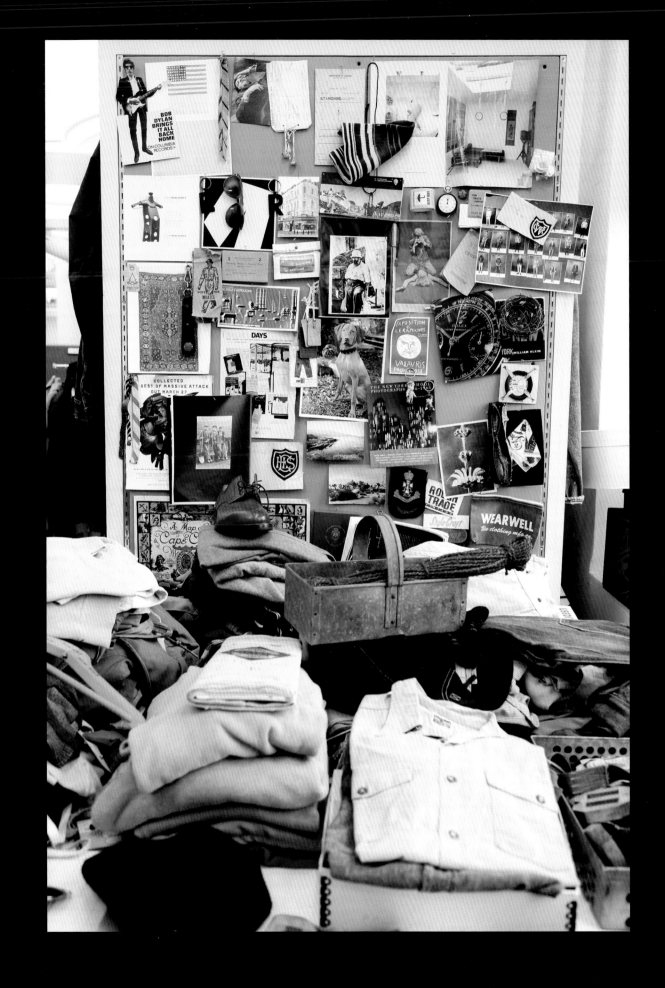

I actually went to college to be an illustrator. It wasn't until I started to take the required fashion classes that it all fell into place.

Back in 1997, I was hired at Polo to work on RRL. It was a crash course in Americana. It was my first big gig in NYC and it was a dream come true.

I think being an outsider allows me to look at American culture from a different perspective. It makes it easier to mix a European with an American sensibility.

Our guy has grown up with us. We try to be consistent and persistent, and go for a more understated, rather than overstated, look. Understated doesn't have to be boring.

Inspiration can range from a Japanese pencil to pictures of Giacometti's studio.

I greatly admire the person who designed the military M65 Field Jacket, issued by the U.S. government. It's a design classic with functional details, and every season I see new iterations of it on the catwalks and the streets. Many military pieces have become design icons.

It excites me that my eye is always changing and keeps me on my toes.

Balance comes by escaping to my house in the country upstate. Friends freak out when they discover I don't have an internet connection. I think it's important to live in the moment. I love working on the house and the garden on the weekend, but also love driving back to the city and getting that first glimpse of the New York skyline. It never bores.

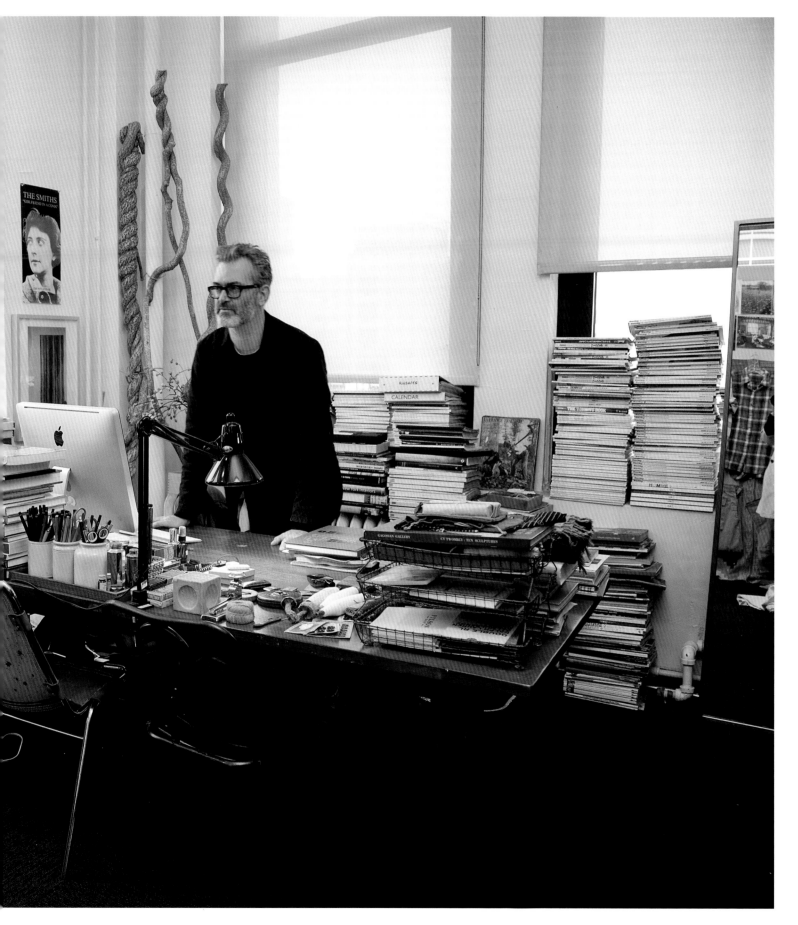

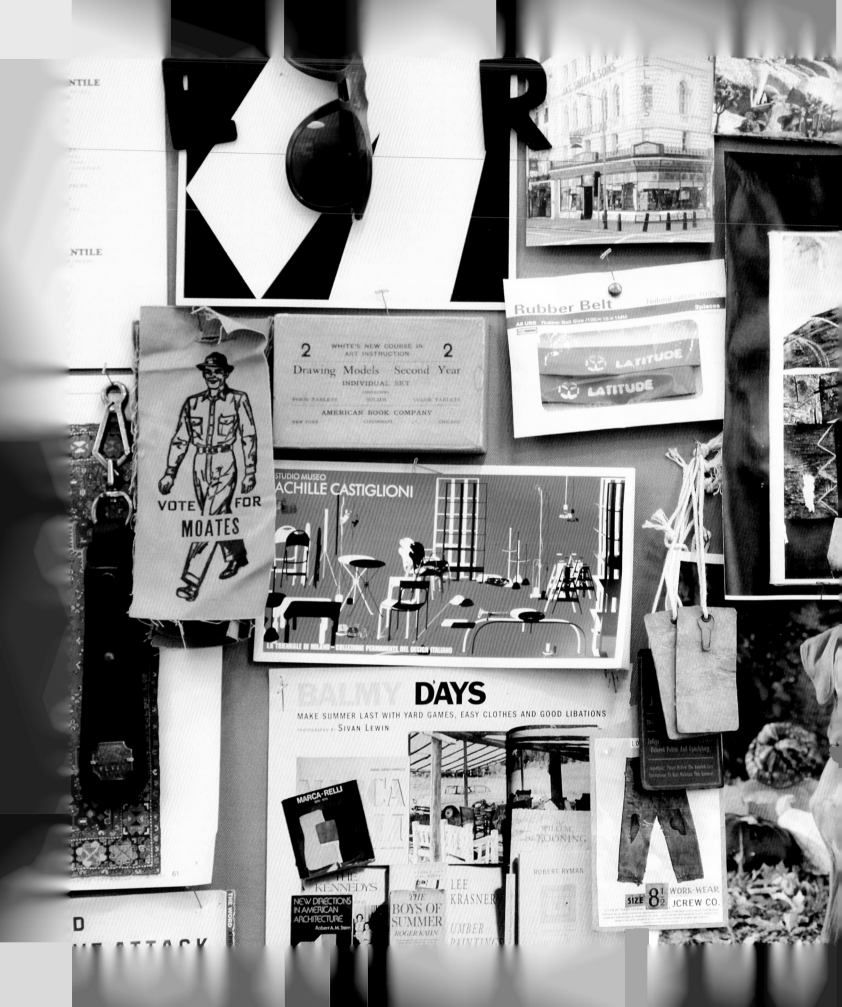

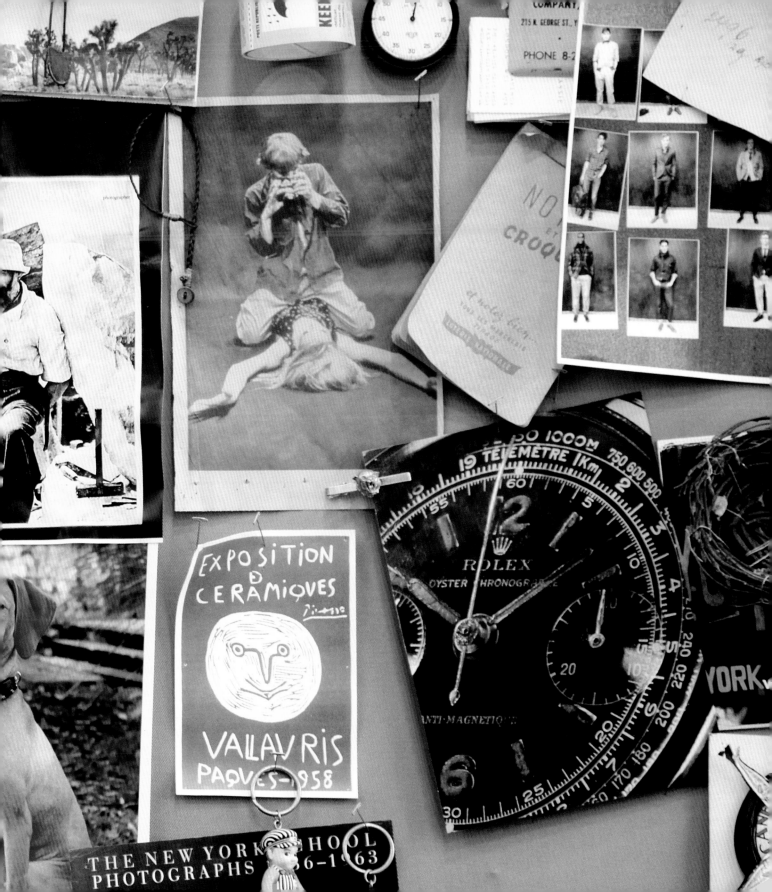

"Simplicity is the ultimate sophistication."

Leonardo da Vinci

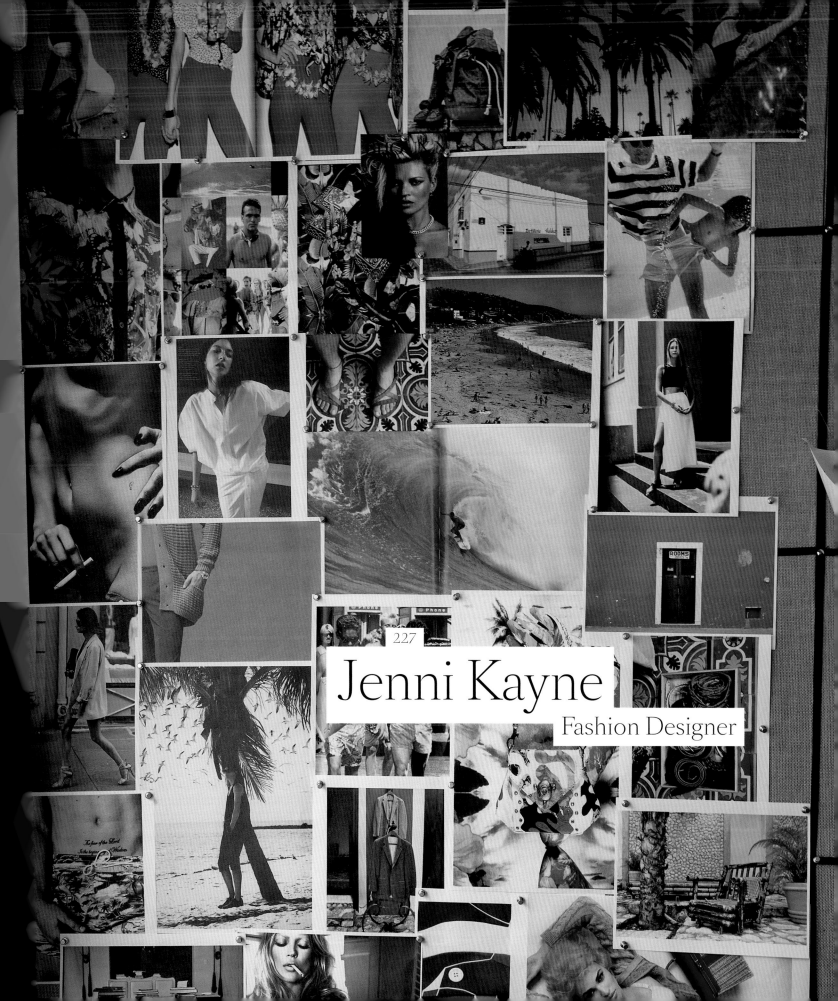

227

Jenni Kayne

Fashion Designer

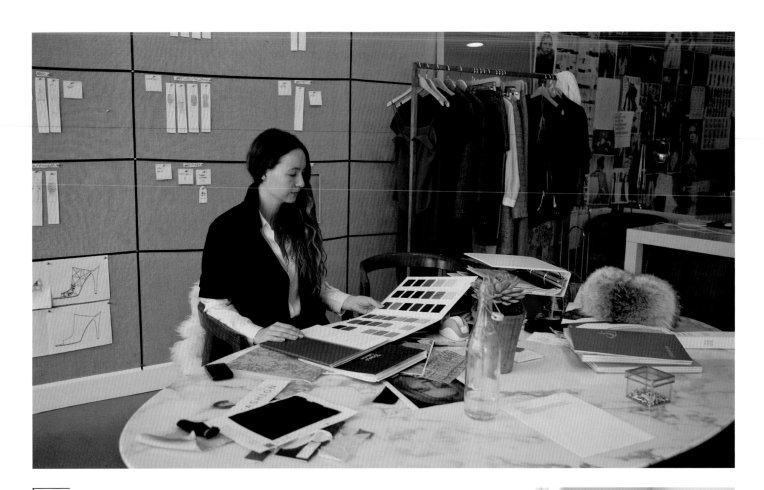

Everyone thinks that you must live in New York to be a fashion designer but Jenni Kayne has done more than alright for herself in Los Angeles. Perhaps being out of the fray is actually an advantage. Her self-described "super-chic, easy to wear clothes," are perfect for the woman who wants to wear accessible and sophisticated clothing whether she lives in California or not. A pop of color always seems to show up in her collections which might not happen if she didn't live in such a sunny landscape. Her wonderfully relaxed life and clothing line are enough to make this New York girl want to move to Los Angeles. And that's saying a lot.

TWILL COATING
W/ LTHR TRIM

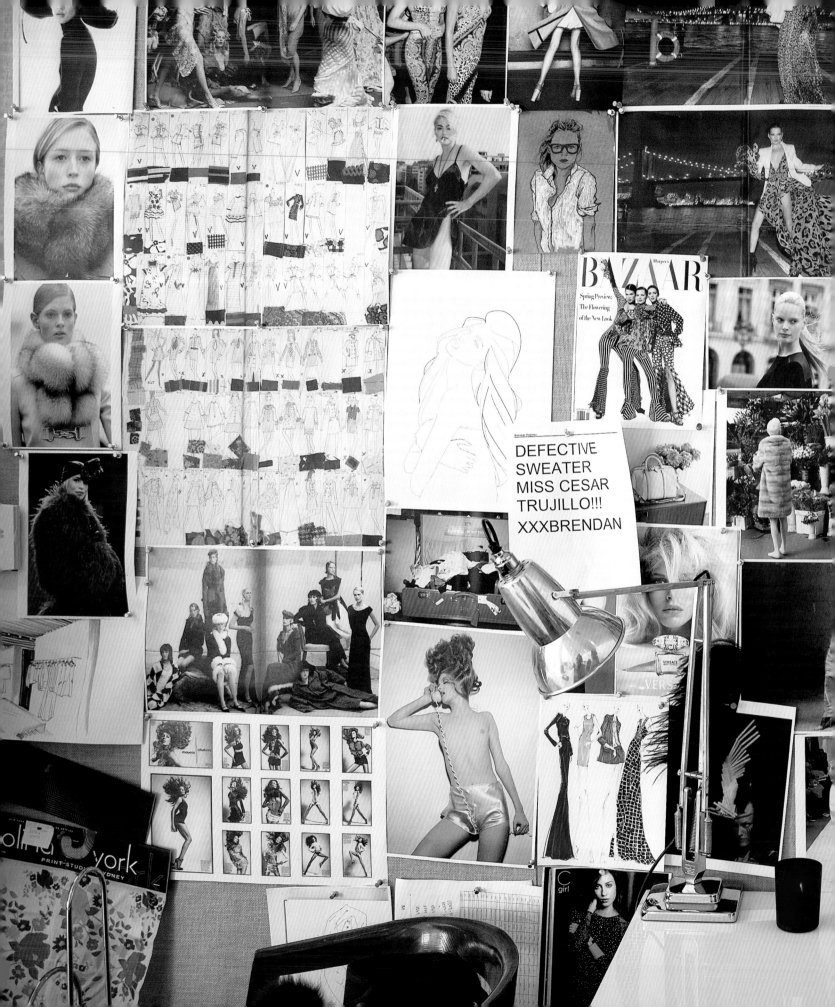

DEFECTIVE
SWEATER
MISS CESAR
TRUJILLO!!!
XXXBRENDAN

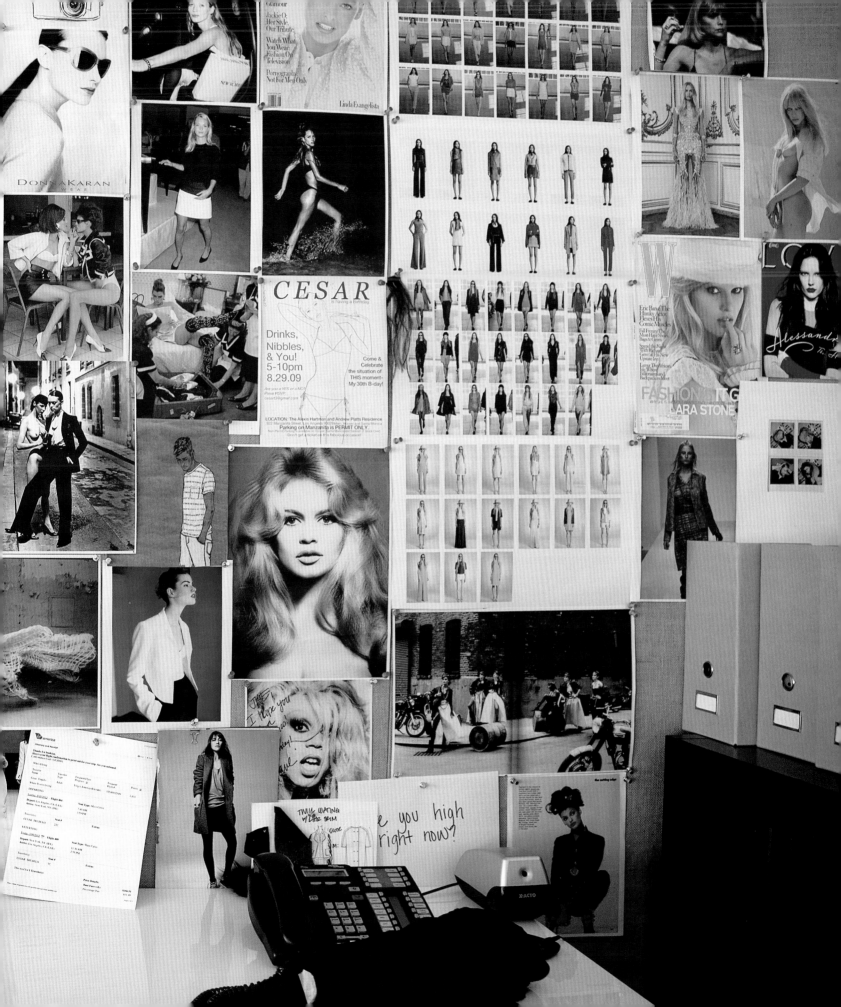

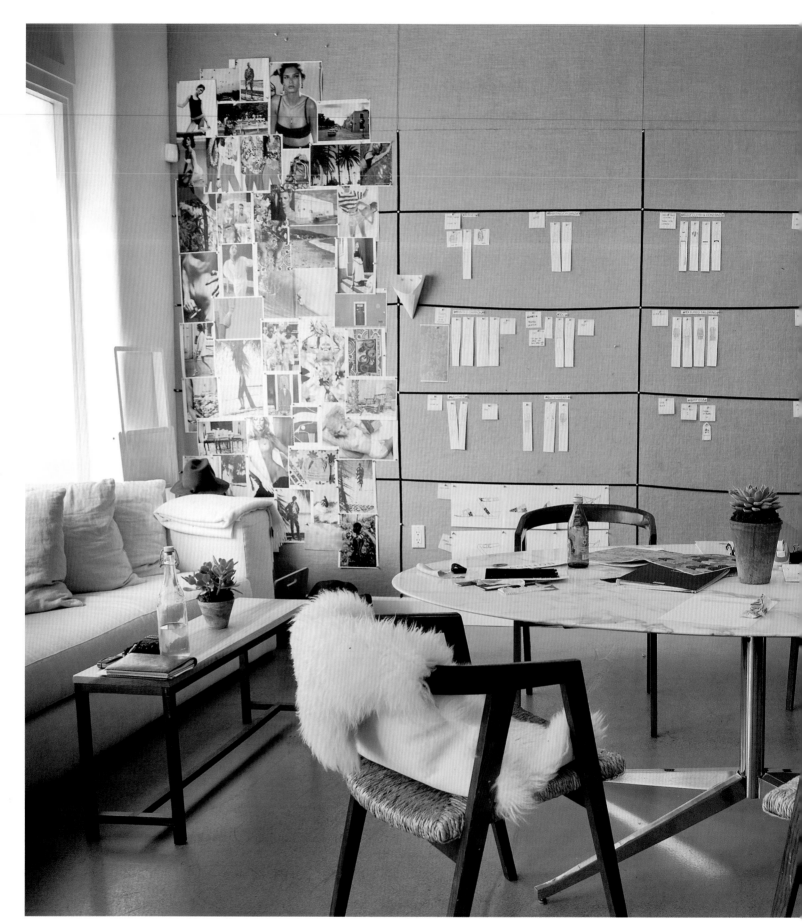

CREATIVITY AT WORK – JENNI KAYNE

I think I was 8...I could have been a little younger. My mom took me to a Chanel charity fashion show that was amazing. Linda Evangelista and all the big super models were in it. I was in awe and knew I wanted to be a designer.

I was young and ambitious when I started my own collection at 19. Looking back on it, it sounds crazy and scary but at the time I was determined and excited.

My first break was meeting with Anna Wintour and walking her through my fall 2006 collection after my first New York presentation for Spring 2006.

I am such an LA girl and I think that translates into my collection and my overall aesthetic. I am constantly inspired by my surroundings and the California landscape. I am based in LA, but I show and sell in NY because that is the center of the fashion world.

Every season is different. Sometimes it's nature, film, or art, but usually it's an overall feeling and mood that inspires me.

I admire so many people but I really look up to Ralph Lauren for the fashion and lifestyle empire he has built so successfully.

My stores really drive me these days. I opened my Almont location five years ago and I just opened a second boutique in the Brentwood Country Mart. From the décor to the jewelry to my collection, I am constantly excited about what I do when I am in my stores.

Balance...that's a joke. I wish I could find balance and am constantly trying to. I just try to be the best working mom I can be.

Life is too short. Fashion is such a stressful business, I try not to put too much pressure on myself because it is not worth all the stress.

"Each man should frame life so that at some future hour fact and his dreaming meet."

Victor Hugo

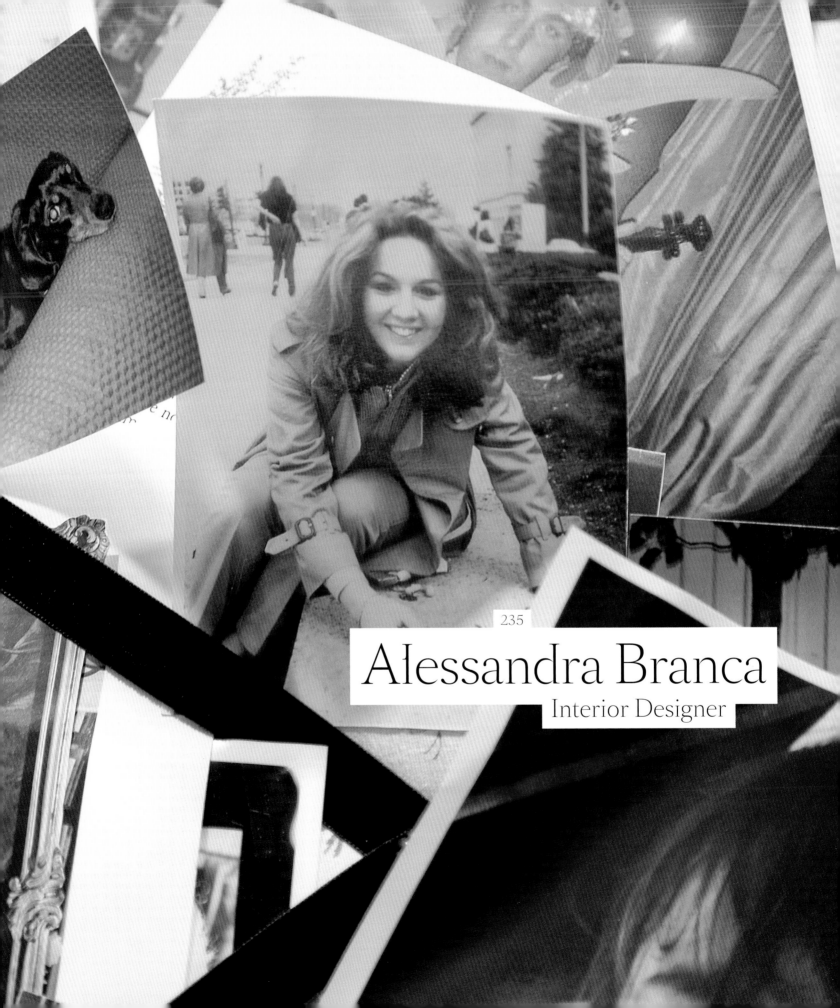

235

Alessandra Branca
Interior Designer

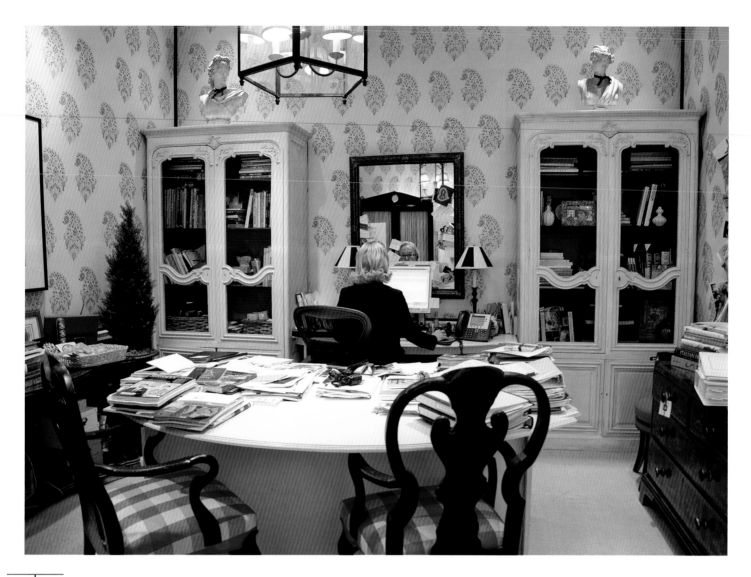

236

There are some people in life who make you want to be a better person. To read more, do more, travel more, and most importantly, try harder. That's how I felt about Chicago-based interior designer Alessandra Branca when I first met her. She is wonderfully well read and intelligent and has a great zest for not only design but also for life. It's quite fitting that her favorite color, which appears in much of her work and her office, is red, the color of passion. It could also be due to her childhood growing up in Rome—a very passionate city. I'm definitely adding more red to my own life regardless.

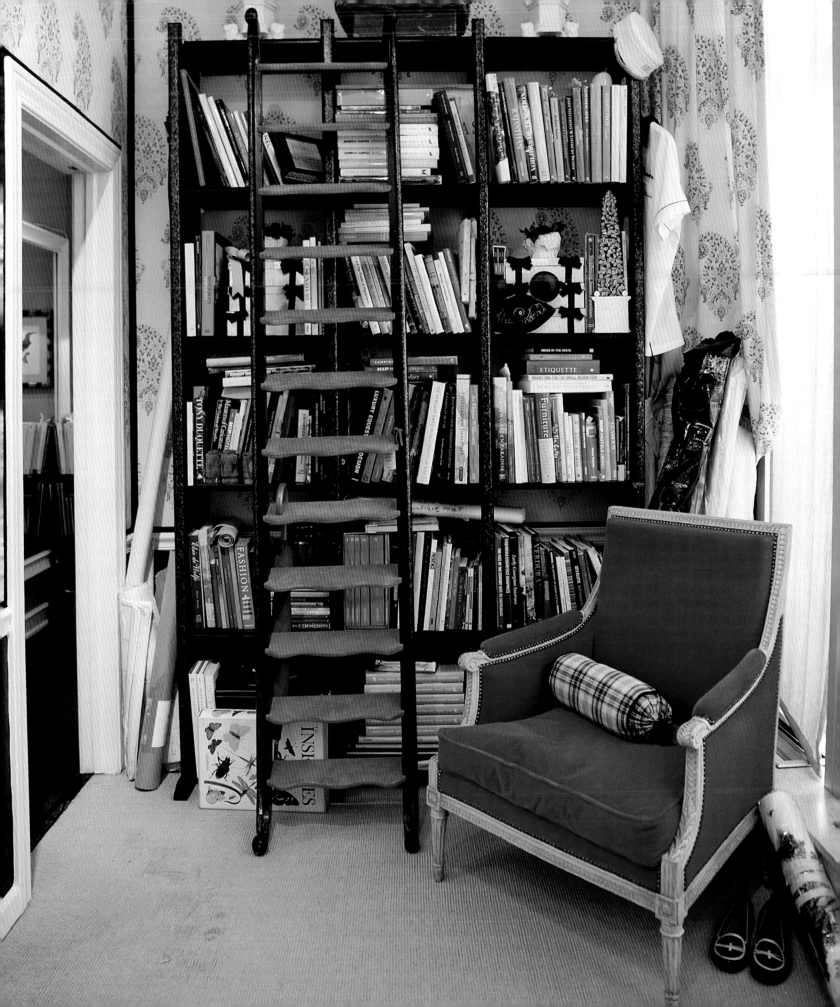

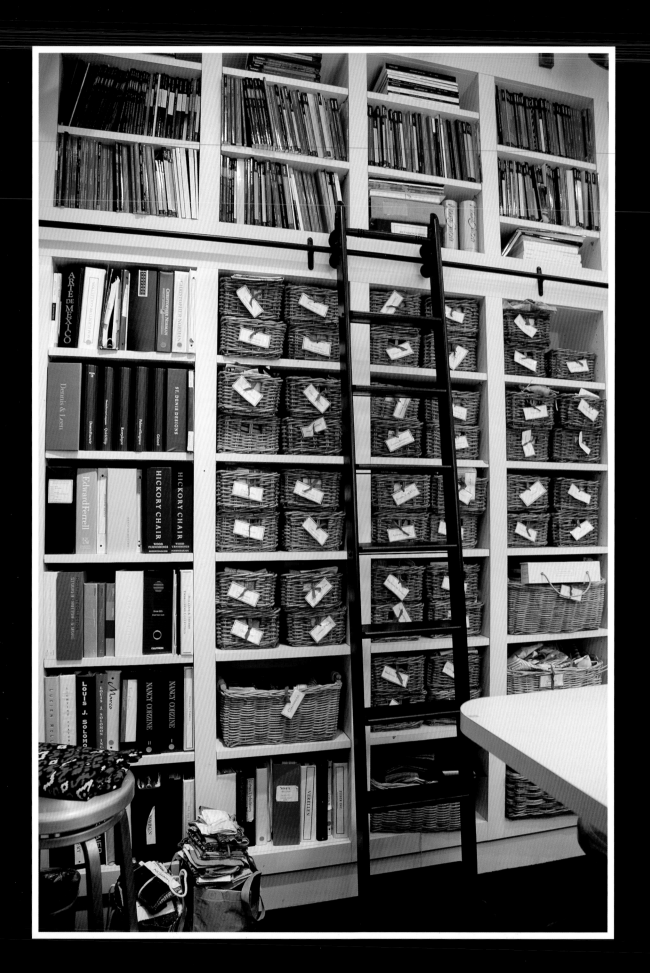

As a child I moved all my furniture around in my room. Obviously the seed was planted. I spent my teenage years going to churches and palazzi and antique dealers in Rome. In my twenties, I started with my first home, our home, then moved on to my gallery and then came my very first commission.

Someone came to my store and loved the way I had designed the space. They asked if I could do their home. I had to think long and hard about it as I felt it was important not just to have the taste but to support that with good technical skills.

I think being brought up in a culture that is deeply imbued in style and aesthetics made it very simple to transition into this field. My grandfather taught me that work which is your passion will never be difficult and can continue forever.

Good design provides the world with good solutions as well as pleasing experiences. I think you have to simply keep your eyes and mind open at all times and you will learn how to be better and better. You will be constantly inspired, which also helps you evolve, which I think is extremely important to everything.

I admire two groups: first, all those who make things and are committed to making them well, such as great carpenters, painters, furniture makers, etc. It is the only way we are able to enjoy such beauty. The second, and no less important, group are the great design icons who have come before us, who had fantastic vision and knew how to make that vision into reality. I love what I do so much it transports me through time without my knowing it.

Every single day is different and I continue to learn, grow, and evolve. This literally gets me out of bed each morning!

Do what you love, and do it with passion and commitment to excellence....no matter what.

Red brings me joy and represents the passion with which I live!

"Early in life I had to choose between honest arrogance and hypocritical humility. I chose the former and have seen no reason to change."

Frank Lloyd Wright

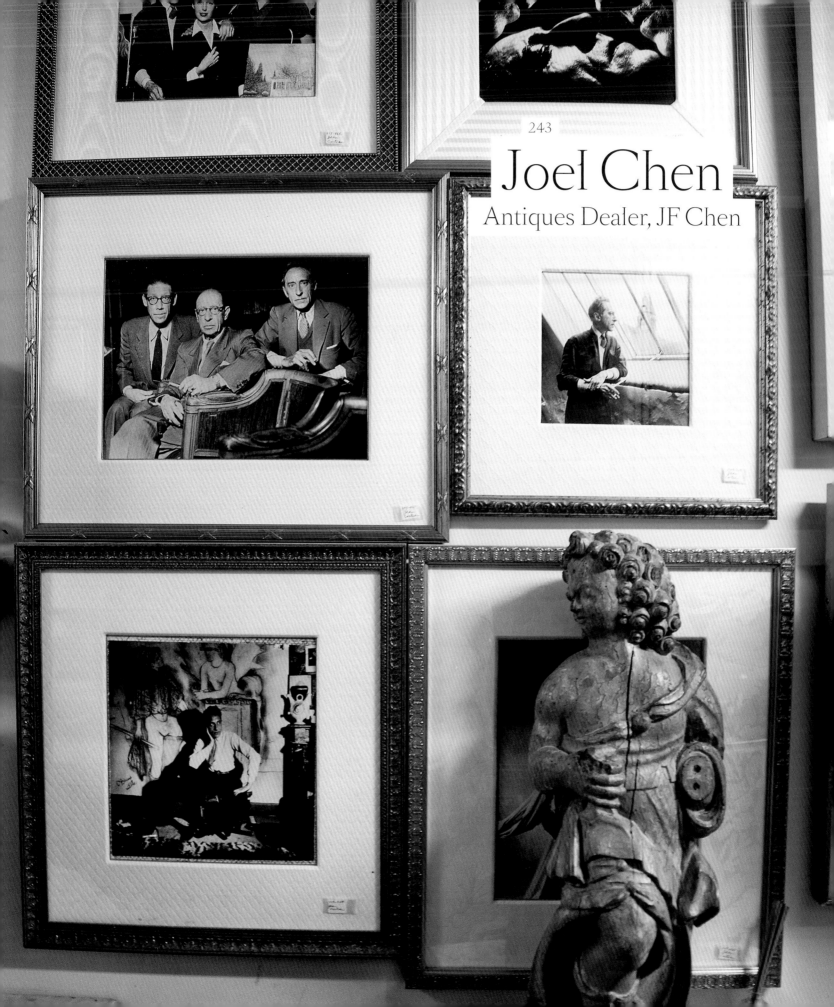

Joel Chen
Antiques Dealer, JF Chen

When you visit the sprawling JF Chen showroom in Los Angeles, you feel like you need to leave a trail of breadcrumbs to find your way out again. Pieces from as far back as the 12th-century coexist with furniture from every decade up to the 1970s in what really seems like a warehouse. I don't know how owner Joel Chen knows where to find anything, yet I have the feeling that he can tell you exactly where to locate anything you might be looking for. The best pieces reside in his own office where he can be found writing up each ticket himself.

He opened JF Chen in 1975 after not being able to access a trade-only showroom, and in the 37 years it has been open it's become a mecca for designers and celebrities. Joel is much too modest to name them but Cameron Diaz, Ralph Lauren, and Jake Gyllenhaal have all stopped by, in addition to countless decorators and set designers. The lower level now hosts contemporary exhibitions bringing things up to the 21st century so you really can find anything your heart desires or didn't even know it wanted.

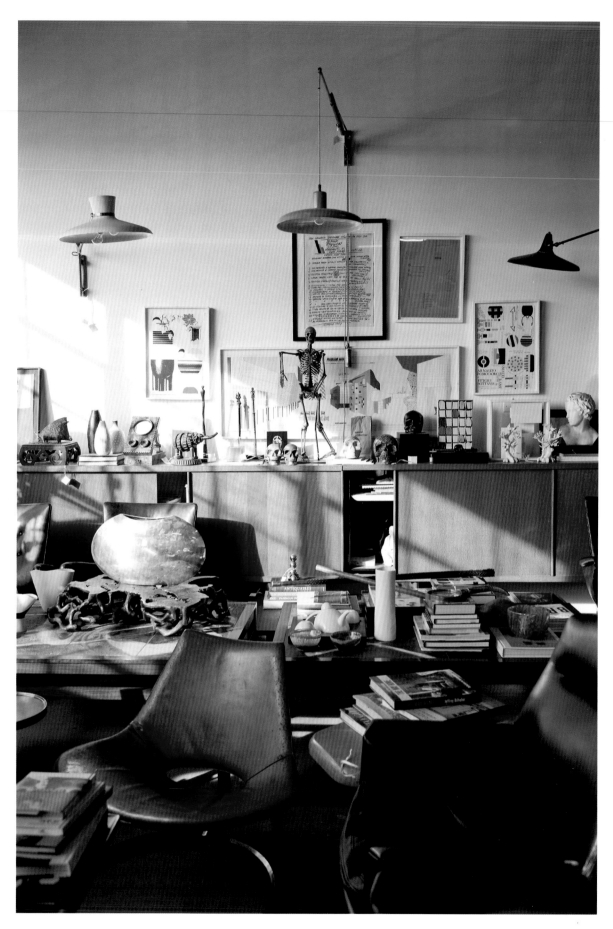

248

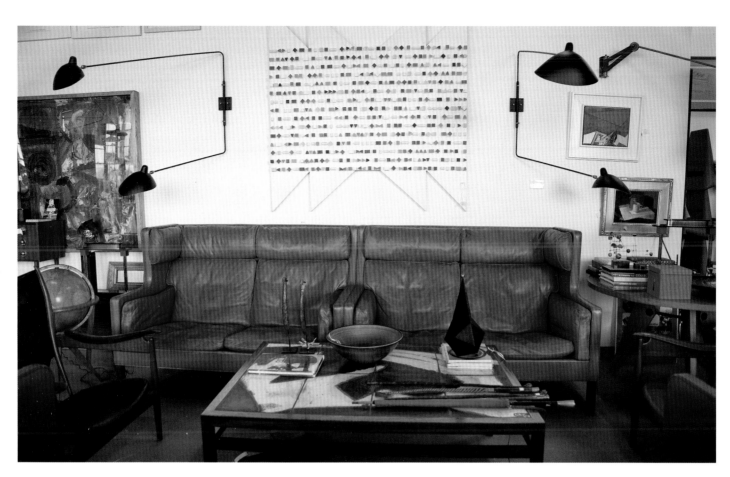

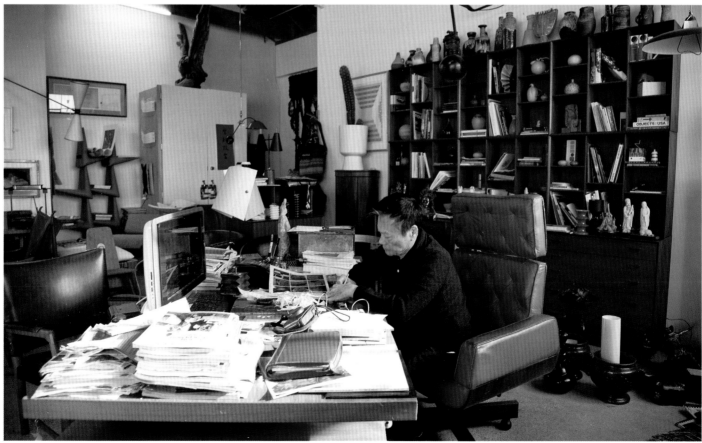

I attribute my longevity in this business to my passion for all things design.

Los Angeles is where I spent my college years and where I have been for the last 40 years, so I could not imagine being anywhere else. Art and design have always been emerging, and now they're here. The attention to the wealth of art and design in Los Angeles and Southern California has definitely grown.

Classics like Robsjohn-Gibbings, Giò Ponti, Jean Prouvé, Charlotte Perriand, and Mies van der Rohe never go out of fashion.

I just went to India and South America and each place has its own interpretation of living, arts, and design. I like to combine different ethnic cultures with something from someplace entirely different, while still achieving harmony.

What's exciting, is that for me, it's not a job... it's a quest for my next endeavor.

My way of relaxing is not relaxing. I always have my eye out for things and love working day and night.

I do not travel as much as I used to. Every new place still excites me, but I love going back to the Scandinavian countries. I have yet to go to Africa or Australia. I'm hoping Africa is my next destination.

If you believe in something substantially, you go for it.

Acknowledgements

I first have to thank everyone who has read my blog Habitually Chic each day for the past five years. Your continued loyalty means the world to me and is the reason I get out of bed every day.

I owe a huge thank you to everyone at powerHouse Books for believing in my vision for *Creativity at Work* and for allowing me to take my own photos. Publisher Craig Cohen for making it all happen, my editor Wes Del Val for guiding the process and putting up with me for the past year and a half, editor Will Luckman for catching all my grammatical and spelling errors, designers Alex Martin and Kris Poluchowicz for assisting with production, and publicist Nina Ventura for spreading the word. It really does take a village to make a book.

This book would not look nearly as chic if not for the amazing work of designers Andrew Wren and Philippe Egger of Everyday Workshop. I especially love the Sang Bleu font they chose for it.

I am extremely grateful to my photo editor Joseph D'Arco for his gorgeous postproduction work on all the photos.

This book would also not be possible without all the gracious creative people who opened up their workspaces to me. Thank you to Peter Som, Albertus Swanepoel, Jeremiah Goodman, Alessandra Branca, Richard Wright, Jenna Lyons, Frank Muytjens, Carlos Huber, Terron Schaefer, Dana Lorenz, Michael Bastian, Chris Benz, Lauren duPont, Philip Crangi, Jonathan Adler, Bunny Williams, Jon Maroto, George Nunno, Jack Gerson, Lorin Stein, Steven Kolb, Thelma Golden, James de Givenchy, Mickey Boardman, John Truex, Richard Lambertson, Gerald Bland, Miranda Brooks, Roman Alonso, Steven Johanknecht, Lulu deKwiatkowski, Jenni Kayne, and Joel Chen.

Just as important as the subjects were all the friends, relatives, publicists, and assistants who facilitated introductions, scheduled shoots, and wrangled interview questions. A huge thank you goes to Andrea Borda Stanford, Karen Peterson, Lara Schriftman, Alice Ryan, Alexandra Carlin, Karen Robinovitz, Dean Rhys Morgan, Tess Riester, Jen Sucher, Heather McAuliffe, Wendell Winton, Shawn Buchanan, Dana Turek, Georgia Frasch, Eleanor Banco, Eugenia Gonzalez Ruiz-Olloqui, Katie Dineen, Sidney Prawatyotin, Jane Son, Gene Migliaro, Alysa Teichman, Diego Louro, Courtney Crangi, Rebecca Gore, Starrett Zenko Ringborn, Carolyn Sollis, Carolyn Coulter, Erin Kent, Elizabeth Gwinn, Olivia Powers, Drew Elliott, Francesca Matteo, Lizzie Bailey, Elizabeth Boyle, Laura McCabe, and Fiona Chen.

A heartfelt thank you goes out to all my lovely friends for their support, encouragement, and feedback during the process of photographing and writing this book. And for keeping me sane. They are Stefan Hurray, Jessica Gold Newman, Joshua Newman, Kelly Reynolds, Tommy Smythe, Alexis Graham, Amina Akhtar, Adam Dadson, David Javadpour, David Lawrence, Liza Weiner, Blue Carreon, Chandler Hudson Kenny, Eleanor O'Connell, Fallon Hogarty, Laurie Reynolds Scovotti, Mercedes Desios, Alberto Villalobos, and Donald Ray.

Most importantly, I want to thank my parents for fostering my own creativity growing up.

"Choose a
job you love,
and you will
never have
to work a day
in your life."

Confucius

HABITUALLY CHIC
CREATIVITY AT WORK

Photographs & text © 2012 Heather Clawson

Published in the United States by powerHouse Books,
a division of powerHouse Cultural Entertainment, Inc.
37 Main Street, Brooklyn, NY 11201-1021
telephone 212.604.9074, fax 212.366.5247
e-mail: info@powerhousebooks.com
website: www.powerhousebooks.com

First edition, 2012

Library of Congress Control Number: 2012942350

ISBN 978-1-57687-607-7

Printed in China by Everbest Printing Company through Four Color Imports, KY

Graphic Design
Everyday Workshop

A complete catalog of powerHouse Books and Limited Editions
is available upon request; please call, write, or visit our website.

10 9 8 7 6 5 4 3 2 1